Bruegel

In the Prado Museum, Madrid, Pieter Bruegel's *Triumph of Death* (Plate 10) hangs between two triptychs by his great Dutch precursor, Hieronymus Bosch. Similarities abound, particularly between the *Triumph of Death* and Bosch's *Haywain* triptych. Both are elaborate allegories, Bosch's of the contemporary state of the Church, Bruegel's of the inevitability of death. Both works are crowded with a mass of tiny, hectically active figures, many of whom are caricatured to the point of grotesqueness. Both artists employed a technique which deliberately emphasized the lack of realism in their work: they painted thinly, scraping their delicate pigments across the gesso ground of the panel.

Despite these similarities, the pictures were painted about half a century apart, during which time there had been great changes in the artistic climate in northern Europe, as well as in Italy. In the first half of the sixteenth century, northern artists discovered the Italian Renaissance. A trip to Italy became obligatory for a young painter and the widespread dissemination of prints in the manner of the Italian masters of the Renaissance provided easily accessible models. In 1554, about eight years before *The Triumph of Death* was painted, Frans Floris, the most successful artist in Antwerp, supervised the erection of his altarpiece *The Fall of the Rebel Angels* in the cathedral. Overwhelmed by his impressions of Michelangelo's *Last Judgement*, and deeply influenced by what he had seen of Tintoretto's figure drawing and sensuous colour, Floris evolved a style which might have been vital but remained clumsily derivative.

Bruegel, however, on his return from Italy reverted at first to Bosch, to the graphic tradition of the Netherlands. Then, in the richly creative decade of the 1560s, with his deepening study of Italian painting, he produced a series of late monumental masterpieces which, in their profound synthesis of the Flemish graphic tradition and the ideals of the Italian High Renaissance, represent the greatest achievement of Netherlandish painting in the sixteenth century. The stylistic wheel had come full circle, for Bruegel's own training was in the Italianate tradition.

The only important early source of information about Bruegel's life is Carel van Mander's *Schilderboeck* (Book of Painters), published in Haarlem in 1604. According to van Mander, Bruegel was apprenticed in the studio of Pieter Coecke van Aelst. The precise date of Bruegel's birth is not known but it seems likely that he was born between 1525 and 1530, probably in or near Breda which was then in the territory of the prince-bishop of Liège.

At the time of Bruegel's apprenticeship, his master Pieter Coecke was working in Brussels, though he retained contacts with Antwerp, where he had earlier been active. Pieter Coecke is an artist whose great contemporary reputation is difficult to understand. Very few of his paintings have survived so it is perhaps difficult to judge him fairly, but, even in those designs for religious pictures which still exist as engravings, vitality and compositional strength have been forfeited by his clumsy attempts to reproduce the figure canon of the Italian High Renaissance, and especially of Raphael. By far the most interesting of his surviving designs is the series of woodcuts, *Moeurs et Fachons de faire de Turcz*, a record of a journey he made to Constantinople which was published after his death by his widow. In this series the pleasure taken in lively incident and exotic costume find a reflection in Bruegel's work. Coecke also collaborated with Jan Cornelisz. Vermeyen on his cartoons for tapestries commemorating Charles V's Tunisian campaign; and Bruegel's *View of Naples* (Plate 64) shows that he had studied these designs. Perhaps more important for Bruegel's development was Coecke's wife, Mayken Verhulst Bessemers, a painter in watercolour on canvas. This kind of painting, which flourished in her native town of Malines, provided a substitute for more expensive tapestries. It was probably she who taught this technique to Bruegel, who used it for the *Adoration of the Kings* (Brussels). Bruegel later married Coecke's daughter and van Mander tells us that Mayken Verhulst taught watercolour painting to her grandson, Jan Brueghel.

Coecke died in Brussels in December 1550. During that year and the following one Bruegel worked with an older Antwerp artist, Pieter Baltens, on an altarpiece for the church of St Rombouts at Malines. In 1551 Bruegel entered the painters' guild at Antwerp as a master. We are told this by van Mander (it is confirmed by the guild records) who says that in Antwerp Bruegel went to work for Jerome Cock, an enterprising and successful publisher who had close links with Pieter Coecke. Although the first concrete instance of the collaboration between Bruegel and Cock is a landscape drawing by Bruegel dated 1555 (later published by Cock) it would seem likely that it was Cock who attracted the young artist to Antwerp. The prosperous port offered great opportunities and, once there, Bruegel applied for admission to the guild.

Soon afterwards, Bruegel went to Italy. He left Antwerp and travelled south through France, returning some time between 1553 and 1555. Though he later made use of his Italian journey in designs for engravings published by Cock, it cannot be certain that this was the purpose of the trip. As van Mander constantly reminded his readers, it was simply a necessary part of a young artist's training to visit Italy. From Jan Gossaert's visit of 1508 until well into the seventeenth century this remained the rule. Bruegel's response to Italy was profound yet selective as we would expect of so original and inventive an artist. Whereas Pieter Coecke had been completely overwhelmed by what he had seen and spent the rest of his creative life attempting to emulate High Renaissance compositions and themes, and whereas Martin de Vos, an Antwerp artist of Bruegel's own generation who travelled with him in Italy for a while, formulated his own curious hybrid version of Italian High Renaissance models, Bruegel derived from his study of Italian painting only what he required to reinvigorate the Netherlandish pictorial tradition. And it was not until years after his return that this study began to have a really significant effect on his work.

We are able to reconstruct Bruegel's Italian journey in some detail—indeed it is the part of his life about which we have the most information. He was not content simply to visit those places usually visited by Netherlandish artists. A drawing of his now in the Boymans-van Beuningen Museum in Rotterdam shows the southern Italian town of Reggio di Calabria, just across the straits of Messina from Sicily. Buildings in the town are on fire and, as we know that it was a Turkish attack of 1552 which caused this conflagration, we can date the drawing to that year. Motifs in *The Triumph of Death*, taken from the frescoes in the Palazzo Sclafani in Palermo of the same subject, suggest that Bruegel crossed to Sicily.

In 1553 Bruegel was in Rome where he met and collaborated with Giulio Clovio, the famous miniaturist whom Vasari called 'a new Michelangelo on a small scale'. Clovio was employed by all the great Roman patrons of the day and, though thirty years older than Bruegel, he had a high opinion of the young Flemish artist and owned a number of paintings and drawings by Bruegel. In Clovio's inventory of 1578, there are three items of particular interest: a view of Lyons in watercolour which confirms van Mander's account that Bruegel travelled to Italy via France, a small *Tower of Babel* on ivory and a miniature by Clovio painted in collaboration with Bruegel. Bruegel's principal interest during these early years was landscape—his earliest drawings are landscapes, his first signed and dated (1553) painting is a landscape—and it is not unreasonable to suppose that in his collaboration with Clovio it was he who painted the landscape and the Italian the figures.

Bruegel returned home across the Alps and his journey can be roughly mapped out in a series of Alpine drawings. These were not sketched on the spot but are rather 'composite landscapes', combining actual elements in an imaginative whole. Back in Antwerp in 1555 he began work on the *Large Landscape* series for Cock in which he reworked much of the material gathered on the journey. Van Mander has a lively account: 'On his journeys Bruegel did many views from nature so that it was said of him, when he travelled through the Alps, that he had swallowed all the mountains and rocks and spat them out again, after his return, on his canvases and panels, so closely was he able to follow nature here and in her other works.'

After his return from Italy, Bruegel was active both as a designer for engravings and as a painter. His interest in prints seems to have predominated until about 1562, when his output of paintings began to increase.

Bruegel's early landscape drawings and the painting *Landscape with Christ appearing to the Apostles at the Sea of Tiberias* (private collection) of 1553, show him to be a landscape painter in the tradition of the Antwerp school founded by Joachim Patinir. Patinir's followers, in particular Herri met de Bles, Matthys Cock (Jerome's brother) and Cornelius Massys, had turned the characteristics of his style—a high viewpoint, an extensive landscape dominated by impossibly sheer outcrops of rock and peopled by tiny figures—into a popular but now stale formula. The sequence of Bruegel's landscape drawings show a gradual abandonment of this formula as he evolved a more naturalistic landscape rendered with an exquisite, almost pointillist, technique which brings to mind Leonardo's landscape drawings. An important step forward was taken in a number of drawings dated 1553 (see Plate 18) which demonstrate how Bruegel, through the study of the Venetian landscapists and particularly of Campagnola and Titian, achieved a new and more dramatic conception. The landscape drawings, almost always 'composite landscapes' which became more and more personal, continued throughout the 1550s only to stop mysteriously in 1562.

Bruegel was at work on the *Large Landscape* series between 1555 and 1558. It was published by Cock, who was also probably the engraver, in 1558. Of the series of twelve, *Solicitudo Rustica* (Plates 22, 23) and *Magdalena Poenitens* (Plate 40) are reproduced here. The preliminary drawing for *Solicitudo Rustica* (Plate 22) was recently rediscovered and acquired by the British Museum. The series represents an intermediate stage in Bruegel's development as a landscapist. Some of the Antwerp school mannerisms remain—the high viewpoint, sheer craggy drops, the irrelevant religious subjects tucked away in corners—but a new, personal vision is developing.

In 1556 there was a sudden change in Bruegel's work for Cock. Having previously worked exclusively as a landscapist and having shown no interest in figure painting, even in Italy, Bruegel executed the first of a long series of moralistic figure compositions in a fantastic manner derived from Bosch. This change is not hard to explain; Cock's commercial instinct told him that this talented young artist would enable him to exploit the popular demand for Boschian prints. Since Bosch's death a number of artists like Jan Mandyn and Peter Huys had worked successfully in his manner but Bruegel was soon to outshine them. The first print to be designed by Bruegel in the manner of Bosch was the *Temptation of St Anthony* published by Cock in 1556; the designer's name is not given. In the second, *Big Fish Eat Little Fish* (Plate 30) published in 1557, and for which Bruegel did a preparatory drawing in 1556, Cock in an act of sharp practice substituted Bosch's name for Bruegel's. However in the subsequent prints he acknowledged Bruegel's design. With the publication of the *Seven Deadly Sins* in 1558 Bruegel's reputation was established and it was for work of this kind (continued until 1564 or 1565) that he was best known to his contemporaries.

This archaic Bosch-derived style seems to have suited Bruegel's moralizing turn of mind very well. Not only are the prints in this manner bursting with visual inventiveness, but he also employed a related style in a group of paintings in the early 1560s. The ideas that Bruegel expressed were new, even radical. Already, prior to his departure for Italy, Bruegel was in contact with a humanist circle in Antwerp centred around the great geographer Abraham Ortelius. Other members included the publisher Christopher Plantin, the engraver Frans Hogenberg and Jerome Cock himself. The group was loosely knit and it would be misleading to suggest that they all shared precisely the same philosophical outlook. They did, however, hold many attitudes in common and these found expression in the work of their spokesman, D. V. Coornhert, an engraver and philosopher who also worked for Cock. Coornhert in his many writings elaborates a religious point of view which finds its direct parallel in Bruegel's work. Described as 'a Catholic but no Papist', Coornhert's religious thought centred on two principal ideas: the personal relationship of the individual to God without the mediation of any particular Church, and man's innate potential to redeem himself by means of a virtuous life, the denial of original sin. Thus Coornhert drew elements from both Lutheran and Catholic doctrine, adopting a middle course, and such is the similarity of Bruegel's viewpoint in the *Seven Deadly Sins* that one scholar has suggested that it was Coornhert who wrote the mottos which appear below the engravings.

After the *Seven Deadly Sins*, Cock commissioned the single drawing *Patientia* (Plate 62) in 1557 and—presumably because of demand—the *Seven Virtues* published in 1560. For the *Sins* and *Patientia* the engraver was Peter van der Heyden, but for the *Virtues* he was replaced by Philippe Galle, a far more sensitive artist. In the *Virtues*, except for *Fortitudo* (Plate 26 bottom), the Boschian monsters are gone; the artist has reverted to a more conventional, Italianate figure canon.

In 1557 the series of dated paintings of the post-Italian period begins. There are dated paintings for each year until 1568, with the exception of 1558 and 1561. The *Landscape with the Parable of the Sower* (Timken Art Gallery, San Diego, California) is close to the landscape vision of the *Large Landscape* series. The viewpoint is lower than in the work of the Patinir followers, the recession confidently handled and the town and mountains in the distance are glimpsed through a shimmering haze. The undated *Landscape with the Fall of Icarus* (Plate 2) is more mannered and therefore probably earlier, though the jutting foreground and the impressive figure of the ploughman cutting furrows in the dry earth give the composition a certain dramatic power. In 1559 Bruegel painted *Carnival and Lent* (Plate 3) and *Netherlandish Proverbs* (Plate 11), allegories of human foolishness and sinfulness in the Boschian manner of the *Seven Deadly Sins*. The following year he painted *Children's Games* (Plate 6) which points up the same moral under the guise of an encyclopaedia of pastimes. The output of paintings increased to four in 1562—the two Boschian allegories, *'Dulle Griet'* (Plate 14) (the date is damaged but is probably 1562), *The Fall of the Rebel Angels*, the Altdorfer-influenced *Suicide of Saul* (Plate 15) and the curious and as yet unexplained *Two Monkeys* (Berlin). The masterpiece of the Boschian manner, *The Triumph of Death*, was probably also painted in or around 1562. Bruegel travelled in 1562 to Amsterdam where he drew the towers and gates of the city (Plate 76 top).

This increase in the production of paintings and a fall in the production of prints is presumably connected with the artist's move from Antwerp to Brussels, where he married Mayken, daughter of Pieter Coecke and Mayken Verhulst, in 1563. Van Mander gives a personal reason for the move: 'As long as he lived in Antwerp, he kept house with a servant girl. He would have married her but for the fact that, having a marked distaste for the truth, she was in the habit of lying, a thing he greatly disliked. He made an agreement or contract with her to the effect that he would procure a stick and cut a notch in it for every lie she told, for which purpose he deliberately chose a fairly long one. Should the stick become covered in notches in the course of time, the marriage would be off and there would be no further question of it. And indeed this happened after a short time. Eventually, when the widow of Pieter Koeck was living in Brussels, he courted her daughter who, as we have said, he often carried about in his arms, and married her. The mother, however, demanded that Bruegel should leave Antwerp and take up residence in Brussels, so as to give up and put away all thoughts of his former girl. And this he did.'

Whatever the motive, Bruegel was settled in Brussels in 1563 and it was in the Brussels period during the last years of his life that his greatest work was produced. In the depiction of peasant life he found a perfect means of presenting his ideas.

Although he continued to execute important designs for Cock, Bruegel tended now to concentrate on private commissions for paintings. Perhaps before the move he had already been in contact with Cardinal Granvelle, and it may have been the prospect of more patronage from the court circle that drew Bruegel to the seat of the government. Certainly the artist received commissions from Granvelle, though, of the extant paintings, only *The Flight into Egypt* (Count Seilern, London) dated 1563, can be traced to his collection.

Two misapprehensions about Bruegel persist, fostered by 'sensationalist' writers: that he was a 'political' artist, and that he was associated with a heretical sect. Neither idea has any justification. However, the times in which Bruegel lived were acutely troubled by political and religious struggles and it is in these events that we can detect the causes for Bruegel's deep-seated pessimism, even cynicism, in his view of life and consequently in his art.

By a dynastic marriage late in the fifteenth century, Flanders and much of the north Netherlands passed under the rule of the Habsburgs. In 1555 the Habsburg emperor Charles V abdicated in favour of his son Philip II. Philip returned from the Netherlands to Spain in 1559 having appointed his sister Margaret of Parma as his regentess. She was advised by a Council of State, set up in the same year, drawn from the aristocracy of the Netherlands and including Antoine Perrenot, Bishop of Arras who was raised to the purple as Cardinal Granvelle in 1561. Granvelle soon established himself as the dominant member of the Council, in the confidence of both Margaret and Philip, and began to exercise a personal rule which increasingly angered and isolated the other members, who belonged to the old Netherlandish aristocracy and included William of Orange and the Count of Egmont. The aristocracy resented Spanish rule—particularly the presence of Spanish troops in Flanders—Spanish taxes, and the gradual undermining of the aristocrats' position in favour of rule by a low-born bureaucracy loyal to the Habsburgs. There was also an explosive religious situation. Calvinism—the predominant form of Protestantism in the Netherlands—did not have a significant following there before 1560, compared, for example, with the situation in France. Yet the political situation which led increasingly to an identification of Catholicism with Spanish tyranny played into the hands of militant Calvinist preachers. Calvinism came to be identified with independence. The split in the Council of State was made worse in 1561 by the publication of a papal Bull which implemented Philip's scheme for ecclesiastical reorganization in the Netherlands. It was a sensible plan but it threatened aristocratic privilege and, combined with Philip's plan for strengthening the activities of the Inquisition in the Netherlands, it cemented the alliance between aristocrats and Calvinists which eventually brought about the creation of an independent Dutch Republic. Orange and Egmont left the Council of State and a campaign was launched against Granvelle. Until recently Granvelle has had a bad historical press, being cast in the role of villain, a tool in the hands of Spanish imperialism. But the truth is rather different. Granvelle consistently warned Philip of the dangers of pursuing too narrow a religious policy. He abhorred fanaticism, believing the strongest line of defence against the spread of Protestantism was a thoroughgoing reform of the Roman Church. In spirit he was closer to Erasmus than to the religious extremists of his day. He was a bibliophile and an enthusiastic patron of the arts. The aristocrats' campaign of vilification against Granvelle—he was caricatured as a 'red devil' and 'Spanish pig'—was remorseless, and eventually Philip was forced to bow to it. Early in 1564, Philip gave Granvelle permission to leave the Netherlands; he was never to return. The reconstituted Council of State, with the aristocratic party triumphant, tried to steer a middle course between Philip's demands for swift action against heretics and the militancy of the Calvinists.

Bruegel

Paintings, drawings and prints

103 reproductions selected & introduced by Christopher Brown

Phaidon

The author and the publishers would like to thank all owners, both
public and private, who have allowed works in their possession to be
reproduced, and who have in many cases also provided photographs.
The author would like to acknowledge his particular indebtedness to
the following books: F. Grossman, *Bruegel: Complete Edition of the
Paintings*, 3rd edition, London, 1973; Ludwig Münz, *Bruegel: The
Drawings*, London, 1961; C. G. Stridbeck, *Bruegelstudien*, Stockholm,
1956.

Phaidon Press Limited, 5 Cromwell Place, London SW7 2JL

First published 1975
© 1975 by Phaidon Press Limited
All rights reserved

ISBN 0 7148 1663 9

Printed in Italy by Amilcare Pizzi SpA, Milan

Orange pleaded for toleration but Philip was adamant. A league of nobles, the Compromise, was formed which demanded an end to the activities of the Inquisition, and a change in religious policy. The lines of battle—Catholic Spain opposed to an aristocratic Netherlandish party still composed of both Catholics and Protestants but increasingly dominated by the Calvinists—began to be more clearly defined.

The tense situation erupted into popular violence in 1566. The immediate cause seems to have been the severe winter of 1565–6 which led to widespread food shortage and unemployment. There were isolated riots early in the year but on 10 August at Steenvoorde in West Flanders a mob sacked the churches, smashing images and looting gold and silver. The iconoclasm spread from village to village, reaching Antwerp on 20 August, Ghent and Amsterdam on the 23rd. When order was eventually restored, a fragile truce was drawn up between Margaret and the Compromise, whose members had been shocked by the popular violence. The Calvinist rebels who had openly defied the government were defeated by this coalition. Philip, however, was not satisfied and he instructed the Duke of Alba, who had experience crushing heretics in Germany, to assemble an army in Italy and march on the Netherlands to restore order. On 22 August 1567 Alba entered Brussels. Margaret, who regarded his presence as an unforgivable provocation to the Netherlanders, left for Parma and Alba assumed the regency. His aim was the total subjugation of the Netherlands—the punishment of the rebels, centralization of government, and the eradication of heresy. He arrested Counts Egmont and Horn, leaders of the aristocratic party, and set up the Council of Troubles—which soon earned the title 'The Council of Blood'—to hunt down and punish those involved in the rebellion. An abortive invasion of the Netherlands in 1568 led by William of Orange, who had escaped into exile, led to even more savage repression: Egmont (the hero of Goethe's play and consequently of Beethoven's incidental music) and· Horn were executed as were many noble signatories of the Compromise. New taxes were levied, though the States General bridled at the imposition of the heaviest. In 1570 with the grim work of religious persecution methodically under way, Spanish troops billeted throughout the country and the opposition fragmented, it must have seemed as if Spain had regained its firm hold on the Netherlands.

Bruegel lived through these events, though he did not comment directly upon them. As the situation deteriorated and Alba crushed the opposition, Bruegel produced his last great series of monumental figure compositions, scenes of peasant life, far from the terrible world of the Council of Troubles. Bruegel's outlook *is* pessimistic, it verges on the cynical but, while he bitterly decries man's wickedness and inhumanity to his fellow man, he is not overtly partisan. His connection with Coornhert's Catholic reformist outlook and the patronage he received from Granvelle and the court circle suggest pro-Establishment sympathies. But this must remain a matter for speculation: in his work he is despairing but uncommitted.

In Brussels, Bruegel's interest in Italian painting was renewed. He studied Marcantonio's prints, Raphael's Acts of the Apostles tapestry cartoons (which had been in the city for weaving since early in the century), as well as the native Italianate tradition in the work of artists like Barent van Orley. He began to paint figures on a larger scale and in *The Adoration of the Kings* (Plate 43) produced his first composition composed exclusively of large human figures. He continued to work on the problem of figure compositions in the two remarkable grisailles *Christ and the Woman taken in Adultery* (Plate 68) dated 1564 and *The Death of the Virgin* (Plate 32). The latter was painted for Ortelius who, after Bruegel's death, had it engraved. He sent copies of the engravings to his friends including Coornhert whose letter of thanks, a rare example of a contemporary appreciation of Bruegel's work, has survived. 'Never', he wrote, 'in my opinion did I see more able drawing or finer engraving than this sorrowful chamber. . . . I actually heard (so it seemed) the melancholy words, the sobbing, the weeping and sounds of woe. It seemed to me that I heard moaning, groaning and screaming and the splashing of tears in this portrayal of sorrow. There, no one can restrain himself from sadly wringing his hands, from grieving and mourning, from lamenting and from the tale of woe. The chamber appears deathlike, yet all seems to me alive.'

In 1565 Bruegel received his most important painting commission. It was for a series of the *Months*, twelve panels for the decoration of the Antwerp home of Niclaes Jonghelinck, a rich merchant. Frans Floris was also engaged on the task of decoration. Bruegel was no doubt introduced to Jonghelinck by his brother, Jacques Jonghelinck, a sculptor who had been in Italy at the same time as Bruegel and who had been a favourite of Cardinal Granvelle, occupying a studio in the Cardinal's palace. Niclaes Jonghelinck owned sixteen paintings by Bruegel including the large *Tower of Babel* (Plate 25) and *The Procession to Calvary* (Plate 34) as well as the *Months*. The five extant paintings of the *Months* are Bruegel's finest landscapes. In each of them the constantly changing landscape is the subject, not the figures who pursue their traditional occupations in the foreground. The mannerism of the Antwerp landscapists has been replaced by Bruegel's personal vision of nature. The whole decorative scheme seems to have been completed in a year for we know that Jonghelinck was in possession of them by February 1566. Bruegel's rapid technique confirms this. He painted very thinly, scraping the colour across the panels, sketching the figures with an absolute sureness of touch and using the light brown underpainting as an element in the design.

The only etching by Bruegel himself, the *Landscape with Rabbit Hunters* (Plate 48) was executed in 1566 and, more than any of the engravings after his designs, it reflects his drawings of landscape. Shapes are built up with short strokes, fine hatching and dots. It was also in this year that he painted *The Wedding Dance* (Detroit), apparently the first of the series of scenes from peasant life. The composition is crowded and it is only in *The Peasant Dance* (Plate 81) and *The Peasant Wedding* (Plate 85) that Bruegel was able to reconcile, with complete success, a figure canon derived from Italian Renaissance models and traditional Flemish subject-matter. The moral is present as it is in the *Seven Deadly Sins*—here lust and gluttony are condemned—but the presentation is quite different; instead of a phantasmagoria of monsters, here is a 'naturalistic' representation of peasant life. There follow, in this heroic late period, a series of masterpieces which further explore the successful possibilities of this new figure-dominated style—*The Land of Cockaigne* of 1567 (Plate 71), *The Peasant and the Birdnester* of 1568 (Plate 93) and *The Parable of the Blind* also of 1568 (Plate 92). Another painting dated 1568, *The Magpie on the Gallows* (Plate 94), marks a new departure; small figures dance on a hillside in the shadow of a gallows and beyond them the landscape stretches away into the far distance. But the subject here is the atmosphere, the sunlight shining through the trees, the mist hanging in the valley. Bruegel's last painting, the unfinished *Storm at Sea* (Plate 95) is also unexpected: it refers back to *The View of Naples* (Plate 64) and to the seascape drawing of Antwerp (Plate 65) but develops this seascape style in the direction of greater vigour and plasticity. Van Mander records that the Brussels City Council commissioned Bruegel a short time before his death to commemorate the digging of the Brussels-Antwerp canal in a few 'pieces'. It was an opportunity to depict the human figure in action on a grand, even heroic scale. What he might have done is perhaps suggested by the digging figure on the left of the *Spring* engraving (Plate 54 top). However nothing remains from that commission and it would seem that Bruegel died before he could begin work on it.

Bruegel died on 9 September 1569 on the verge of further discoveries in his constantly developing art. His friend Abraham Ortelius, recorded a tribute to him in his *Album Amicorum*, begun in 1573. Beneath the conventional humanist rhetoric and the obligatory classical references we can detect a deep admiration for the artist and a profound sense of loss:

> 'Sacred to the Gods of the Underworld

No one except through envy, jealousy or ignorance of that art will ever deny that Pieter Brueghel was the most perfect painter of the century. But whether his being snatched away from us in the flower of his age was due to Death's mistake in thinking him older than he was on account of his extraordinary skill in art or rather to Nature's fear that his genius for imitation would bring her into contempt, I cannot say.

Abraham Ortelius dedicated this with grief to the memory of his friend.

The painter Eupompus [a Greek painter mentioned by Pliny], it is reported, when asked which of his predecessors he followed, pointed to a crowd of people and said it was Nature herself, not an artist, whom one ought to imitate. This applies also to our friend Bruegel, of whose works I used to speak as hardly works of art, but as works of Nature. Nor should I call him the best of painters but rather the very substance of painters. He is therefore worthy, I claim, of being imitated by all of them.'

Bruegel was buried in Notre-Dame de la Chapelle in Brussels. Over the tombs of both his parents, Jan Brueghel placed Rubens' *Christ giving the Keys to St Peter*; this was an appropriate artistic tribute, for it was Rubens who brought about the complete synthesis of Italian style and the Netherlandish graphic tradition which Bruegel had been striving to achieve.

In this selection, Bruegel's work in four media has been reproduced—the drawings, his only etching, the engravings which he designed and the paintings.

The landscape drawings provide us with a clear sequence of the development of Bruegel's view of landscape. There are no hasty compositional sketches. All the surviving landscape drawings are carefully finished (some preparatory to engravings) and all are considered as independent works of art. Usually executed in pen and brown ink over a preliminary design in black chalk, they would seem to have been executed in the studio. Only the placing of the shadows in the 1553 *Alpine Landscape* (Plate 18) in the Louvre

suggest that this particular drawing may have been taken directly from nature. For the most part these are imaginary landscapes built up from observed details which have been combined. As well as a refinement of eye, developing from a formula towards a personal view, there is a continuing refinement of technique. The long flowing lines of the early drawings are gradually shortened and eventually replaced by short strokes and dots.

The preparatory drawings for the engravings of figure subjects, with their firm hard line, are fascinating for the light they throw on the relationship between the designer and the engraver. There are many instances, particularly in the engravings by Pieter van der Heyden, where the savagery and bite of the original is lost. Sometimes a too-bold accusation is watered down: in the drawing for *Luxuria* (Brussels), one of the *Seven Deadly Sins*, a conspicuous naked sinner wears a mitre, which in the print has been turned into an innocuous paper hat. Philippe Galle, who engraved the *Virtues*, was a far more sophisticated artist than van der Heyden and perhaps because of this he diverged from Bruegel's original designs even more. The finest of the figure drawings are the late *Bee Keepers* (Plate 76 bottom) prepared for an engraving, and *The Painter and the Connoisseur* (Plate 77) which was never intended for use as an engraving or a painting. Only Bruegel's own solitary etching *Landscape with Rabbit Hunters* of 1566 reproduces the particular quality of his draughtsmanship accurately.

In his designs for engraving, Bruegel was working for a commercial enterprise, directed by Jerome Cock, and in consequence he was restricted to some extent in both subject-matter and style. The Boschian horrors of the *Seven Deadly Sins* were commissioned by Cock to take advantage of a well-tried and popular style. The *Men-of-War* series, too, was intended to exploit a popular print market. The *Large Landscapes* published in 1558 introduce Bruegel's personal landscape vision. In the *Virtues* which complement the successful *Sins* the monsters have fled and human figures enact the moral. After the move to Brussels the production slows down but designs like *Spring* (Plate 54 top) and *Summer* (Plate 54 bottom), both engraved after Bruegel's death, demonstrate how well the late monumental figure style was suited to the medium of prints.

Above all, it is the paintings which we admire and enjoy. After centuries of neglect Bruegel is now considered one of the greatest of all northern artists occupying a place in the pantheon which also includes Jan van Eyck and Rubens, and he is more truly popular than both. What then do we admire about the paintings that causes them to be so frequently reproduced and discussed? Is it the detail, the milling crowds, the small individual figures, the knots of children, beggars and townspeople that we admire? Or is it the grotesque quality of the clumsy figures, cavorting to the sound of the bagpipes, that holds our attention? The monsters and hybrids, who have leapt from the borders of Gothic prayer-books to torment humans, are endlessly fascinating. The weird Hell mouth stormed by *'Dulle Griet'* (Plate 14) and above all the skull-strewn orange landscape of *The Triumph of Death* (Plate 10), crammed with incident, compel us by their vigour and their unfamiliarity. At the same time we are impressed by the profound religious feeling of *The Death of the Virgin* (Plate 32) and *Christ and the Woman taken in Adultery* (Plate 68). We admire Bruegel the figure painter in *The Peasant and the Birdnester* (Plate 93), Bruegel the landscapist in the *Months* series, Bruegel the topographer in *The View of Naples* (Plate 64).

Yet all these imaginative flights have a solid basis in Bruegel's remarkable technique. He was a superb draughtsman and a colourist of exquisite sensitivity. The tiny figures are often no more than notations but the artist brings them to life. Bruegel's facility is best observed in the panels of the *Months*, a massive decorative project completed in a year and requiring in its speedy execution an absolute sureness of hand. No stroke, however short, is out of place; no colour is too weak, however thinly applied, or too strong. The underpainting can be glimpsed and is always a deliberate, conscious element in the design. Essentially, it is this complete sureness of hand in setting down the products of his imagination that we admire so much today in Bruegel's art.

Bruegel's is a moral art. He lived in an age which believed that art should have a didactic purpose—that it should help man to live a more moral, that is, a more religious life—and even his landscapes are hymns of praise to God. Though his age was torn by religious and political strife, he did not take up a partisan position: in his art he made a humane comment on those divisions. He was acutely aware of man's foolishness and, though he retained the belief that man was capable of his own redemption, he seems to have been deeply pessimistic; at moments he was cynical and even despairing. Yet, amid the brutality and vanity of men, he was possessed by a sense of wonder when confronted by God's creation and his rare gift of genius enabled him to convey this vision; as we can see in *The Magpie on the Gallows* (Plate 94), that sparkling panel he painted a year before his death.

Unless otherwise stated, all the paintings discussed are on panel.

1 The Peasant Dance *(detail of Plate 81)*

2 Landscape with the Fall of Icarus

Transferred from panel to canvas, $29 \times 44\frac{1}{8}$ in. Brussels, Musées Royaux des Beaux-Arts.

Bruegel's earliest signed and dated painting is the *Landscape with Christ appearing to the Apostles at the Sea of Tiberias* of 1553 (private collection). The composition of the *Landscape with the Fall of Icarus* (the authenticity of both this version and another closely related version in a private collection have been doubted by scholars) is generally thought to date from soon after, about 1555, when the artist had recently returned from Italy.

The picture is the only one with a mythological subject in Bruegel's painted œuvre. Two prints after designs by Bruegel, the *Landscape with Winding River and Fall of Icarus* (etched in Rome by Georg Hoefnagel and dated 1553) and the *Man-of-War with Fall of Icarus* (Plate 19), display the artist's continuing preoccupation with this myth, though in all these cases the myth is peripheral to the principal subject of the design, whether landscape or ship.

The literary source is Ovid's *Metamorphoses* (though it is worth noting that the myth is also related in that influential moral textbook of the late Middle Ages, Sebastian Brant's *Ship of Fools*), in which the poet tells the story of the great engineer Daedalus, who constructed the Labyrinth for King Minos, and his son Icarus. Daedalus had designed wings which enabled him and his son to fly. Icarus, overambitious, ignored his father's warning and flew too close to the sun, the strength of which melted the wax holding the wings together. He plunged to his death in the sea which was consequently named the Icarian. In Bruegel's painting only his legs can be seen above the water.

The artist has followed Ovid's text accurately. The ploughman, fisherman and shepherd are all mentioned, although a curious feature is the position of the sun. Sinking, and already on the horizon, it does not fit in with Ovid's account of its position as high in the sky. It is noticeable that in the print of the *Man-of-War with Fall of Icarus* it is in a midday position. There, Daedalus is also shown and Icarus's wings are in the process of disintegration.

The motif of the peasant with the plough is given added significance by the presence of the corpse of an old man, only just visible, lying in the bushes on the left. This refers to the Flemish proverb 'No plough stops because a man dies.'

The man-of-war in the right foreground reflects Bruegel's interest in ships which received expression in the *Men-of-War* series of engravings (see note to Plate 19). The high viewpoint and the town glimpsed in the distance are recurring features of Bruegel's early landscape style which derives strongly from the Antwerp followers of Patinir.

3 The Fight between Carnival and Lent

$46\frac{1}{2} \times 64\frac{3}{4}$ in. Signed and dated: BRVEGEL 1559. Vienna, Kunsthistorisches Museum.

The picture is first mentioned by van Mander in his account of Bruegel's life (see Introduction). With *The Netherlandish Proverbs* (Plate 11), this is the first of a series of Bosch-derived allegories of human wickedness and foolishness. The high viewpoint and the mass of small figures are compositional devices borrowed from Bosch, and the figure pattern of *Carnival and Lent* has particular similarities to Bosch's *Garden of Earthly Delights* in the Prado Museum, Madrid. (For discussion of the relationship between Bruegel and Bosch, see the Introduction).

Bruegel's work is almost invariably to be interpreted on two levels, the realistic and the allegorical. In his earlier work such as the *Carnival and Lent* the allegorical element is more apparent: the later work, for example *The Peasant Dance* (Plate 81), seems more realistic, yet it too is an allegory of human sinfulness.

The festivities here depicted were part of the traditional yearly carnival which during the week before Lent dominated life in Flemish villages and towns. One of the many half-religious, half-secular festivals characteristic of the later Middle Ages, its religious element was often simply an excuse for orgies of sex, eating and drinking, to such an extent that it was known as *'de duivelsweek'*. At least this is what churchmen and moralists said, and there is little doubt that Bruegel's attitude, too, was a critical one.

Dressed in fantastic carnival costumes, villagers and townspeople sang and danced in the streets. Bosch depicted the scene in a

composition which now exists only in copies; a group of dancers and drinkers (among whom are several monks and nuns) are headed by the allegorical figure of Prince Carnival. The revelry is interrupted by the sudden and unwelcome arrival of the allegorical figure of Lent, who is portrayed as a thin, female figure.

Bruegel gives the subject a slightly different treatment, stressing the opposition between the two traditional enemies, Carnival and Lent, by presenting their conflict as a formal combat or passage of arms. The two adversaries—the obese Carnival, astride a barrel and with a spit for his tilting lance, and the thin, pinched Lent who sits in a cart and uses a baker's shovel as a weapon—come to blows in the square of a small Flemish village. The whole panel is crammed with their various partisans and followers: on Prince Carnival's side is a swarm of eating, drinking and gambling figures, while Lent's half of the picture is characterized by the abstinence and piety of her retinue. There are figures drawing water from the well, eating bread and biscuits, giving alms to the poor and going to church. On Lent's side of the square (see Plate 5) the church is the dominant building; on Carnival's (see Plate 4), the inn.

Bruegel's precise intention in this picture is confused by the fact that both the combatants are satirically represented. Lent can hardly be supposed to represent Virtue or Righteousness. She is ridiculous in appearance (the figure is copied from that of a witch in a Bosch drawing). She clutches a bunch of dead twigs, a symbol of human degredation. The children at play who follow her symbolize folly and vanity. Bruegel's depiction of the two figures has led one scholar to suggest (ingeniously, if not altogether convincingly) that the picture is a satire upon the contemporary state of the Christian Churches (Carnival as Protestant, Lent as Catholic) which Bruegel and the humanist circle with which he is known to have been associated decried as being at the root of the troubled state of northern Europe.

Certainly we may say that, as in *The Netherlandish Proverbs* (Plate 11) of the same year, his painting, in spite of its burlesque and humorous appeal, illustrates Bruegel's belief that all human actions tend to be motivated by folly and self-seeking. (For a longer consideration of Bruegel's moralizing see note to Plate 26 top.)

An interesting example of the recurrence of certain motifs in Bruegel's work is the group of cripples and beggars in the middle ground on Carnival's side of the picture ignored by the revellers. One of Bruegel's latest pictures is the *Cripples* of 1568 (Louvre) which, with important variations, repeats part of this group. Bruegel's depiction of these ridiculed members of society is naturalistic, unromantic and yet sympathetic.

4 Carnival and Lent (detail of Plate 3)

This detail illustrates some of Prince Carnival's followers, dressed in bizarre costume. On Carnival's side of the square two comedies are being performed: 'Urson and Valentine', in the background left, in front of the Dragon inn, and here (top left) 'De Vuile Bruid' (The Dirty Bride) is being played in front of the Blue Ship inn.

There is a woodcut (the only woodcut after a Bruegel design) dated 1566 of the popular carnival play, 'Urson and Valentine' and an engraving of 1570 of 'The Dirty Bride'. The latter is a farce at the expense of the poor peasant who tries to emulate the lavish weddings of the rich. Here he is seen dancing with his unkempt bride to the marriage bed which is the ground inside his rickety tent.

Among the other followers of Prince Carnival are the pot-bellied man who plays a mandolin and the man with waffles in his hatband and a mirror on his back who throws dice with his masked companion.

5 Carnival and Lent (detail of Plate 3)

This detail shows the church which dominates Lent's side of the square. Inside the church, a priest hears confession; at the door, figures beg for alms and have set up stalls. Near by children whip tops.

6 Children's Games

$46\frac{1}{2} \times 63\frac{3}{8}$ in. Signed and dated: BRGVEEL (sic) 1560. Vienna, Kunsthistorisches Museum.

First mentioned in van Mander's life of Bruegel: one of the early Bosch-derived allegories, it has compositional similarities to the Prado *Garden of Earthly Delights*. Bruegel's intention was more serious than simply to compile an illustrated encyclopaedia of children's games, although some eighty have been identified in the picture. He has purposefully given the children the features of adults (see Plate 7) and has shown them engaged in their games with a degree of absorption usually displayed by adults in their (apparently) more important pursuits. The moral is that in the mind of God these games possess as much significance as adult activities.

7 Children's Games (detail of Plate 6)

8 Fall of the Rebel Angels (detail of Plate 9)

Note the Beast of the Apocalypse wearing crowns on its heads.

9 Fall of the Rebel Angels

$46 \times 63\frac{3}{4}$ in. Signed and dated: MDLXII BRVEGEL. Brussels, Musées Royaux des Beaux-Arts.

Dated 1562, the picture demonstrates once again Bruegel's debt to Bosch, not only in the multiplicity of monsters but also in more general compositional devices. Bosch painted the subject on a wing of his *Last Judgement* altarpiece, now in the Academy, Vienna. Another important influence on Bruegel's interpretation of the subject is Frans Floris's crowded *Fall of the Rebel Angels* of 1554, painted for Antwerp cathedral and now in the museum there. Floris, a near contemporary of Bruegel and the most successful painter in Antwerp in the 1550s and 60s, worked in a powerful style which combined Italian High Renaissance figure painting with a northern Gothic psychological intensity and lack of spatial clarity. A comparison between Bruegel's and Floris's interpretation of the subject provides a fascinating insight into the varying artistic currents in mid-sixteenth century Antwerp.

The general compositional layout of a large central figure set amongst innumerable smaller figures was a favourite with Bruegel at this moment. It recurs in 'Dulle Griet' (Plate 14) and in the *Vices* and *Virtues* series which he had just completed (see note to Plate 26 top).

The Archangel Michael and his companion angels are shown fighting the sins. Bruegel has metamorphosed the fallen angels into grotesque half-human, half-animal monsters which embody the various sins. It was, of course, pride which brought about the fall of Lucifer and his followers from Heaven. The conflict which is here represented, between virtue and vice, good and evil, is a theme that occurs again and again in Bruegel's work.

10 The Triumph of Death

$46 \times 63\frac{3}{4}$ in. Madrid, Prado Museum.

Neither signed nor dated, its content and its connection with the world of Bosch place it close to the 'Dulle Griet' (Plate 14) and the *Fall of the Rebel Angels* (Plate 9) both of which are dated 1562.

It is presumably the picture mentioned by van Mander 'in which expedients of every kind are tried out against death.'

It has been correctly noted that Bruegel combines two visual traditions in this picture: northern woodcuts of the Dance of Death and the Italian conception of the Triumph of Death such as those he would have seen in the Palazzo Sclafani in Palermo. Yet Bruegel's image of the army of death relentlessly advancing across a hellish landscape is quite original, one of the most remarkable products of his imagination.

From Death there is no escape. He comes to every man. Across a vast barren landscape of bare hills, leafless trees, stagnant pools of water, ruined or burning buildings, lit by the glow of fires, the massive army of death with coffin lids for shields advances to the constant, doleful beat of kettle drums played by one of its skeleton members. It moves forward on either side of an open vault into the mouth of which humanity is driven by Death on a pale horse wielding a scythe. From other directions too the army closes in: a boat-load of white-robed skeletons, a barrow-load of skulls driven by a skeleton, tolling a bell and carrying a lantern, on a gaunt horse. A hurdy-gurdy player accompanies him.

This fiery landscape of death is crammed with individual incidents; in the top right hand corner Death as an executioner beheads and hangs his victims. In the bottom right corner, a dinner has been broken up (Plate 13): a skeleton disguised with mask and jerkin as a servant pours the wine away, the playing cards and backgammon board lie abandoned, another skeletal servant presents a skull on a plate to a horrified lady, a skeleton embraces another lady in hideous mockery of after-dinner amorousness. A charming duet, a man playing the lute and singing, a lady singing and holding the music, becomes a trio with the intrusion of a grinning skeleton playing a viola da gamba. The jester foolishly tries to escape beneath the table. More bravely but no less hopelessly, a gentleman draws his sword.

In the centre, the net of death traps those who flee and a pilgrim's throat is cut. In the lower left hand corner (Plate 12), a dead mother still clutches her child which is licked by a mangy dog, a cardinal is helped to his fate by a skeleton who mockingly wears the red hat, and the dying king's barrels of money are pilfered by a skeleton in chain-mail and breastplate. Beneath the deathcart's wheels a woman with spindle and distaff (the classical symbols of the fragility of life) is about to be crushed, the slender thread about to be cut by the scissors in her other hand.

11 The Netherlandish Proverbs

$46 \times 64\frac{1}{8}$ in. Signed and dated: BRVEGEL 1559. Berlin-Dahlem, Staatliche Museen.

With *Carnival and Lent* (Plate 3), this is the earliest of the allegorical paintings influenced by Bosch. The picture is first mentioned in the 1668 inventory of Pieter Stevens, an Antwerp collector who amassed a great collection of paintings by Bruegel in the mid-seventeenth century. Although isolated proverbs and small groups of proverbs had been represented before in Flemish art, this is the first painting to create a complete environment, as it were, a world of proverbs. They fall into two principal groups: those which turn reason on its head, demonstrating the absurdity of much human behaviour. This

group has for its symbol the world upsidedown represented by the upturned orb, on the house-sign on the left. The second group—here Bruegel is in more serious, moralizing mood—illustrates the dangers of folly which can lead to sin, such as the prominent scenes in the centre, of the woman 'hanging a blue coat on her husband' (cuckolding him) and, immediately above, the man 'lighting two candles for the devil'.

Other proverbs illustrated include 'He blocks up the well after the calf is drowned' (centre, bottom); 'One shears the sheep, another the pig' (left, bottom); 'One holds the distaff which the other spins' (spreading evil gossip: centre, middle); 'The pig has been stuck through the belly' (centre, middle); 'He throws roses to the swine' (centre); 'He brings baskets of light into the daylight' (left, centre).

This picture, which catalogues individual acts of foolishness creating chaos, surely reflects Bruegel's concern with the contemporary state of the world.

12 The Triumph of Death (detail of Plate 10)

13 The Triumph of Death (detail of Plate 10)

14 'Dulle Griet' (Mad Meg)

$45\frac{1}{4} \times 63\frac{3}{8}$ in. Antwerp, Musée Mayer van den Bergh.

Little remains of the signaure and date, the most likely reading of the date is MDLXII (1562). It is certainly close in style and composition to *Fall of the Rebel Angels* (Plate 9), dated 1562. The composition—a female allegorical figure amidst a variety of grotesques and monsters—relates the picture to the series of engravings of *Seven Deadly Sins* (see note on Plate 26 top) and *Seven Virtues* executed a few years previously. It seems most likely that the sin which is represented here is covetousness. 'Dulle Griet' (Plate 21) personifies this sin; though already burdened with possessions, she is on her way to raid the very mouth of Hell itself. Behind her, to the right, a mass of covetous women are looting a house. Above them, a tempter, with a man's face yet dressed in woman's clothes, shovels money from his own body down to them and also entices them with other sins (including gluttony) offered to them in a glass ball, the symbol of vanity (see *The Misanthrope*, Plate 96).

Covetousness has led 'Dulle Griet' and her legions of women into the landscape of Hell. It is populated by all the sins and their victims. Satan, on the left, is represented by a Hell Mouth familiar from medieval manuscript illumination. On the far right (Plate 21) the fortress of Hell is defended against the women by armed monsters.

15 The Suicide of Saul

$13\frac{1}{4} \times 21\frac{5}{8}$ in. Inscribed and signed: SAUL XXXI. CAPIT. BRVEGEL MCCCCCLXII. Vienna, Kunsthistorisches Museum.

The inscription makes it clear that the subject of the picture is the unusual one of the suicide of Saul after his defeat by the Philistines. It is related in 1 Samuel 31: 1–5: 'Now the Philistines fought against Israel: and the men of Israel fled from before the Philistines and fell down slain in Mount Gilboa. And the Philistines followed hard upon Saul and upon his sons: and the Philistines slew Jonathan, and Abinadab and Malchishua, Saul's sons. And the battle went sore against Saul, and the archers hit him; and he was sore wounded of the archers. Then Saul said unto his armourbearer, Draw thy sword and thrust me through therewith: lest these uncircumcised come and thrust me through and abuse me. But his armourbearer would not; for he was sore afraid. Therefore Saul took a sword, and fell upon it. And when his armourbearer saw that Saul was dead he fell likewise upon his sword and died with him.'

Bruegel's choice of this story may perhaps be explained by the fact that Saul's suicide was interpreted as punishment of pride. He is, for example, included among the Proud met by Dante in the *Purgatorio* (Canto XII, 40–2):

> O'Saul, come su la propria spada
> Quiui paremi morto in Gelboè
> Che poi non senti pioggia ne rugiada!

(O Saul, how you appeared there dead on your own sword on Gilboa, which never afterwards felt rain or dew!).

Also in the *Purgatorio* there was Nimrod, the builder of the Tower of Babel, Bruegel's only other early Old Testament subject. As with most of his biblical compositions, Bruegel has represented the scene as a contemporary event, depicting the armies in sixteenth century armour. An important source for the composition is Albrecht Altdorfer's *The Battle of Issus* (Alte Pinakothek, Munich) which, painted in 1529, depicts Alexander the Great's victory over Darius as a contemporary battle. The clashing armies are particularly derived from Altdorfer's picture.

The *Suicide of Saul* is an early attempt by Bruegel to reconcile landscape and figure painting. A comparison with *The Magpie on the Gallows* of 1568 (Plate 94) shows how much progress he was to make. The foreground and background are not yet reconciled and the jutting outcrop of rock in the centre is a mannerist device which recurs in the *Procession to Calvary* (Plate 34). Yet the background is a wonderfully observed landscape seen through a haze which serves to throw the detail of the foreground into sharper contrast. It can be

seen in the context of Bruegel's increasing sureness in handling naturalistic landscape. In the foreground, amid the stage props of the Antwerp landscape tradition, the clash of armies is compellingly depicted, as is the excitement of the Philistines closing in on the dead King of Israel.

16 Triumph of Death (detail of Plate 10)

17 'Dulle Griet' (Mad Meg) (detail of Plate 14)

18 Alpine Landscape

Pen and brown ink drawing, $9\frac{1}{4} \times 13\frac{1}{2}$ in. Signed (falsely?) and dated 1553. Paris, Musée du Louvre, Cabinet des Dessins.

Executed during Bruegel's Italian trip, this drawing marks a new stage in his assimilation of Venetian landscape influences, particularly that of Campagnola. This is the first of a series of landscape drawings which reached their culmination in the *Large Landscape* engravings (Plates 22 and 23). The Antwerp school landscape manner has given way to grandiose Alpine vistas rendered naturalistically with short pen strokes and dots. The viewpoint is lower, and here the treatment of the shadows suggest that it was done from nature or at least from sketches taken from nature.

19 Man-of-War with Fall of Icarus

Print, $8\frac{7}{8} \times 11\frac{3}{8}$ in. London, British Museum.

Living in a huge and prosperous port, Bruegel saw many of the ships which traded with Antwerp from all parts of Europe. He was fascinated by them and so, it seems, were his fellow citizens, for his publisher Jerome Cock, whose commercial sense was as well developed as his artistic one, commissioned from him a series of thirteen *Men-of-War* in about 1565. They were engraved by Frans Huys in Cock's workshop 'Aux Quatre Vents' in Antwerp. In Bruegel's day there was often little difference between merchantman and man-of-war. Most merchantmen were armed and men-of-war often were simply converted merchantmen. The English fleet which destroyed the Armada was largely composed of armed merchantmen.

As in the *Large Landscape* series (see note to Plate 23) the warship engravings sometimes include a religious or mythological scene, which varies the composition. Here the scene is the *Fall of Icarus*, a recurrent subject in Bruegel's work (see note to Plate 2).

20 The Suicide of Saul (detail of Plate 15)

21 'Dulle Griet' (Mad Meg) (detail of Plate 14)

22 Solicitudo Rustica (Country Concerns)

Pen and brown ink drawing over black chalk, $9\frac{5}{8} \times 13\frac{7}{8}$ in. London, British Museum.

Preparatory drawing for the engraving by Jerome Cock. See note to Plate 23.

23 Solicitudo Rustica

Print, $12\frac{3}{4} \times 16\frac{3}{4}$ in. London, British Museum.

One of the series of twelve *Large Landscapes* executed by Jerome Cock after Bruegel's designs. The series is not dated but a preparatory drawing for an engraving of an Alpine Landscape (Louvre. Plate 18) is dated 1555.

24 The Tower of Babel

$44\frac{7}{8} \times 61$ in. Signed and dated: BRVEGEL. FE. M.CCCCC. LXII. Vienna, Kunsthistorisches Museum.

This is presumably the picture recorded in the collection of Niclaes Jonghelinck in Antwerp in 1566. Later both the Vienna and Rotterdam version were in the collection of the Emperor Rudolph II.

Bruegel treated the subject three times. A very small version, on ivory, is recorded in the inventory of Guilio Clovio but is now lost. The Vienna version, the larger of the two extant versions, is dated 1563 and the Rotterdam version is generally thought to date from a little later.

The Vienna version is the more traditional in its iconography incorporating the visit of Nimrod to the Tower in the lower right hand corner (Plate 29).

Two levels of meaning can be detected in Bruegel's interpretation of the theme. The Tower of Babel was an example of pride punished (as was *The Suicide of Saul*, see note to Plate 15), a particular sin illustrated. The scurry of activity by the builders—Bruegel's knowledge of engineering techniques was extensive and correct in detail—points up a second moral, the inanity and futility of all

human endeavour. This is the moral spelt out by Nimrod's building in Sebastian Brant's *Ship of Fools*.

Bruegel's tower recalls the Colosseum and other Roman ruins, which Bruegel had seen ten years before, and which he could also study in Jerome Cock's engravings, some of which he has actually used with only minor changes. No doubt the use of elements of Roman architecture also possessed a symbolic significance: Rome as Babylon, the 'Eternal City' brought to ruination.

The skill with which Bruegel has represented the technical procedure of building recalls his last commission, a series of pictures recording the excavation of the canal linking Brussels and Antwerp, a scheme apparently left unfinished at the painter's death.

25 The Tower of Babel

$23\frac{5}{8} \times 29\frac{3}{8}$ in. Neither signed nor dated. Rotterdam, Boymans-van Beuningen Museum.

See note to Plate 24.

26 (*top*) Avaritia (Avarice)

Print, $8\frac{7}{8} \times 11\frac{5}{8}$ in. London, British Museum.

Avaritia is the first in a series of the *Seven Deadly Sins*, engraved by Pieter van der Heyden and published by Jerome Cock in Antwerp in 1558. All Bruegel's preliminary drawings survive, *Avaritia* is dated 1556, the rest 1557. The others are *Superbia* (Pride Plate 50), *Invidia* (Envy Plate 51), *Ira* (Anger Plate 45), *Gula* (Gluttony Plate 55 bottom), *Luxuria* (Lechery) and *Desidia* (Sloth Plate 27 top). It is fascinating to compare the preparatory drawings with the published engravings which display in a few details a sort of censorship exerted by the publisher, not of sexual explicitness but of over-bold accusation. For example, in *Luxuria* the engraver has transformed the bishop's mitre of a sinner into a fantastic head-dress. On other occasions, the engraver seems to have misunderstood the artist's intention: buildings that in the drawing have human features occasionally lose them in the engravings. There is a good deal of evidence—discussed in the Introduction—that Bruegel was associated with a humanist religious-ethical movement. Others connected with it were Abraham Ortelius, the great geographer; the publisher Christopher Plantin and the engraver Frans Hogenberg. The leading spokesman of this group was Coornhert, himself an artist working for Cock, and also a preacher and philosopher. Coornhert's outlook has been described as 'centred on a personal relationship with God that dispensed with the outward ceremonies of the Churches (Catholic, Lutheran or Calvinist) [and] a moral philosophy concerned with men's duty to overcome sin, to which he is driven by foolishness.' This enlightened view differs drastically from both Calvinist and Lutheran doctrine which regards sin as inherent; nor is it Catholic dogma. Yet it is the view expressed in the *Vices* and *Virtues* engravings.

Coornhert's conception of sin was not that it was punishable in an after-life but that sin corrupted man while he was still on earth. Sin leads to degradation, to spiritual and physical decay. Sin is its own punishment; it is compulsive and holds the sinner in thrall that, sinning, he sinks further and further into sinfulness but by an act of will the sinner can redeem himself. Sin is not original, every man has the power to reform himself through a personal contact with God.

Formally, the whole series, as well as the *Virtues* (see Plate 26 bottom), employs the same scheme. A central allegorical figure, always a woman, personifies the sin. Around and behind her are figures and groups who illustrate the effects of the particular vice. They are tormented and harassed by weird monsters, half human, half animal.

The original drawing of *Avaritia*, in the British Museum, is dated 1556. Greed for money and gain, occupies a crucial place in the series, being the moral source of all the other sins—money (or at least the desire for it) is the root of all evil. The Latin motto reads: Does the greedy miser ever suffer fear or shame? The rhyming Flemish couplet can be translated:

> Grasping Avarice does not understand
> Honour, decency, shame or divine command.

The central personification of Avarice is a seated woman with money in her lap. With her free hand she reaches into a treasure-chest which is being refilled by two monsters from a broken jug. Her eyes are downcast, intent on the money—or she may be blind. She is certainly blind to all that is happening around her, so preoccupied is she by the money. By her feet is a toad, her animal counterpart; in Cesare Ripa's *Iconologia*, the most influential of all iconographical text books of the Renaissance, the toad stands for avarice because although able to eat earth and sand which are so readily available, he does not, for fear that he should not have enough.

Behind Avarice is the moneylender's hut: he is seen taking a plate from a poor man. To the right are a naked pair with a sheet of debts which is pointed out by a winged monster. They have sold their souls for money. Close by, a monster rolls a naked miser inside a spiked barrel and, instead of blood, money spills out. The moneylender's victims are caught in massive shears. Even the moneylender is not secure; he is being robbed by a thief climbing on his roof. On top of the roof is a domed savings-bank surmounted by an elaborate spire. Inside the bank is a fist, symbol of greed. From the spire a stick projects, dangling a bag of money. Crossbowmen, below, the points of their arrows tipped with coins fire at it and money showers down

upon them. So absorbed are they that they do not notice their own purses being cut. Greed prays upon greed. Behind them a man rides an ox backwards, while after him a man drags a heavy load. Behind this group a huge bellows fans a fire which sends smoke through a hat pierced by a saw-bladed sword.

On the left hand side a large onion-shaped piggy-bank is being attacked. One man is getting a coin out of the slot with a long pole, another has climbed a ladder and is about to smash it. Beside this scene a castle burns, spelling out the moral that wealth, once accumulated, is vulnerable. In the foreground monsters beg, and count money.

26 (*bottom*) Fortitudo (Fortitude)

Print, $8\frac{7}{8} \times 11\frac{5}{8}$ in. London, British Museum.

Fortitudo is one of the *Seven Virtues* series, a sequel to the *Seven Deadly Sins*. With *Fortitudo*, they comprise *Fides* (Faith Plate 63), *Spes* (Hope Plate 44), *Caritas* (Charity), *Justicia* (Justice), *Prudentia* (Prudence) and *Temperantia* (Temperance Plate 27 bottom). *Patientia* (Patience Plate 62) is not strictly one of the series; it was engraved by Pieter van der Heyden and published in 1557 and forms a fascinating link between the two series, the *Sins* and the *Virtues*.

All the preparatory drawings for the series of the *Seven Virtues* survive. They were executed by Bruegel in 1559 and 1560. The engravings are not signed but it is clear by stylistic comparison that the engraver was Philippe Galle, the greatest of those who worked from Bruegel's designs. The quality of the *Virtues* is far higher than that of the *Seven Deadly Sins*, engraved by Pieter van der Heyden.

In terms of the composition, the *Virtues* repeat the scheme of the *Sins* with an allegorical female figure in the foreground surrounded by groups and individuals who illustrate the virtue in action. The moral is spelt out in a Latin motto below. Yet in graphic terms there is a crucial change. The Bosch-derived monsters are gone (except in the case of *Fortitudo*). There are no tormenting or masquerading devils, no weird or fiery landscapes, no grotesque or macabre hybrids. Instead there is a move towards the more familiar Italian-derived graphic tradition of the early sixteenth century Netherlands with its realistic figure canon.

Sixteenth century 'virtue' is not necessarily twentieth century 'virtue' and there are some aspects of the series that will shock a modern audience. In the *Justicia* print, for example, a variety of judicial executions are taking place under the fascinated gaze of eager crowds. This has led some critics to see the series as satiric, but this is incorrect; they depict virtues as conceived by sixteenth century standards of morality.

The original drawing of *Fortitudo*, dated 1560, is in the Boymans Museum, Rotterdam. Bruegel's conception of *Fortitudo* is an aggressive, active one: it is not enough to be virtuous, it is necessary to positively fight against evil. Thus the print shows a battlefield in which the monsters representing evil (the only occurrence of Boschian monsters in the *Virtues* series) are routed by soldiers.

The figure of Fortitude herself crushes the dragon of evil beneath her feet. To demonstrate her absolute supremacy she holds an iron chain attached to a collar about the monster's neck. Its tail is clamped in a press. On her head Fortitude wears an anvil for she is as impervious to the pressure of evil as the anvil is to hammer blows. She holds a pillar, symbol of strength.

Around her, her soldiers kill animals symbolizing vices which we recognize from the *Seven Deadly Sins*—the toad of avarice, the peacock of pride, the swine of gluttony, the ass of sloth, the bear of anger, the monkey of lechery, the turkey of envy.

In the background is a four-towered castle resolutely guarded by men and angels, strong against attack from the forces of evil. The mass of soldiers on the left in tightly-packed formation recall the Altdorfer-inspired armies of *The Suicide of Saul* (Plate 15). On the far right the monsters are being driven into a broken egg, a now familiar symbol of evil and sinfulness. The Latin motto reads: To conquer the passions, to check anger and the other failings and vices, is true fortitude.

27 (*top*) Desidia (Sloth)

Print, $8\frac{7}{8} \times 11\frac{5}{8}$ in. London, British Museum.

One of the *Seven Deadly Sins* series, engraved after Bruegel's designs by Pieter van der Heyden and published by Jerome Cock in 1558. For discussion of the series, see note to Plate 26 top.

The original drawing for *Desidia* dated 1557 is in the Albertina, Vienna. Sloth is asleep, open-mouthed, lying on a soft pillow held by a monster. It rests on the flank of a sleeping ass, her animal counterpart. Around her, snails move slowly. To the right a man in bed is pulled along by a devil in a monk's habit; the man is so lazy he is eating as he sleeps. Behind this group is Sloth's house, a ramshackle structure containing a table at which two devils sleep drunkenly (an empty jug at their elbow) and a naked girl is about to give in to the entreaties of devils, one of whom offers a large soft pillow. Behind a curtain a couple lie together in bed. Sloth encourages other sins. Above, the hour is struck by a man who hammers a bell. Beneath him, on a ledge, are a pair of dice; gambling is another sin encouraged by sloth. In the centre of the background is a constipated giant illustrating the proverb: 'He's too lazy to shit'. A group of small figures wielding poles are assisting him. To their left is a massive clock-face half-submerged the water. The hand points to eleven, for the lazy put everything off till the eleventh hour. The Latin motto reads: Sloth destroys strength, long idleness saps the sinews.

27 (*bottom*) Temperantia (Temperance)

Print, $8\frac{7}{8} \times 11\frac{5}{8}$ in. London, British Museum.

One of the *Seven Virtues* series engraved after Bruegel's designs by Philippe Galle and published by Jerome Cock. For discussion of the series see note to Plate 26 bottom.

Bruegel here conceived of Temperance as the opposite of Sloth. Around and behind the central female figure are examples of many socially useful human activities. The tall female figure of Temperance balances a clock on her head—time passes quickly and must be put to good account. She has a bit in her mouth and a bridle, symbol of self-restraint, in her hand. In her other hand she holds a pair of glasses to enable her to see clearly. Around her waist tied like a belt is a snake which symbolizes the subjection of physical desire. She stands on the blade of a windmill, an example of man's ability to harness the forces of nature.

Illustrating the effects of Temperance are the Seven Liberal Arts; from the left clockwise are Arithmetic, Music, Rhetoric, Astronomy, Geometry, Dialectic and Grammar. The Arts are not necessarily presented in their abstract forms. Arithmetic is put to good use in an accounting shop. Just behind this group is the intriguing sight of Bruegel's own art—painting. The artist, with palette and maulstick in hand, unfortunately has his back to us. Above him music is seen in its many forms: an organ, an orchestra, a choir for religious music, and a lute for secular music. Behind the musicians, a drama is performed, presumably a morality play, with the two richly-dressed actors representing abstract ideas and declaiming rhetorical speeches. A fool pokes his head round the backcloth and above him hangs a sign, showing the world upsidedown. Of the two astronomers, one measures the earth, the other the heavens. The geometers, with plumb-line and compasses, measure a column. To their right are cannon and cannonballs, for ballistics is a branch of geometry. Beside the column, a workman squares up a stone decorated in bas-relief. A group of scholars representing Dialectic stand in front of the geometers. Here Bruegel has allowed himself a hint of satire: while the dialecticians argue, the Bible stands unopened on a lectern. The sentiment is close to Erasmus's in *The Praise of Folly* where he pillories theologians who argue endlessly over details and never read the Bible itself. In the foreground a schoolmaster, unsympathetically treated, with a switch of twigs tucked into his belt, and his eager class, represent Grammar. The Latin motto reads: We must see that we do not abandon ourselves to indulgence, extravagance or lechery, neither must we live in squalor and ignorance because of miserliness and greed.

28 The Tower of Babel (*detail of Plate 24*)

29 The Tower of Babel (*detail of Plate 24*)

30 Big Fish Eat Little Fish

Print, $9 \times 11\frac{3}{4}$ in. London, British Museum.

Engraved by Pieter van der Heyden and published by Jerome Cock in 1557. The original pen drawing is in the Albertina, Vienna and is dated 1556. Bruegel's name, however, does not appear on the print; instead, in the bottom left hand corner, above the oar blade, is the inscription 'Hieronymus Bos inventor'. This is a deliberate attempt by the publisher to pass off the young Bruegel's work as that of the popular Bosch. See note to Plate 26 top. The moral is as obvious as it is tragic: Man's inhumanity to man. Fifty years or so after Bruegel's design, Shakespeare employed the same allegory:

Third Fisherman: . . . Master, I marvel how the fishes live in the sea.
First Fisherman: Why, as men do a-land; the great ones eat up the little ones. I can compare our rich misers to nothing so fitly as to a whale; a' plays and tumbles, driving the poor fry before him, and at last devours them all at a mouthful. Such whales have I heard on o' the land, who never leave gaping till they've swallowed the whole parish, church, steeple, bells, and all.
Pericles (aside): A pretty moral . . .
. . . How from the finny subject of the sea
These fishers tell the infirmities of men;
And from their watery empire recollect
All that many men approve or men detect!

Pericles, Act II, Scene I

The Flemish text beneath the Latin are the words spoken by the old man in the boat in the foreground to his son: 'See, my son, I have known this for a very long time—that the large swallow up the small.'

On the shore a particularly Bruegelian figure in armour, his face obscured by a huge helmet, cuts the belly of the large fish with an enormous knife which bears upon it what may at first look like a maker's mark but is in fact an orb, a symbol for the world. Out pour a mass of fish, mussels and eels, some in the act of swallowing each other. A second man is about to plunge a trident into the fish. On the right hand side, at the edge of the water, sits the fool of the world, catching a fish with another fish. The allegory is brought even closer home on the left hand side where the fish holding a smaller fish in its mouth has human legs.

31 St Jerome in the Desert (S. Hieronymous in Deserto)

Print, $12\frac{3}{4} \times 16\frac{3}{4}$ in. London, British Museum.

One of the *Large Landscape* series, engraved by Jerome Cock after designs by Bruegel. The drawings were executed *c.* 1555–8. Other landscapes in the series are *Solicitudo Rustica* (Plate 23) and *Magdalena Poenitens* (Plate 40).

The landscape is by no means the Syrian desert to which the historical St Jerome retired as a hermit. Rather it is an Alpine landscape based on Bruegel's memory of his crossing over the Alps.

32 The Death of the Virgin

$14\frac{1}{2} \times 22$ in. Signed: BRVEGEL (traces of the date are illegible). National Trust. Upton House, Banbury, Oxfordshire.

This grisaille was painted about 1564 for Abraham Ortelius, the great Antwerp geographer, who was a close friend of Bruegel. Ortelius had an engraving made after it by Philippe Galle in 1574 for presentation to his friends. One of these was D. V. Coornhert, the great theologian resident in Haarlem whose influence on Bruegel's thought has been discussed in the Introduction and in the notes to the plates, particularly the *Seven Deadly Sins* (see note to Plate 26 top). He recorded his thanks for the gift in a letter, a fascinating and moving response to Bruegel's art: 'Your valued gift, good Ortelius, came to me as I was pondering how to express my gratitude in return. I examined it with pleasure for the artistry of its drawing and the care of its engraving. Neither of them, in my opinion, could have done better. Their friend, Abraham Ortelius's favour has spurred on their natural talents, so that this work of art in its skill shall survive for art-loving artists for all times. Never, in my opinion, did I see more able drawing or finer engraving than this sorrowful chamber. What do I say? I actually heard (so it seemed) the melancholy words, the sobbing, the weeping and the sounds of woe. I believe I heard moaning, groaning and screaming and the splashing of tears in this portrayal of sorrow. There no one can restrain himself from sadly wringing his hands, from grieving and mourning, from lamenting and from the tale of woe. The chamber appears deathlike, yet all seems to me alive.'

The picture is a profound expression of Bruegel's belief in the resurrection and salvation of the just who crowd in unusually large numbers around the death bed. The literary source is Jacobus de Voragine's *Golden Legend* which describes numerous holy persons being present when Mary was reunited with her son.

33 The Calumny of Apelles

Pen and brown ink drawing with brown wash, $8\frac{1}{8} \times 12\frac{1}{8}$ in. Signed and dated P. BRVEGEL MDLXV. London, British Museum.

This drawing discovered in 1959 and acquired by the British Museum is the only drawing of a classical subject. Its discovery further confirmed the conception of Bruegel as a sophisticated and literate artist. The subject is taken from Lucian's *De Calomnia* and was depicted by a number of Italian Renaissance artists, notably Mantegna. The passage in Lucian (from Melanchton's Latin text of 1543) reads: 'On the right sits a man conspicuous for his very long ears which are almost similar to those of Midas. He is extending a hand towards Slander (*Calumnia*) who is approaching from a distance. Near him stand two young women, Ignorance (*Ignorancia*) unless I am mistaken, and Suspicion (*Suspicio*). From the other side Slander, elegantly adorned, approaches rapidly, her face and gestures disclosing the wild frenzy and anger she has conceived in her burning breast; she holds in her left hand a blazing torch, and with her right hand drags a youth who raises his hands in supplication to the immortal gods to act as witnesses of his innocence. They are preceded by a pale man of foul appearance; he has a very piercing glance but in other respects clearly resembles someone who is wasting away from a serious illness. This, it is easy to conjecture, is Envy (*Lyvor*). Women follow in attendance on Slander, encouraging, directing and organizing their mistress. An interpreter of the painting says that they represent Treachery (*Insidiae*) and Deceit (*Fallacia*). Penitence (*Penitencia*) follows behind dressed in rags, in mourning; with her head cast down, she glances back in tears from a sense of shame towards Truth (*Veritas*), who approaches.'

Bruegel has followed the text carefully except in two details: Penitence is not dressed in rags and Truth, naked, is seated in a niche. It has been suggested that this is a preparatory drawing for a painting.

34 The Procession to Calvary

$48\frac{3}{4} \times 66\frac{7}{8}$ in. Signed and dated: BRVEGEL MD.LXIIII. Vienna, Kunsthistorisches Museum.

The largest painting by Bruegel to survive, this is the picture mentioned in the inventory of Niclaes Jonghelinck in 1566. One of his sixteen paintings by Bruegel, it may well have been painted for this rich Antwerp patron.

The composition is within a well-worn tradition, deriving particularly from the work of Jan van Amstel (The Brunswick Monogrammist) and Pieter Aertsen. Christ's insignificance amidst the crowds is a familiar mannerist device (it recurs in *The Sermon of St John the Baptist*, Plate 84), as is the placing of Mary and her companions in an artificial foreground, separated from the events behind them.

The immediacy of the scene would seem to derive from Bruegel's own memory of public executions. Certainly the scene is represented as a contemporary one, with all the crush of onlookers, pedlars and thieves who attended executions. The indifference of the spectators to the victims is especially poignant. Simon of Cyrene is quite obviously reluctant to assist Christ with his burden; in his fight with the soldiers, he is stoutly assisted by his wife from whose waist hangs a rosary—an eloquent condemnation of hypocritical Christianity.

35 The Procession to Calvary (detail of Plate 34)

36 Everyman (Elck)

Pen and ink drawing on white paper, $8\frac{1}{4} \times 11\frac{1}{2}$ in.
Signed and dated: brueghel 1558. London, British Museum.

See note to Plate 37.

37 Everyman (Elck)

Print, $9 \times 11\frac{5}{8}$ in. Dated 1558. London, British Museum.

Both the preparatory drawing for this print and the engraving after it by Pieter van der Heyden, are reproduced. The print was published by Jerome Cock.

There is a picture within the picture: a man in old-fashioned medieval dress stands in a shambles of broken furniture looking at his own reflection in a mirror. The legend below reads: 'No one knows himself'. Below, five men, each with Elck (Everyman) on the hem of his robes, are searching through a jumble of objects and looking into barrels with lanterns. A sixth, in the left foreground, can be glimpsed within a barrel. Two have abandoned their search temporarily to have a tug-of-war over the possession of a long piece of material.

The subject of Everyman, who is always seeking outside but never within, was the subject of earlier German woodcuts. Here the moral is spelt out in the texts. The Latin one reads: 'There is no one who does not seek his own gain everywhere, no one who does not look after his own interests in all he does, no one who does not always hope for his own enrichment—this one pulls, that one pulls, all have the same love of possession (*amor habendi*)'. This same sentiment is stated at greater length in the French and Flemish legends.

38 The Procession to Calvary (detail of Plate 34)

39 The Procession to Calvary (detail of Plate 34)

40 The Penitent Magdalen (Magdelena Poenitens)

Print, $12\frac{3}{4} \times 16\frac{7}{8}$ in. London, British Museum.

One of the *Large Landscape* series engraved by Jerome Cock after designs by Bruegel. The series is not dated but a preparatory drawing in the Louvre for one of the engravings (Plate 18) is dated 1555, and the series is generally thought to have been executed by Bruegel *c.* 1555-8. The *Solicitudo Rustica* (Plate 23) is also one of this series.

41 The Fight of the Money Bags

Print, $9\frac{3}{8} \times 12\frac{1}{8}$ in. London, British Museum.

Engraved by Pieter van der Heyden after Bruegel's design and published by Jerome Cock. It bears the name of his shop in Antwerp 'Aux Quatre Vents'. The print is undated but was probably executed during the late 1550s.

The moral—the destructive power of money—is easy to read. The inscriptions, in Latin and Flemish couplets, spell it out. The Flemish inscription reads:

Go to it, you chests, pots and fat money-bags
You are fighting in ranks for gold and for possessions.

If anyone says differently, they are lying—
That's why we're fighting back so hard.

People are looking for ways now to do without us
But they wouldn't fight, if there weren't such spoils to be had.

The Latin motto repeats the sentiment.

The principal combatants are in fact more like piggy-banks than money-bags. They were the typical Flemish savings-bank, a pear-shaped porcelain piggy-bank with a slit at the top which was broken open when money was needed.

42 Procession to Calvary (detail of Plate 34)

43 The Adoration of the Kings

$43\frac{3}{4} \times 32\frac{3}{4}$ in. Signed and dated: brvegel m.d.lxiiii. London, National Gallery.

An important departure in Bruegel's work, this is the first painting to be built up almost exclusively of large figures. The compositional device, which is borrowed from Italian mannerist artists like Parmigianino, permits a concentration in intensity and range of facial expression among the participants and the bystanders in this scene.

This *Adoration* and a *Resurrection* in grisaille at the Boymans Museum, Rotterdam, are the only upright paintings by Bruegel.

44 Spes (Hope)

Print, $8\frac{7}{8} \times 11\frac{5}{8}$ in. Rotterdam, Boymans-van Boeningen Museum.

One of the *Seven Virtues* series engraved after Bruegel's designs by Philippe Galle and published by Jerome Cock. For discussion of the series see note to Plate 26 bottom.

The original drawing of *Spes* is in the Kupferstichkabinett, Berlin. The female figure of Hope stands firmly on an anchor amid a raging sea. She has a beehive on her head and carries a spade and a scythe, tools used by peasants and farmers who hope for a good harvest. To her right shipwrecked men hope to reach the shore in safety. On the shore a pregnant woman prays for the safety of her husband. Beside her, a fisherman hopes for a good catch. Behind them, a house burns and men try to douse the flame. They hope to succeed before all is destroyed. On the roof of a neighbouring house a man is trapped; he hopes for rescue. In the foreground men in prison hope for their release, and perched at the window a broken falcon hopes for the moment his hood is removed. The Latin motto reads: The assurance hope gives us is both pleasant and necessary in an existence among so many intolerable misfortunes.

45 Ira (Anger)

Print, $8\frac{7}{8} \times 11\frac{5}{8}$ in. London, British Museum.

One of the *Seven Deadly Sins* series, engraved after Bruegel's designs by Pieter van der Heyden and published by Jerome Cock in 1558. For discussion of the series see note to Plate 26 top.

The original drawing for *Ira*, dated 1557, is in the Uffizi Gallery, Florence. The figure of Ira, a woman dressed in armour, an arrow through the helmet and carrying a sword and a burning torch, leads a group of monsters on foray out of her war tent. Her animal equivalent, the bear, bites the leg of a cowering naked sinner. Her party is headed by two soldiers carrying an enormous knife like a battering-ram with which they cut down naked figures; with their helmets over their faces, they recall the figure cutting the fish in *Big Fish Eat Little Fish* (Plate 30). One naked man evades the knife, only to be attacked by a monster wielding a mace.

In the same manner as Dante in the *Inferno*, Bruegel has devised appropiate punishments for those who display anger. The heat of anger is punished by the heat of fire. At the left a naked sinner is roasted over a spit and basted by a demon. On the roof of Ira's tent a couple are boiled alive. The middleground is dominated by a huge female figure, a knife between her teeth, her right arm in a sling, a phial in her left. Her hat is decorated with a thorn branch. In a barrel beneath her cloak a bar-room brawl has broken out. Both men have knives; a woman blows the alarm on a trumpet. To the left a man in a tree house tolls a bell. From a nearby branch a fish hangs by the gills, on another an egg rests in a nest of dry twigs. In the air above, two birds fight. In the right foreground a battle between monsters is fought out, perhaps in mockery of human war. The crippled creature drawing a sword wears on top of his helmet a flag which bears the key of St Peter, symbol of the Papacy. Behind them is a landscape of death and destruction, the fruits of war. The Latin text reads: Anger swells the mouth, makes the veins black with blood.

46 Adoration of the Kings
(detail of Plate 43)

47 Adoration of the Kings
(detail of Plate 43)

48 Landscape with Rabbit Hunters

Etching, $8\frac{3}{8} \times 11\frac{1}{2}$ in. London, British Museum.

Signed and dated 1566, this is the only etching from Bruegel's own hand. More than any of the engravings after his designs by other artists, it is very close to his individual style of draughtsmanship in which shapes are built up by a mass of short strokes and dots.

49 Haymaking (July)

$46 \times 63\frac{3}{8}$ in. Neither signature nor date now visible. Prague, National Gallery.

One of the series of the *Months*, painted in 1565. For discussion of the series see note to Plate 74.

50 Superbia (Pride)

Print, $8\frac{7}{8} \times 11\frac{5}{8}$ in. London, British Museum.

One of the *Seven Deadly Sins* series, engraved after Bruegel's design by Pieter van der Heyden and published in 1558 by Jerome Cock. For discussion of the series see note to Plate 26 top.

The original drawing of *Superbia*, dated 1557, is in the Institut Néerlandais, Paris. The central female figure is a woman dressed in the height of fashion admiring herself in a mirror. Her animal equivalent, the peacock, stands beside her in full plumage. It is worth noting that Pride is dressed in contemporary fashion whereas other figures in this print and in the rest of the series are in fifteenth century dress.

Superbia's vanity is mocked by an armoured monster with a peacock's feather for a tail, at the bottom left. His mouth padlocked, he admires himself in a mirror. A nun, with a fish's tail, points out a group of vain monsters. Behind the mirror-gazing monster, another performs elaborate contortions to enable him to see his anus in a mirror. He has an arrow in his back which he seems not to have noticed, so absorbed is he in self-love. Above him, a terrified, naked girl has fallen into the hands of monsters, one disguised as a shepherd, another as a nun. The group illustrates the proverb 'Where pride and luxury lead, shame and poverty follow'. On the right side is Superbia's house, a hairdresser-cum-beauty parlour, where monsters wash a woman's hair. The shop displays the Barber's Licence to cut hair and to practise as a surgeon (below he is seen drawing a tooth); the mortar and pestle indicate that he is also a pharmacist.

In the background groups of naked sinners are tormented within a variety of fantastic buildings and structures. The Latin text reads: The proud do not love the gods, nor do the Gods love the proud.

51 Invidia (Envy)

Print, $8\frac{7}{8} \times 11\frac{5}{8}$ in. London, British Museum.

One of the *Seven Deadly Sins* series, engraved after Bruegel's designs by Pieter van der Heyden and published by Jerome Cock in 1558. For discussion of the series see note to Plate 26 top.

The original drawing for *Invidia*, dated 1557, is in a private collection in Basle. The central female figure—in a high old-fashioned wimple—is eating her heart out. According to Coornhert, Envy 'is the eldest daughter of Pride' for Pride cannot accept the success of others. Envy points to her animal equivalent, the turkey. Behind her, one monster holds a mock crown above her head, while another tempts a woman with an apple. Beneath her feet, two dogs fight over a bone.

To the right is a shoe-shop. Shoes, boots and clogs recur throughout the print and have a two-fold significance: they refer to the envious man's desire to step into another's shoes and also to the social distinction between the peasant's shoes or clogs and the gentleman's boots.

In the left foreground is another shoe-seller. Behind her, a demon licks its own anus. Further back, a boat drifts into view, with a fantastic cargo. Much of the precise meaning of the symbolism is lost but here—as elsewhere in Bruegel's work—the dry twigs stand for folly. Across a bridge a funeral procession of hooded monks carries a coffin to a chapel which is half-enclosed in a structure the door of which is guarded by a monster behind whom we can glimpse a mass of sinners; the monster opens the door to receive one more naked man who is carried up the ladder on the back of another monster. The smoke billowing out indicates that this is Hell. In the left background a boat sinks, emptying its sinful occupants including a monk and a naked woman into the water. Nakedness and immersion in water are throughout the series symbols of degradation. Beyond them a church burns and a tower is also on fire. The Latin motto reads: Envy is a horrible monster, a very destructive plague.

52 The Hunters in the Snow (January)
(detail of Plate 74)

53 Haymaking (July)
(detail of Plate 49)

54 *(top)* Spring

Print, $9 \times 11\frac{1}{4}$ in. London, British Museum.

Engraved by Pieter van der Heyden and published by Jerome Cock in 1570. The original drawing by Bruegel is dated five years earlier, 1565; it is in the Albertina, Vienna.

This is the first of two seasons: the other, *Summer*, is reproduced below. The series was completed after Bruegel's death from original drawings of Autumn and Winter by another artist Hans Bol.

Spring shows the seeding and laying-out of an aristocratic garden. The lady of the house, accompanied by her daughter, supervises the operation. Behind the garden, to the right, the sheep are being sheared by the farm workers. By contrast, on the left, richly-dressed nobles eat, drink, dance and listen to music. The figure in the foreground on the left digging a trench brings to mind Bruegel's last commission—a series of paintings recording the construction of Brussels–Antwerp canal. The Latin inscription reads:

> March, April, May are the months of Spring
> Spring, like childhood
> In Spring golden Venus is dressed in garlands of flowers.

54 *(bottom)* Summer

Print, $8\frac{7}{8} \times 11\frac{1}{4}$ in. London, British Museum.

This is a sequel to *Spring*. The engraver is not credited nor is the plate dated. It was published by Jerome Cock, presumably about 1570. The original drawing, dated 1568, is in the Kunsthalle, Hamburg. As we should expect of a design from Bruegel's last years, the foreground is dominated by monumental figures. Obscure Renaissance and classical sources have been suggested for the figure of the drinking peasant; the important point is that here, as in the late paintings, Italian Renaissance models have been grafted with great success onto the Netherlandish graphic tradition. This synthesis characterizes Bruegel's greatest work.

An obvious contrast exists between this print and *The Corn Harvest* (August, Plate 66) one of the *Months* series executed in 1565. There the figures are less monumental, less heroic. The subject of the painting is the landscape, the subject of the print is man. The Latin motto reads:

> July, August and also June are the Summer
> Summer, image of youth
> Hot summer brings rich crops in the fields.

55 *(top)* The Ass at School

Print, $9\frac{1}{8} \times 11\frac{3}{4}$ in. London, British Museum.

This version of the engraving is by Pieter van der Heyden which was published by Jerome Cock in 1557. The original drawing, dated 1556, is in the Kupferstichkabinett, Berlin.

A schoolmaster tries in vain to teach his pupils to read. Though having the stature of children they have the faces of adults and are crouched in a multitude of contorted positions. All are fools and any amount of teaching or beating will not help them to learn. Two sit within a huge hat with a peacock feather in the band, put on them by a figure who has slipped around the corner. This refers to the Flemish proverbs: 'Two fools under a single hood' and 'Easily caught under a hat' (i.e. gullible). The peacock feather here indicates cowardice because of the similarity of the Latin words *paveo* ('I am afraid') and *pavo* (peacock): The ass has a candle and a pair of glasses to help him read the music in front of him, but it will make no difference to his singing voice. The moral is spelt out by the Latin text: 'You may send a stupid ass to Paris [the most famous of all medieval universities]: if he is an ass here he won't be a horse there'.

55 *(bottom)* Gula (Gluttony)

Print, $8\frac{7}{8} \times 11\frac{5}{8}$ in. London, British Museum.

One of the *Seven Deadly Sins* series, engraved after Bruegel's designs by Pieter van der Heyden and published by Jerome Cock in 1558. For discussion of the series, see note to Plate 26 top.

The original drawing for *Gula*, dated 1557, is in the Institut Néerlandais, Paris. Gluttony is personified by a woman in the dress of a Flemish burgher's wife. She guzzles from a jug. At her feet her animal equivalent, a hog with the ears and back feet of a dog, feasts on turnips and carrots which have spilled from an upturned basket, bearing Bruegel's signature. A naked human couple are eating from the same table as Envy; they are encouraged by demons who are about to carry off the woman. Another human, his head held by a demon, vomits into the river, narrowly missing a naked swimmer. Behind him, only the top half of another swimmer's head is visible and on top of it he balances an egg, a recurring symbol of sin in Bruegel's work. Behind Envy is her 'house', a ramshackle tent. It partially shelters a wine barrel from which a monster in monk's cowl drinks wine. In the branches of the blasted tree hang bagpipes, its bag denoting obesity. To the left is a giant on his knees imprisoned in a mill with spiked wheels. He is trapped, tormented by all the self-indulgence around him, unable to participate.

In the right foreground a bloated fish, his split belly sown up but splitting again, eats a smaller fish. To his left a dog upsets a tray carried by a monster dressed as a butcher. Behind, a naked man is trapped, legs flailing, in a wine barrel—again, a punishment fitting his sin, drunkenness. At the water's edge an obese man has to carry his own distended stomach in a cart. Above him a windmill is fashioned from a human face; sacks are shovelled into the mouth which, mechanically, unceasingly, grinds them. In the background is

the familiar landscape of ruined and burning buildings. The Latin motto reads: Drunkenness and gluttony must be shunned.

56 The Return of the Herd (November)

$46 \times 62\frac{5}{8}$ in. Signed and dated: BRVEGEL MDLXV. Vienna, Kunsthistorisches Museum.

One of the series of the *Months*, painted in 1565. For discussion of the series, see note to Plate 74.

57 The Return of the Herd (November)
(detail of Plate 56)

58 (*top*) The Alchemist

Print, $13\frac{1}{2} \times 17\frac{5}{8}$ in. London, British Museum.

Bruegel's name and that of the publisher, Jerome Cock, appear on this print. There is no date or engraver's monogram, but the date would seem to be 1558 or 1559 and the engraver Philippe Galle. The preparatory drawing is in the Kupferstichkabinett, Berlin; it is signed and dated 1558 in a hand that is not Bruegel's, but the information would seem to be correct.

Alchemy—not unreasonably seen as the precursor of modern science—is here mocked. The alchemist in his fanatical attempt to conjure gold from base metal is ruining himself and his family. His wife shakes her purse to find a coin but it is empty. Behind her, the three children scamper, one with a pot over its head. Beside her the alchemist's crazed assistant works the bellows to fan the fire. Some of the alchemist's ingredients are clearly marked: a bag with the label DROGERY lies in the left hand corner. On the table beside the assistant stand jars, one of which is clearly marked SULFER. Above the alchemist's head is a paper covered with calculations and diagrams, the only word which can be made out is *Misero*.

On the right hand side of the print sits a scholar at his desk. He points at the alchemist and at the book in front of him which carries the punning chapter heading 'Alghe Mist', literally, 'All Rubbish'.

Through the window can be seen the culmination of the alchemist's folly: with his wife and children (one still wears the pot) he is entering the 'hospital', the poor house. Such is the end of the fool's search for gold.

58 (*bottom*) St James and the Magician Hermogenes

Print, $8\frac{5}{8} \times 11\frac{3}{8}$ in. London, British Museum.

In this design, engraved by Pieter van der Heyden and dated 1565 as in its sequel *The Fall of the Magician* Bruegel resorts to the Boschian manner of the *Seven Deadly Sins*. The encounter here depicted is described in Jacobus de Voragine's *Golden Legend*. The pilgrim apostle, James the Greater, one of the sons of Zebedee, was preaching in Judaea. The Pharisees called upon the assistance of a magician, Hermogenes, in order to discredit him. St James confounded him and his assistant Philetus, and they were both converted. Here St James has been brought before Hermogenes by magic. Although surrounded by devils he is calm; it is Hermogenes who looks uneasy, as well he might, for in the sequel St James sets his own devils upon him. The Latin motto reads: St James is brought before the magician by devilish arts.

59 (*top*) The Fair at Hoboken

Print, $11\frac{3}{4} \times 16\frac{1}{8}$ in. Rotterdam, Boymans-van Beuningen Museum.

Published by Bertolomeus de Momper and engraved by Frans Hogenberg. Bruegel's preparatory drawing dated 1559 is in the Courtauld Institute Gallery, London. As in the closely-related *The Fair of St George's Day* (Plate 69) it shows a kermesse in full swing, this time in the village of Hoboken. The banner on the right has a scroll reading: Dit is de Guilde van Hoboken (This is the guild of Hoboken). Peasants dance, drink, take part in a religious procession and watch plays being performed.

59 (*bottom*) Skaters before the Gate of St George in Antwerp

Print, $9\frac{1}{8} \times 11\frac{3}{4}$ in. London, British Museum.

Engraved by Frans Huys and published by Jerome Cock. The preparatory drawing, dated 1558, is in a private collection in America. Observed from life, this plate shows the pleasures of winter enjoyed by the citizens of Antwerp.

60 The Return of the Herd (November)
(detail of Plate 56)

61 The Massacre of the Innocents

$45\frac{5}{8} \times 63$ in. Inscribed: BRVEG undated. Vienna, Kunsthistorisches Museum.

There are two versions of this composition by Bruegel. The one reproduced is at Vienna, probably a workshop replica partially retouched by Bruegel himself. The one at Hampton Court is probably from Bruegel's own hand but is extensively damaged and repainted. Both were painted *c*. 1565–7.

As in *The Procession to Calvary* (Plate 34) Bruegel has represented a biblical scene as a contemporary event, in this case the sacking and plundering of a Flemish village. It is unlikely in view of Bruegel's ambiguous political and religious stance (see Introduction) that he intended to condemn a particular act of Spanish destruction. More probably he is here making a more general condemnation of war, and the individual acts of atrocity that war condones. It was not until Alba's arrival in August 1567, after the execution of this picture, that there was a significant Spanish military presence in Flanders.

62 Patientia (Patience)

Print, $8\frac{7}{8} \times 11\frac{5}{8}$ in. London, British Museum.

This is not one of the *Seven Virtues* series. It was executed as a single sheet, engraved by Pieter van der Heyden and published by Jerome Cock in 1557. No original drawing survives. It is a Virtue executed in the style of the *Seven Deadly Sins*. Instead of the allegorical figure of the virtue being surrounded by demonstrations of that virtue, she is here surrounded by temptations and evils which take the form—as they do in the *Sins* series—of Boschian monsters and devils. It is a quite different conception from the *Virtues* as finally executed and a comparison demonstrates Bruegel's changing ideas within the short space of two years.

Patience is a classically-dressed figure, her hands clasped, holding a cross, her eyes raised to heaven. Shackled to a block of stone, she prays for the patience to endure temptation. The temptations are many, varied, and familiar from the *Sins* series. Dominating the left hand side is a giant imprisoned within an egg-man. His cardinal's hat bears the crossed keys of the Papacy, tucked in his belt is a paper, presumably an Indulgence. As ever the egg symbolizes futility and the giant must be taken as a satire on corruption in the Roman Church. Assorted monsters disport themselves on the banks of the sea. On the right is a familiar hollow tree populated by (at the top) an amorous lutanist, a man tapping a barrel and (below) a monster dancing to a fiddler's tune. Gluttony too is present with a fowl being roasted on a spit. In the background of all this sinfulness and folly, buildings burn and the sun is setting. The Latin motto is a quotation from Lactantius (*Institutiones Divinae*): Patience is the calm endurance of evils caused by malice or by accident.

63 Faith (Fides)

Print, $8\frac{7}{8} \times 11\frac{5}{8}$ in. London, British Museum.

One of the *Seven Virtues* series engraved after Bruegel's designs by Philippe Galle and published by Jerome Cock. For discussion of the series see note to Plate 26 bottom. The original drawing is in the Rijksmuseum, Amsterdam. It is dated 1559 in a hand which is not Bruegel's.

The allegorical figure of Faith stands in the tomb in which Christ's body was buried, empty since the Resurrection. On her head is the Old Law, the tablets brought down from Mount Sinai by Moses, in her right hand is the New Law, the New Testament on which rests the haloed dove symbolizing the third person of the Trinity, the Holy Ghost. She stands amidst the Instruments of the Passion: the column at which Christ was whipped and the whips, the rooster which crowed at Peter's betrayal, the pincers which removed the nails, the jug and ewer with which Pilate washed his hands. On the tomb are the Marys' ointment jars, the seamless cloak and the dice thrown for it, and the hammer; on the far side, the lantern which illuminated the Arrest, the High Priest's servant's ear and the sword that struck it off, and Judas's thirty pieces of silver. Behind her is the cross, the crown of thorns, spear, the vinegar-soaked sponge, and the cloth St Veronica used to wipe Christ's brow and which miraculously preserved His image. Faith stands on a church and, behind her, sacraments of the church are being performed; on the left, marriage, communion, baptism and confession. On the right a friar preaches to a large congregation while at the back a priest raises the Host.

This juxtaposition of foreground and background raises interesting questions about Bruegel's religious beliefs and some critics have detected a satirical intention in the depiction of the sacraments. They see a contrast between Faith as embodied in the Gospels and the sacraments, the outward ceremonies of the Church which are meaningless if performed without true faith. It is argued that this is a reflection of Coornhert's views. I do not believe that Bruegel had so didactic an intention in this print. While it is true that in the preparatory drawing several faces of participants in the sacraments are grotesque, this is not unusual in Bruegel's work and does not necessarily point to a satirical purpose. There is no doubt that the group with which Bruegel was associated placed great stress on the individual's relationship with God but the sacraments of the Church, properly conducted, were respected. The Latin motto reads: Faith above all is to be preserved, especially in religion, for God comes before and is greater than any man.

64 The View of Naples

$15\frac{5}{8} \times 27\frac{3}{8}$ in. Rome, Galleria Doria.

The only painting of a particular locality to remain in Bruegel's œuvre, though others are mentioned in old inventories. Previously thought to be a very early work, this picture is now generally accepted to have been painted *c*. 1562–3. The composition is connected with the design by Bruegel for a print engraved by Frans Huys in 1561 of a *Battle in the Straits of Messina*, and leads to that of *The Tower of Babel* (Plate 24).

Bruegel was in Naples in 1552 and although the picture would seem to have been done later from memory, he presumably was able to utilize sketches made there during that visit. This same creative procedure is apparent in the *Straits of Messina* engraving, one of the drawings used for which, the *View of Reggio*, is preserved in the Boymans Museum, Rotterdam. The landmarks of Naples are all visible: the Castel dell'Ovo, the island tower of S. Vincent (subsequently destroyed), the Castel Nuovo and, on the hill, the Castel Sant'Elmo. He transformed the actual rectangular harbour jetty into a circular one for compositional reasons. It has been suggested that the ships in the foreground may be involved in a sea battle, perhaps an episode in the defence of Naples against the Turks.

The sea, and in particular ships, had a great fascination for Bruegel. His earliest extant painting was *The Sea of Tiberias with Christ appearing to the Apostles* (dated 1553. Private collection), his last, *The Storm at Sea* (Plate 95). Between these is *The Fall of Icarus* (Plate 2) with its man-of-war, the *Straits of Messina* engraving of 1561 and the series of thirteen *Men-of-War* (Plate 19) which he drew to be engraved by Frans Huys. A sea scene by Bruegel is recorded among Rubens's possessions at his death. It is not known whether it was this picture.

65 Marine Landscape with a view of Antwerp

Pen and brown ink drawing, $8 \times 11\frac{3}{4}$ in. London, Count Seilern collection. The signature on the lower left is false.

In the vigorous plastic modelling of the waves and in the choice of low viewpoint, this drawing is closely related to the unfinished *Storm at Sea* (Plate 95) which is now generally accepted as Bruegel's latest work. The drawing would seem to date from the second half of the 1560s. Bruegel's continuing interest in ships and the sea has been discussed in the context of the *Man-of-War* series (see note to Plate 19).

66 The Corn Harvest (August)

$46\frac{1}{2} \times 63\frac{1}{4}$ in. Signed: BRVEGEL (only the last figures of the date, LXV, are legible). New York, Metropolitan Museum.

One of the series of the *Months*, painted in 1565. For discussion of the series see note to Plate 74.

67 The Gloomy Day (February)

$46\frac{1}{2} \times 64\frac{1}{8}$ in. Signed and dated: BRVEGEL MDLXV. Vienna. Kunsthistorisches Museum.

The February panel from the series of the *Months*. The series is discussed in the note to the first, *The Hunters in the Snow* (January) (Plate 74). February was carnival month and it is for this reason that the child on the right hand side wears a paper crown and the man is eating waffles.

68 Christ and the Woman taken in Adultery

Print, $10\frac{1}{2} \times 13\frac{1}{2}$ in. London, British Museum.

This engraving is after an original grisaille dated 1565 now in the collection of Count A. Seilern, London. The picture remained in the possession of the artist's family until the death in 1625 of Jan Brueghel who bequeathed it to Cardinal Federigo Borromeo, Archbishop of Milan. The engraving, exactly the same size as the painting, was made in 1579 by Pierre Perret and the painting displays fine pricks made along the edge by the engraver to secure his tracing paper.

The scene represented is described in John's gospel, chapter 8: 'And the scribes and the Pharisees brought unto him a woman taken in adultery . . . Now Moses in the Law commanded us, that such should be stoned: but what sayest thou? . . . Jesus stooped down and with his finger wrote on the ground, as though he heard them not. So when they continued asking him, he lifted up himself and said unto them, He that is without sin among you, let him first cast a stone at her.'

It has been convincingly argued that the image is a plea for toleration in the religious controversies of Bruegel's day.

The composition is rare in Bruegel's work consisting as it does entirely of figures, without landscape. Although the iconography follows the traditional Flemish depiction of the scene, the monumentality of the figures and the relationship between them attest to Bruegel's study of Andrea del Sarto's frescoes in the Chiostro dello Scalzo, Florence, and the Raphael Cartoons, particularly *The Healing of the Lame Man*, which in Bruegel's time were in Brussels and are now in the Victoria and Albert Museum, London.

69 The Fair of St George's Day

Print, $13\frac{1}{8} \times 20\frac{3}{4}$ in. London, British Museum.

Engraved and published by Jerome Cock. The plate is undated. A Flemish kermesse, half-religious festival, half-carnival is in full swing. On the right flutters the banner of the patron, St George, carrying his bow and arrows. Above his head a scroll bears the legend: Laet die boeren Laer Kermis Louven (Let the peasants hold their kermesse). There are games, dancing, wrestling, a dramatization of St George and the dragon and on a hill in the background a group of archers shoot at a target, in honour of the patron saint.

70 Haymaking (July) (detail of Plate 49)

71 The Land of Cockaigne

$20\frac{1}{2} \times 30\frac{3}{4}$ in. Signed and dated: MDLXVII BRVEGEL. Munich, Alte Pinakothek.

Bruegel here represents Never-Never land, where everything is done for the inhabitant and all there is to do is sleep. Bruegel's targets are gluttony and sloth; in Dutch the Land of Cockaigne is *Luikkerland*: *lui* meaning lazy and *lekker*, gluttonous. Bruegel has here returned to his earliest Bosch-derived idiom and, except for the monumental figure drawing, the picture recalls *The Netherlandish Proverbs* (Plate 11).

The picture was engraved in the same year, 1567, by Pieter van der Heyden and published by Jerome Cock. Beneath, a four-line Flemish verse was added to underline the message:

> All you loafers and gluttons always lying about
> Farmer, soldier and clerk, you live without work.
> Here the fences are sausages, the houses are cake
> And the fowl fly roasted, ready to eat.

All three professions are here: the clerk lying on his fur robe, ink and pen at his waist, book beside him; the peasant sleeping on his flail; and the soldier with lance and gauntlet lying useless beside him. Beneath the clerk and the peasant runs an egg, already eaten; empty eggshells in Bruegel as in Bosch are symbolic of spiritual sterility. Behind the sleepers a roast goose lays itself down on a silver platter to be eaten. To its right a traveller has reached *Luikkerland*; he has eaten his way through a mountain of pudding and is swinging down with the aid of a conveniently placed tree. The fence at the edge of the sleepers' enclosure is woven out of sausages. On the left under a roof laden with pies and cakes an open-mouthed, helmeted figure awaits a fowl which is flying, ready cooked, into its mouth (this is clearly visible in the engraving but not in the painting).

72 The Poor Kitchen

Print, $8\frac{3}{4} \times 11\frac{5}{8}$ in. Rotterdam, Boymans-van Beuningen Museum.

73 The Rich Kitchen

Print, $8\frac{5}{8} \times 11\frac{1}{2}$ in. Rotterdam, Boymans-van Beuningen Museum.

This pair of prints were engraved by van der Heyden and published by Cock. Both are dated 1563. No original drawings survive. The contrast is obvious, perhaps too overstated to be genuinely moving. In *The Poor Kitchen* everyone, down to the bitch beneath the table trying to feed her pups, is thin and hungry. The meal on the table is a meagre one of bread, turnips and mussels. A fat man has strayed from the rich kitchen and, though invited in and offered a turnip and parsnip, he has seen quite enough and is eager to go. It is he who speaks the rhymed French and Flemish texts beneath the print: Where Thin Man is cook, the food is meagre and one's stomach hurts, I'm off to Rich Kitchen, while I'm still alive.

In the second print, one of the men from the Poor Kitchen, has taken the old thin bagpipes from the wall and tries to get into the Rich Kitchen. He is sternly rebuffed, pushed and kicked out by one of the overweight eaters. At the same time he is bitten by a fat dog. Seated at table in the Rich Kitchen is that traditional figure of fun, the fat monk.

The cry set up by the Fat Man is the text for Rich Kitchen: Get out of here, Thin Man, with your horrible appearance. You've no place here, this is Rich Kitchen.

74 The Hunters in the Snow (January)

$46 \times 63\frac{3}{4}$ in. Signed and dated: BRVEGEL MDLXV. Vienna, Kunsthistorisches Museum.

The first of a series of the *Months*, of which only five remain: *The Gloomy Day* (February), *Haymaking* (July), *The Corn Harvest* (August) and *The Return of the Herd* (November). The series was commissioned by Niclaes Jonghelinck, a rich Antwerp merchant who owned sixteen paintings by Bruegel. He was the brother of the sculptor Jacques Jonghelinck who was a friend of the artist. The pictures were in Jonghelinck's possession by February 1566. They were presumably intended as part of a large-scale scheme of decoration for his palatial house in Antwerp; Frans Floris, the most

successful Antwerp artist of the day, had a leading part in this scheme. Bruegel's *Months* probably hung above the panelling, forming a continuous frieze.

There has been discussion as to whether the series was made up of twelve panels or of six, each representing the activities of two months. There is, however, little reason to believe that the traditional scheme of twelve panels was not adopted. The iconography of the remaining paintings accords largely with the well-established Flemish tradition of the *Months*.

The whole massive decorative scheme would seem to have been completed in a year. Bruegel's rapid technique tends to confirm this. With an astonishing sureness of brush he painted thinly, often using the underpainting as a distinct element in the composition. His treatment of figures is reduced to a swift notation with every line and every area of colour in its correct place. The subject of the *Months* is the landscape in its ever-changing variety. Human activity is peripheral to the evocation of the mood of the landscape.

75 The Numbering at Bethlehem

$45\frac{5}{8} \times 64\frac{3}{4}$ in. Signed and dated: BRVEGEL 1566. Brussels, Musées Royaux des Beaux-Arts.

Again a biblical story is treated as a contemporary event. And once again reference to particular political events has been adduced, in this case, the severity of Spanish administration in the southern Netherlands. For reasons discussed in the Introduction, I prefer to consider it as a more general criticism of bureaucratic methods.

The events depicted are described in Luke 2, 1–5: 'And it came to pass in those days, that there went out a decree from Caesar Augustus, that all the world should be taxed . . . And all went to be taxed, every one into his own city. And Joseph also went up from Galilee, out of the city of Nazareth into Judaea, unto the city of David, which is called Bethlehem (because he was of the house and lineage of David) to be taxed with Mary his espoused wife, being great with child.'

It is a rare, though not unknown, subject in previous Netherlandish art.

The ruined castle in the background is based on the towers and gates of Amsterdam, drawn by Bruegel in 1562 (Plate 76 top).

76 (top) The Towers and Gates of Amsterdam

Pen and brown ink drawing, $7\frac{1}{4} \times 11\frac{5}{8}$ in. Signed and dated: P. BRVEGEL 1562. Besançon, Musée des Beaux-Arts.

In 1562, the year before he established himself in Brussels, Bruegel visited Amsterdam, a staunchly Catholic city. There are two other views of the city walls of Amsterdam, one also at Besançon and the other in the Museum of Fine Arts, Boston. Both are dated 1562.

76 (bottom) The Bee Keepers

Pen and brown ink drawing, $8 \times 12\frac{1}{8}$ in. Signed and dated: BRVEGEL MDLXV . . . (cut on right obliterates the last numerals). Berlin, Kupferstichkabinett.

Intended for an engraving which was never executed, the drawing dates from *c*. 1568.

77 The Painter and the Connoisseur

Brown ink drawing, $9\frac{7}{8} \times 8\frac{1}{2}$ in. Signed. Vienna, Albertina.

Probably executed about 1565 or later, this is one of Bruegel's most accomplished figure drawings. The contrast between the wild-eyed, wild-haired artist and the dry, elderly connoisseur looking over his shoulder clearly spells out Bruegel's feelings about the intensity of creative work compared with the cool appraisal of the patron.

78 The Peasant Wedding (*detail of Plate 85*)

79 The Conversion of St Paul (*detail of Plate 83*)

80 The Wedding Dance

Print, $14\frac{3}{4} \times 16\frac{7}{8}$ in. Rotterdam, Boymans-van Beuningen Museum.

Engraved by Pieter van der Heyden and published by Jerome Cock from 'Aux Quatre Vents', this print is closely related in design to the Detroit *Wedding Dance* of 1566. The rhyming Flemish verses exhort the musicians to play up and the couples to dance on; ruefully the last two lines lament:

> But our bride has already given up Dancing,
> And all for the best too, as she's full and sweet.

'Full and sweet' is a euphemism for pregnant.

81 The Peasant Dance

$44\frac{8}{8} \times 64\frac{5}{8}$ in. Signed: BRVEGEL. Vienna, Kunsthistorisches Museum.

Though neither are dated, both *The Peasant Dance* and *The Peasant Wedding* (Plate 85) were painted at about the same time, *c*. 1567. The sizes of the two panels are the same and they may well have been intended as pendants or as part of a series. They are the two outstanding examples of Bruegel's late style characterized by monumental Italian-derived figures.

There is another interpretation of a very similar subject, a *Wedding Dance* in the Museum at Detroit, dated 1566, which is now generally accepted as being from Bruegel's own hand. More crowded and consequently less forceful as a composition, it represents Bruegel's first thoughts on this subject.

Like *The Peasant Wedding*, the two versions of *The Peasant Dance* are not simply genre paintings but rather condemnations of the sin of lust. Other sins, too, are pictured: anger and gluttony are incarnated at the table on the left. The man seated next to the bagpipes wears in his hat, a peacock feather (clearly visible in Plate 1), symbol of vanity and pride.

The occasion for the revelry is a saint's day but the dancers turn their backs on the church and pay no attention to the image of the Virgin hung in the tree. The prominence of the tavern gives a better indication of their current priorities.

82 The Massacre of the Innocents
(*detail of Plate 61*)

83 The Conversion of St Paul

$42\frac{1}{2} \times 61\frac{3}{8}$ in. Signed and dated: BRVEGEL MDLXVII. Vienna, Kunsthistorisches Museum.

St Paul's conversion on the road to Damascus is told in the Acts of the Apostles, 9: 3–7: 'And as he journeyed, he came near Damascus: and suddenly there shined round about him a light from heaven: And he fell to the earth, and heard a voice saying unto him, Saul, Saul, why persecutest thou me? And he said, Who art thou, Lord? And the Lord said, I am Jesus whom thou persecutest . . . And he trembling and astonished said, Lord, what wilt thou have me to do? And the Lord said unto him, Arise, and go into the city, and it shall be told thee what thou must do. And the men which journeyed with him stood speechless, hearing a voice, but seeing no man.'

Bruegel's representation of the scene in a mountainous setting may have been suggested by Lucas van Leyden's engraving of 1509. As in *The Sermon of St John* the placing of the central figure in the middle distance, almost lost in a group of other small figures and the concentration upon the large foreground figures are familiar mannerist compositional devices.

The picture is not only the telling of a biblical story which illustrates the need for faith but also an example of the sin of pride.

84 The Sermon of St John the Baptist

$37\frac{3}{8} \times 63\frac{1}{4}$ in. Signed and dated: BRVEGEL MDLXVI. Budapest, Museum of Fine Arts.

The subject is quite familiar in Flemish art but Bruegel's interpretation is novel. Compositionally—with the most important figures, St John and Christ, placed in the middle distance and almost lost among the crowd—it follows mannerist precedents. By contrast, the foreground figures, members of the crowd, are treated in detail. Among these figures is the head of a gentleman, which would seem to be—exceptionally in Bruegel's work—a portrait, having his fortune read by a gipsy.

The preaching would certainly seem to refer to the open-air sermons held by the Reformed Communities. St John is specifically represented as the precursor of Christ whom he points out in the crowd. Fortune-telling was generally condemned in the Netherlands and particularly railed against by Calvin. The conspicuous placing of the gentleman in the foreground with his back turned on the main scene may indicate his rejection of Calvinism, but the precise meaning of the picture remains unclear.

85 The Peasant Wedding

$44\frac{7}{8} \times 64\frac{1}{8}$ in. Neither signed nor dated. Vienna, Kunsthistorisches Museum.

A strip along the bottom of the panel is a later addition, probably replacing a lost strip which contained the signature and date. Painted about 1567, this picture has traditionally been considered simply as a genre painting, a representation of a peasant celebration. However, with our increasing knowledge of the symbolic content of much sixteenth century northern painting, it would seem more likely to be a condemnation of the sin of gluttony. The celebration of the sacrament of marriage has become simply an excuse for self-indulgence. Whereas in his earlier, engraved, work Bruegel represented the vices as elaborate allegories peopled by Bosch-derived

figures, in these late pictures they are condemned in more naturalistic guise. The man pouring out wine in the left foreground (Plate 78), the beautiful still life of empty wine jugs, and the greedy child emphasize gluttony as the theme of the picture.

A perennial problem of this, the most popular of all Bruegel's panels, is the identity of the bridegroom. The wedding is dominated by the bride who, radiant and composed, presides over her table beneath a canopy. The bridegroom would seem to be the figure in black, with his back to the spectator, leaning back on his stool with a mug in his hand. A curious detail of the picture is the presence on the far right hand side of a richly-dressed nobleman apparently being blessed by a monk.

86 The Gloomy Day (February)
(detail of Plate 67)

87 The Sermon of St John the Baptist
(detail of Plate 84)

88 The Peasant Dance *(detail of Plate 81)*

89 The Peasant Wedding *(detail of Plate 85)*

90 The Peasant Wedding *(detail of Plate 85)*

91 The Peasant Dance *(detail of Plate 81)*

92 The Parable of the Blind

Canvas, $33\frac{7}{8} \times 60\frac{5}{8}$ in. Signed and dated: BRVEGEL MDLXVIII. Naples, Museo Nazionale.

This late tragic work illustrates the words of St Matthew's gospel 15: 14: 'If the blind lead the blind, both shall fall into the ditch.' In the parable Christ was giving readily appreciable physical form to a spiritual condition, an inner blindness to true religion. In the same way Bruegel gives expression to this idea in a heart-rending image. The staggering line of the six blind men reaches an agonizing climax in the expression of the second who is falling. It is contrasted to the solidity and strength of the church behind them, representing the faith which gives true vision. Once again in another of the late works Bruegel gives a particular and realistic interpretation to a Christian moral. The blind fascinated Bruegel; he introduced a group into *Carnival and Lent* (Plate 3) of 1559. A drawing in Berlin dated 1562 shows three blind people, and inventory references to lost paintings and copies after them confirm this fascination. The subject was treated by Bosch who depicted two blind men, but compositionally this picture—with the frieze-like procession of large figures, belongs to the late group which show Bruegel's interest in Italianate models.

93 The Peasant and the Birdnester

$23\frac{1}{4} \times 26\frac{3}{4}$ in. Signed and dated: BRVEGEL MDLXVIII (the signature and date have been strengthened). Vienna, Kunsthistorisches Museum.

This curious subject has been explained as an illustration of the Netherlandish proverb: 'He who knows where the nest is, has the knowledge: he who robs it, has the nest.' More elaborately, it has been interpreted as a moralizing contrast between the active, wicked person and the passive man who is virtuous in spite of adversity. The

monumental figure drawing of *The Land of Cockaigne, The Peasant Dance* and *The Peasant Wedding* is skilfully evident here. As has been pointed out, it undoubtedly reflects Bruegel's study of Michelangelo. The gesture of the peasant may be seen as a profane parody of the gesture of Leonardo's St John. The great technical skill of this late picture combined with the brilliantly successful placing of the figures in landscape makes this panel one of Bruegel's greatest works.

94 The Magpie on the Gallows

$18\frac{1}{8} \times 20$ in. Signed and dated: BRVEGEL 1568. Darmstadt, Hessisches Landesmuseum.

This picture is mentioned in van Mander's life of Bruegel: 'In his will he bequeathed to his wife a painting of a magpie on the gallows. By the magpie he meant the gossips whom he would deliver to the gallows.' On the basis of this reference the picture has been thought to represent the idea that harmful gossip brings people to the gallows, particularly spiteful accusations of heresy, so common in the religious conflicts of the day, which caused unnecessary death and suffering. This explanation does not, however, account for a number of features of the picture, particularly the gaiety of the peasants' dance and the beauty of the sunlit landscape. Perhaps, more simply, it refers to the transience of pleasure, the threat of death that hangs over all mortals. Most of the late works are dominated by large figures. However in this picture and in the unfinished *Storm at Sea* (Plate 95) he is concerned to render atmosphere, landscape and sunlight.

95 Storm at Sea

$27\frac{5}{8} \times 38\frac{1}{4}$ in. Unfinished; neither signed nor dated. Vienna, Kunsthistorisches Museum.

There has been some doubt in the past whether this uncharacteristic picture is actually by Bruegel and an alternative attribution to Joos de Momper has been proposed. But though related in manner, it is far superior to any known work by Momper. Its similarity to the drawing in Count Seilern's collection (Plate 65) and the subtlety of both the conception and the execution have convinced most scholars that it was Bruegel's last work, probably left unfinished at his death.

It has been interpreted by reference to the text: 'If the whale plays with the barrel that has been thrown to him and gives the ship time to escape, then he represents the man who misses the true good for the sake of futile trifles.' This explanation is substantiated by the church (top left) which stands as a place of safety amid the storms of life. In this sense the storm may be likened to the difficulties of life, the dangers and temptations which fill it and the casting over the side of the barrel to the abandonment of material possessions in order to gain salvation.

96 The Misanthrope

Canvas, $33\frac{7}{8} \times 33\frac{1}{2}$ in. Signed and dated in the painted frame: BRVEGEL 1568. Naples, Museo Nazionale.

The Flemish inscription at the bottom reads: 'Because the world is perfidious, I am going into mourning.' The moral, however, is that if one is occupied with worldly matters it is impossible to cut oneself off and avoid the world's treachery. The misanthrope's mourning robe does not fend off the world's evil, he is being robbed by the world he has relinquished in the form of a small figure in a glass ball, symbol of vanity. This figure also occurs in *The Netherlandish Proverbs* (Plate 11), foreground bottom right. The hooded misanthrope is walking towards the mantraps set for him by the world. This man, who is trying to renounce the world of which he remains a part is not free from sin: he hides a purse beneath his monastic cowl and is therefore guilty of covetousness. By contrast the shepherd in the background, guarding his sheep, is far more virtuous than the would-be reformed man of the world.

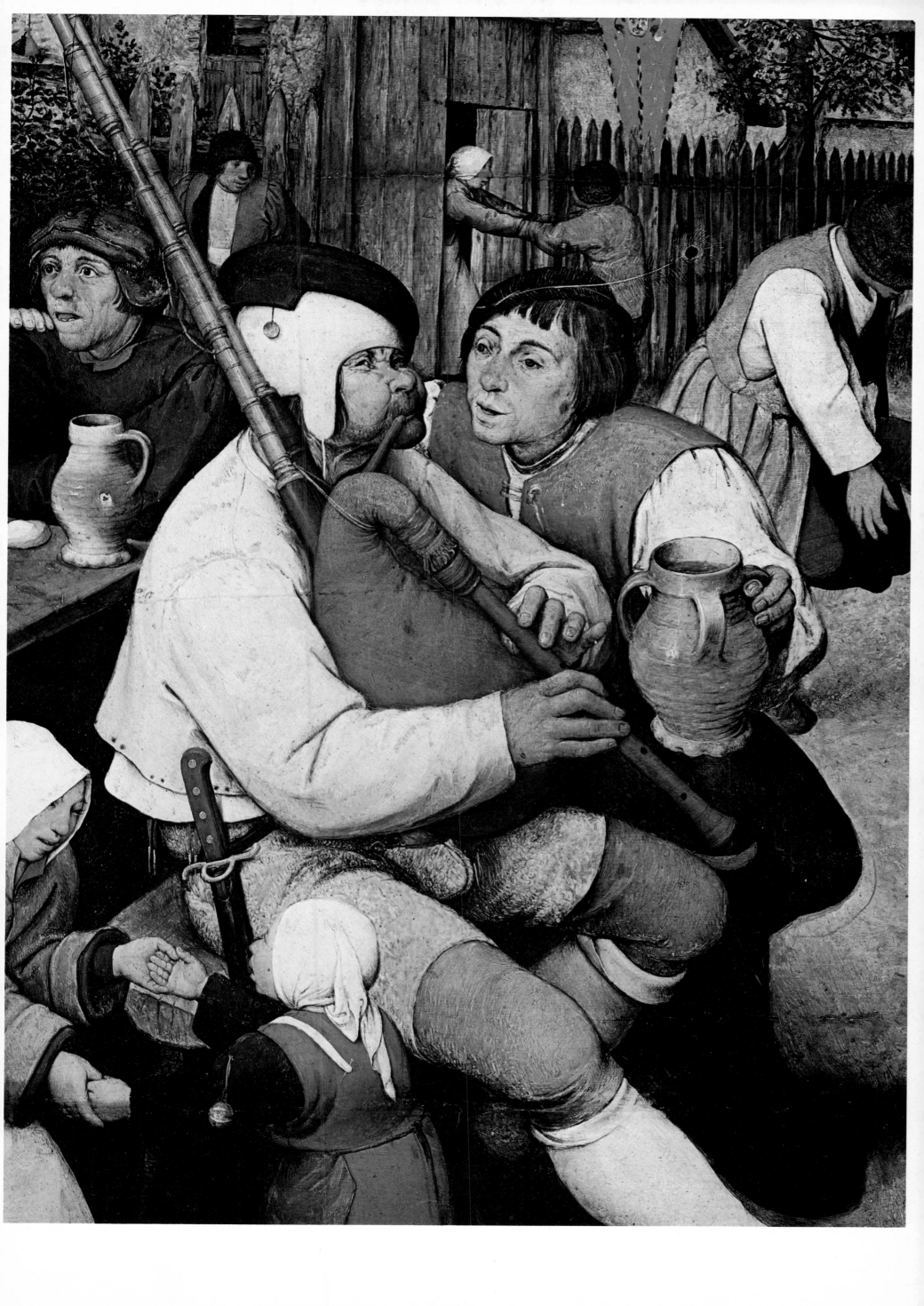

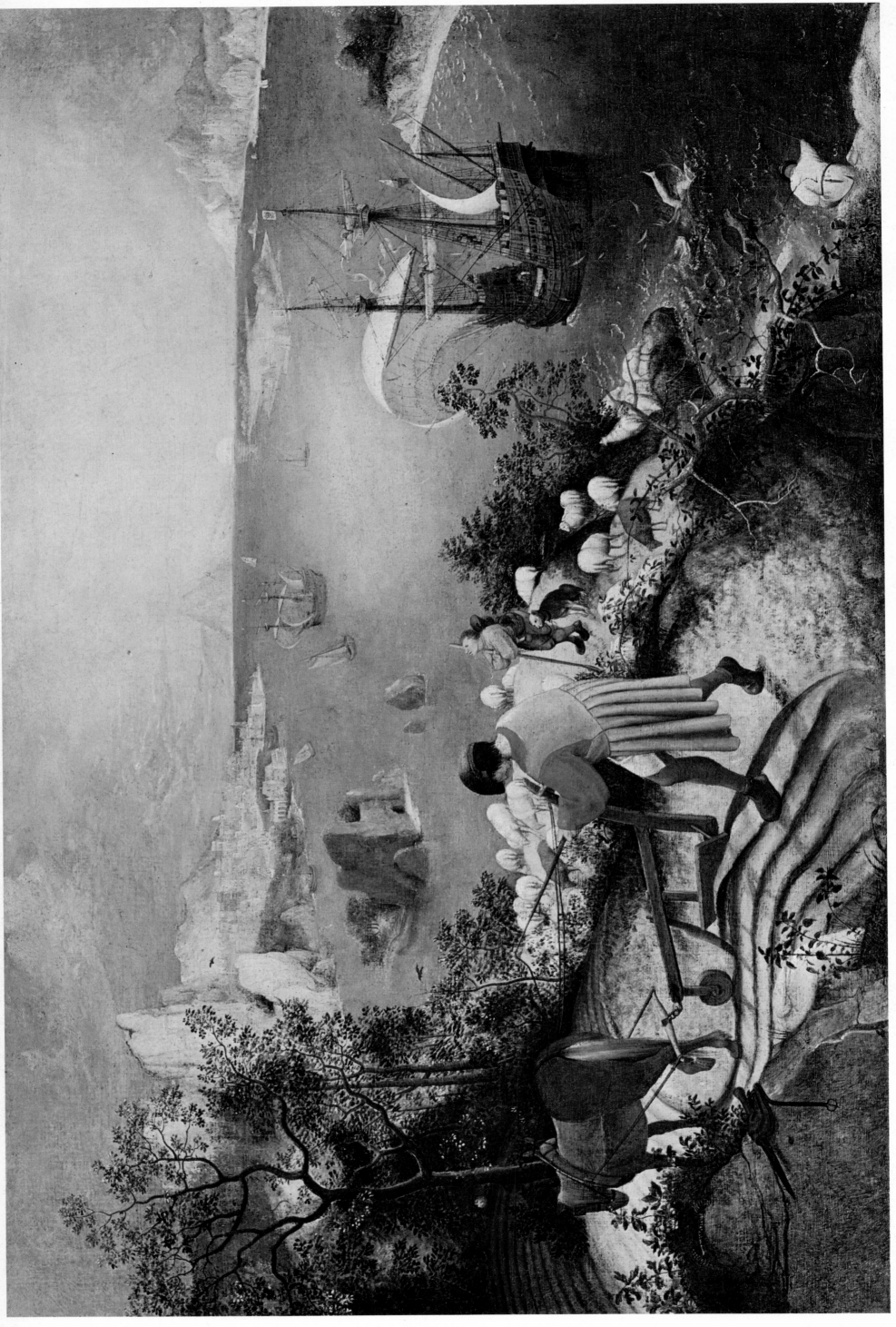

2

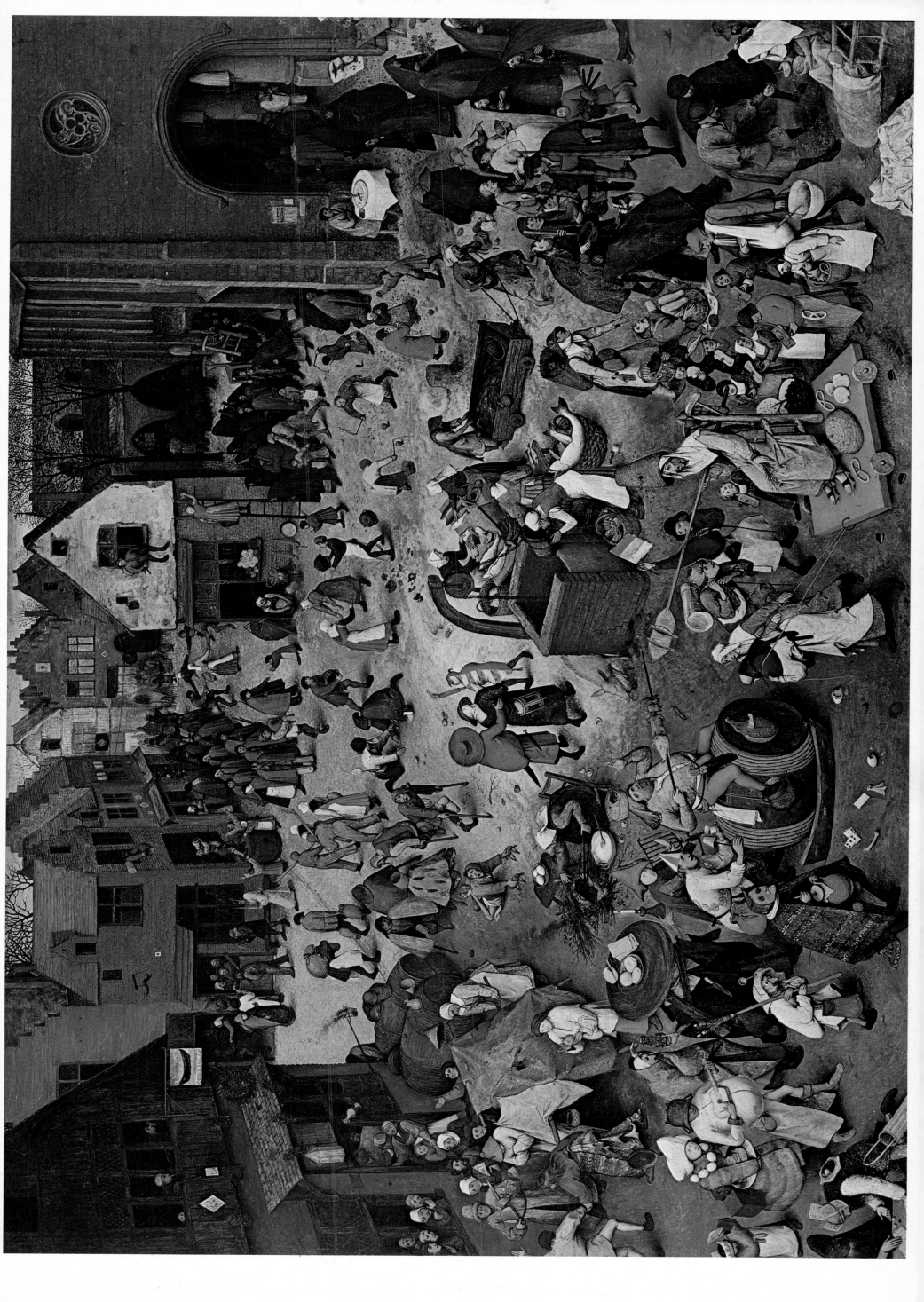

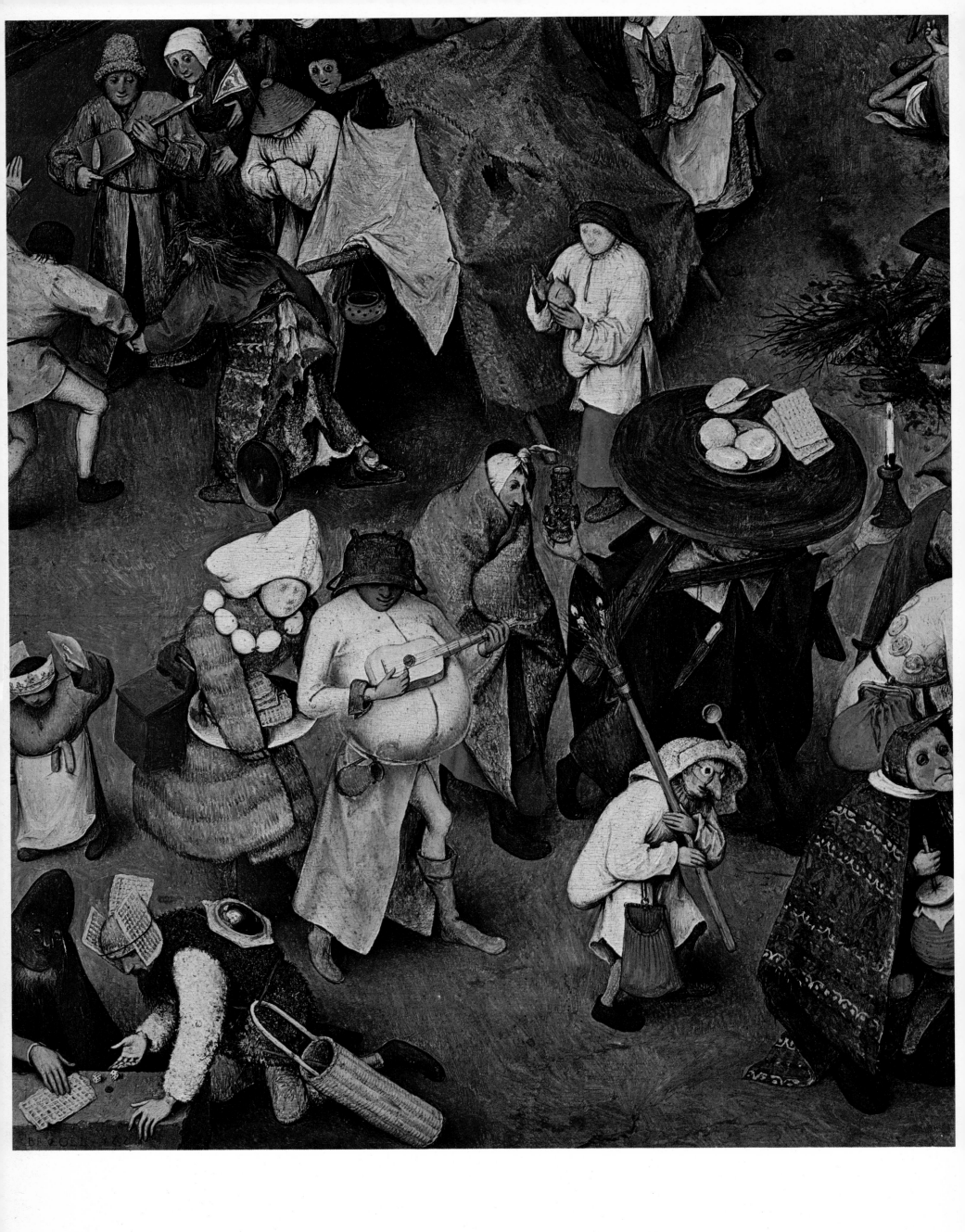

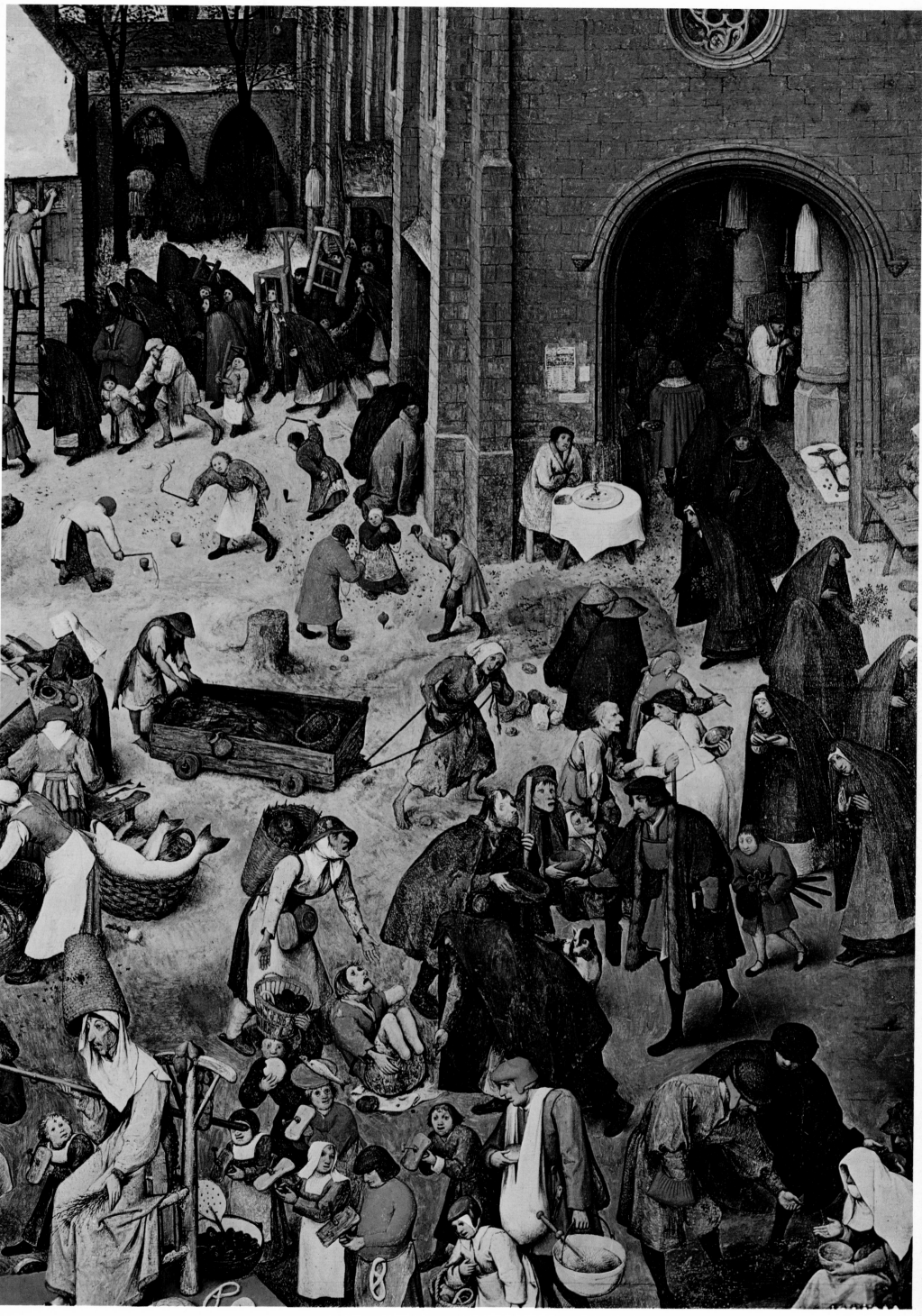

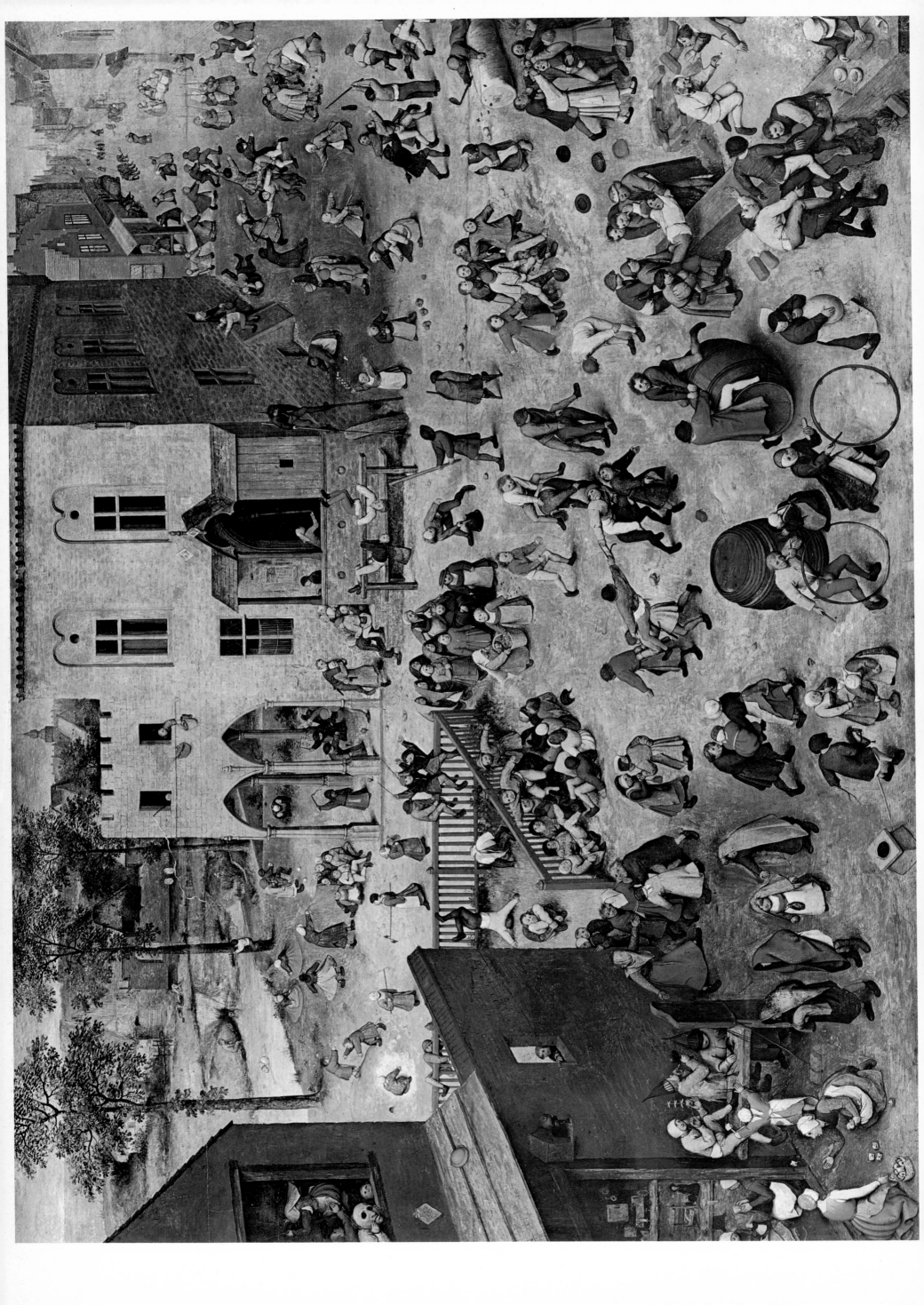

6

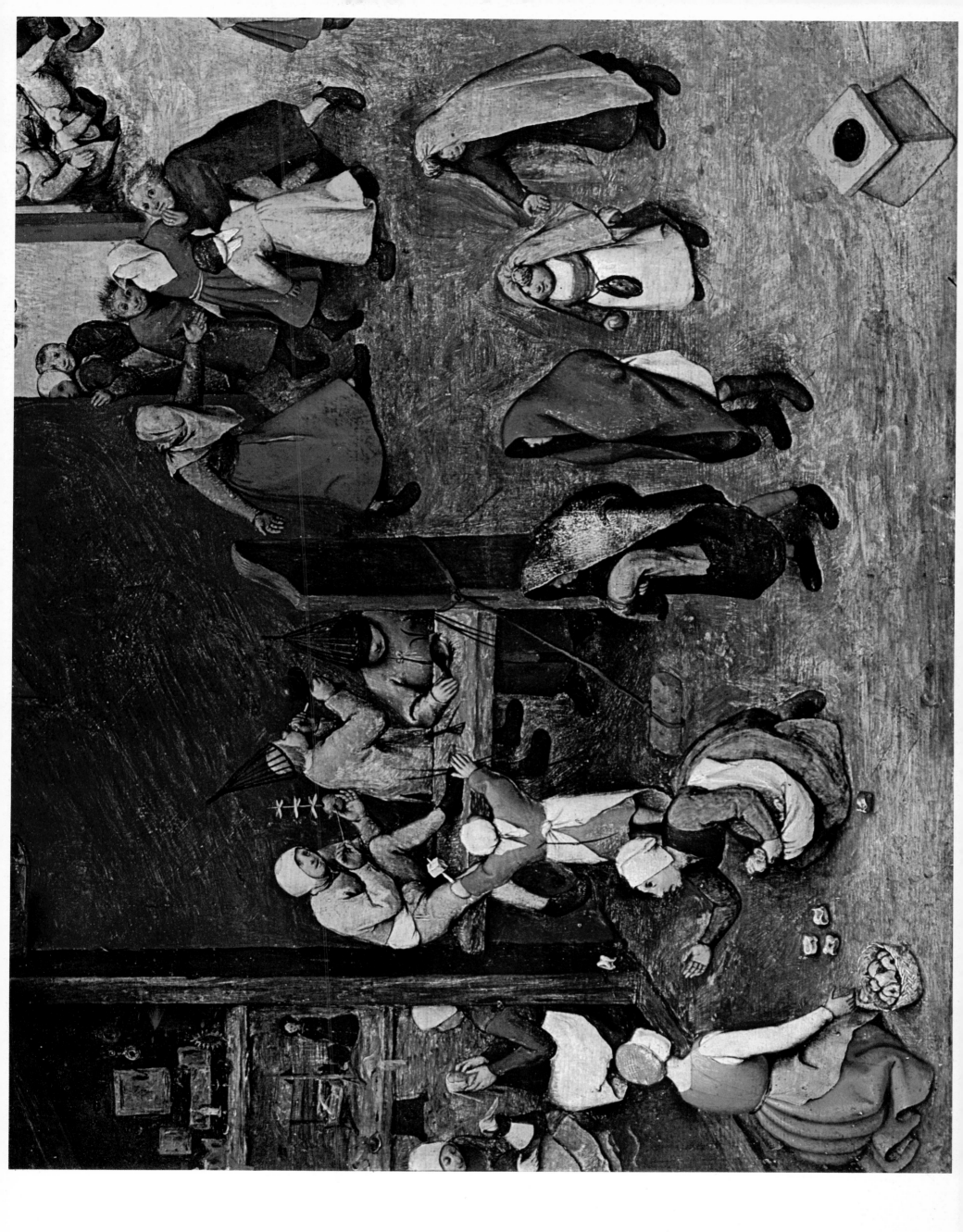

7

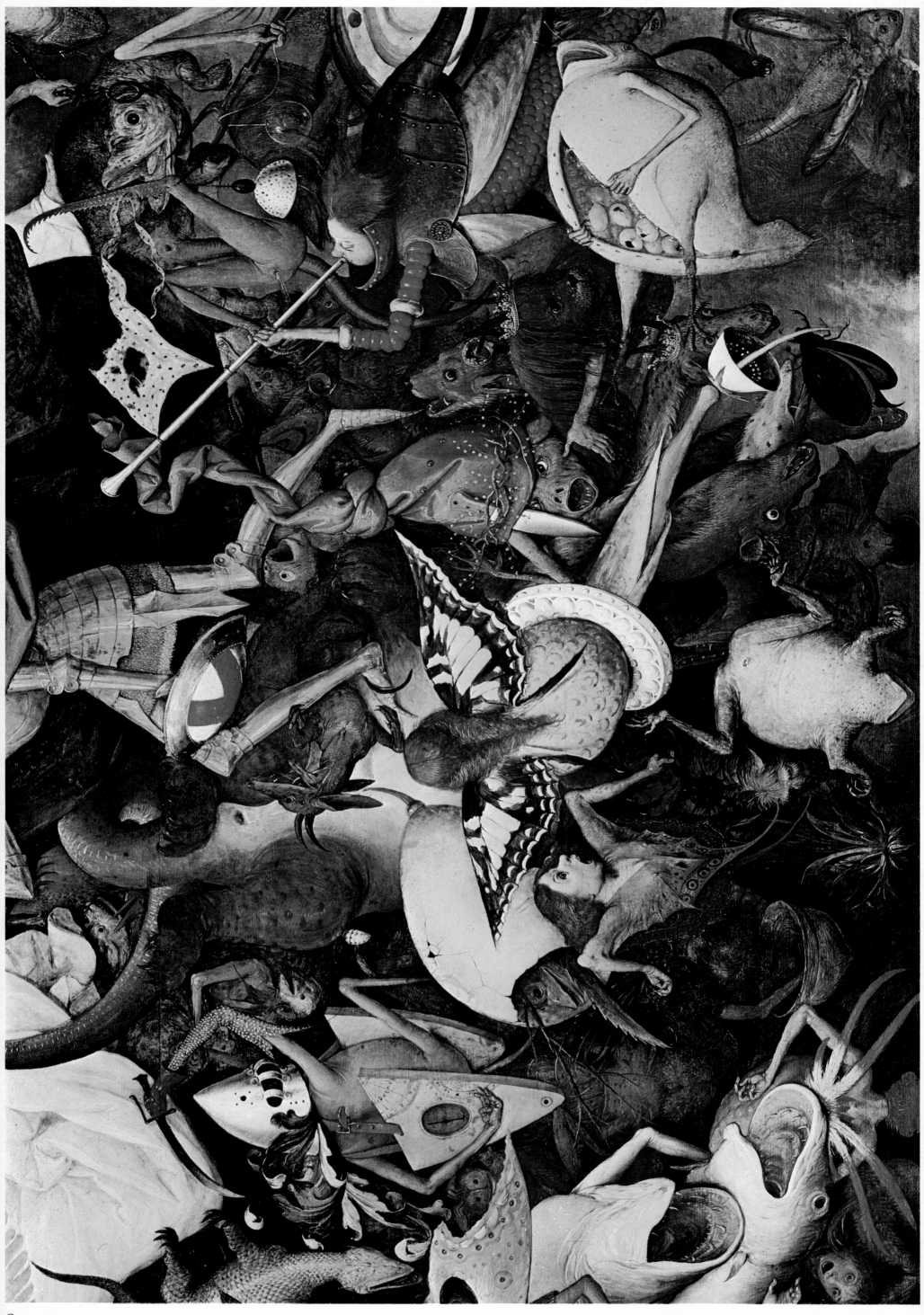

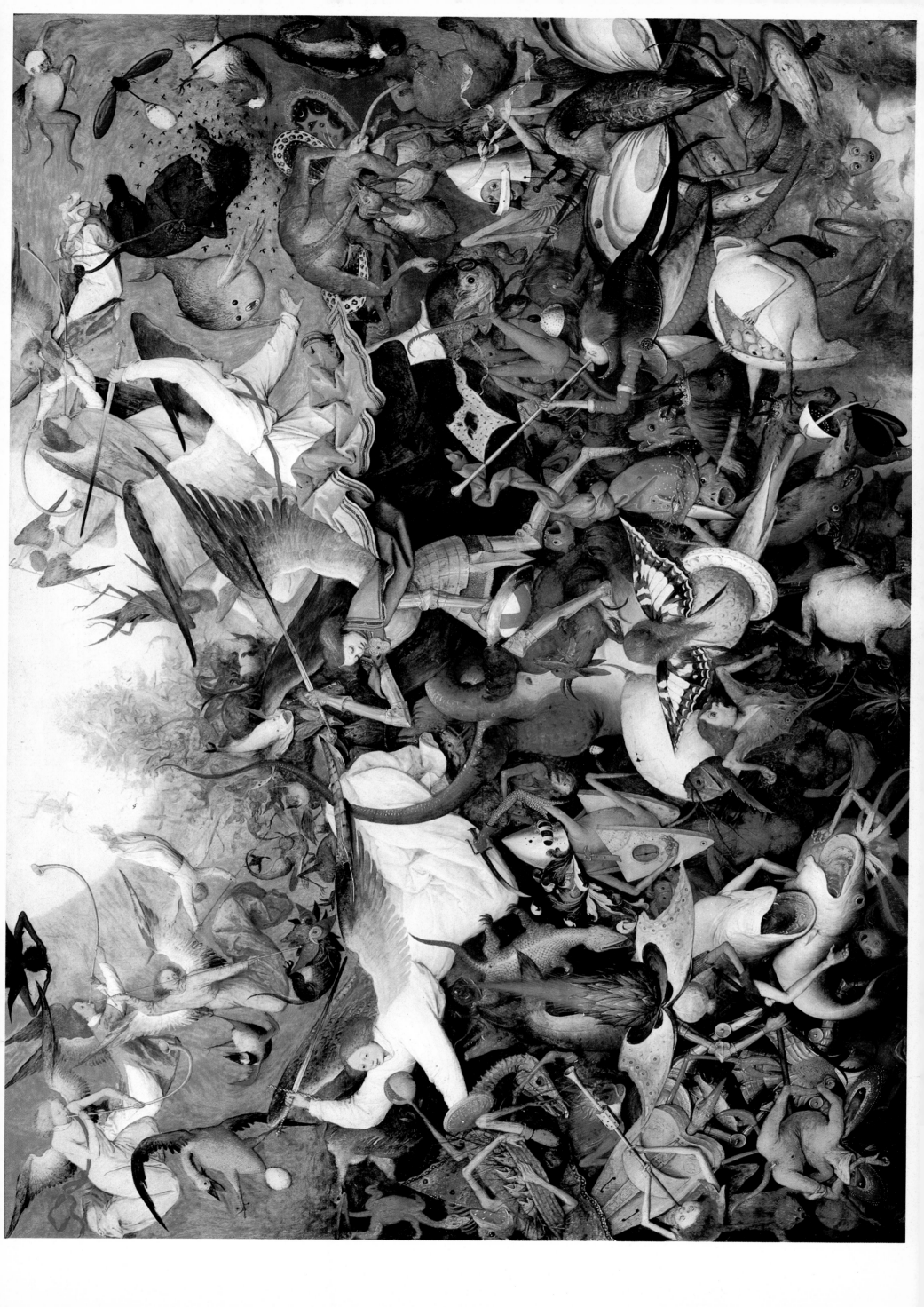

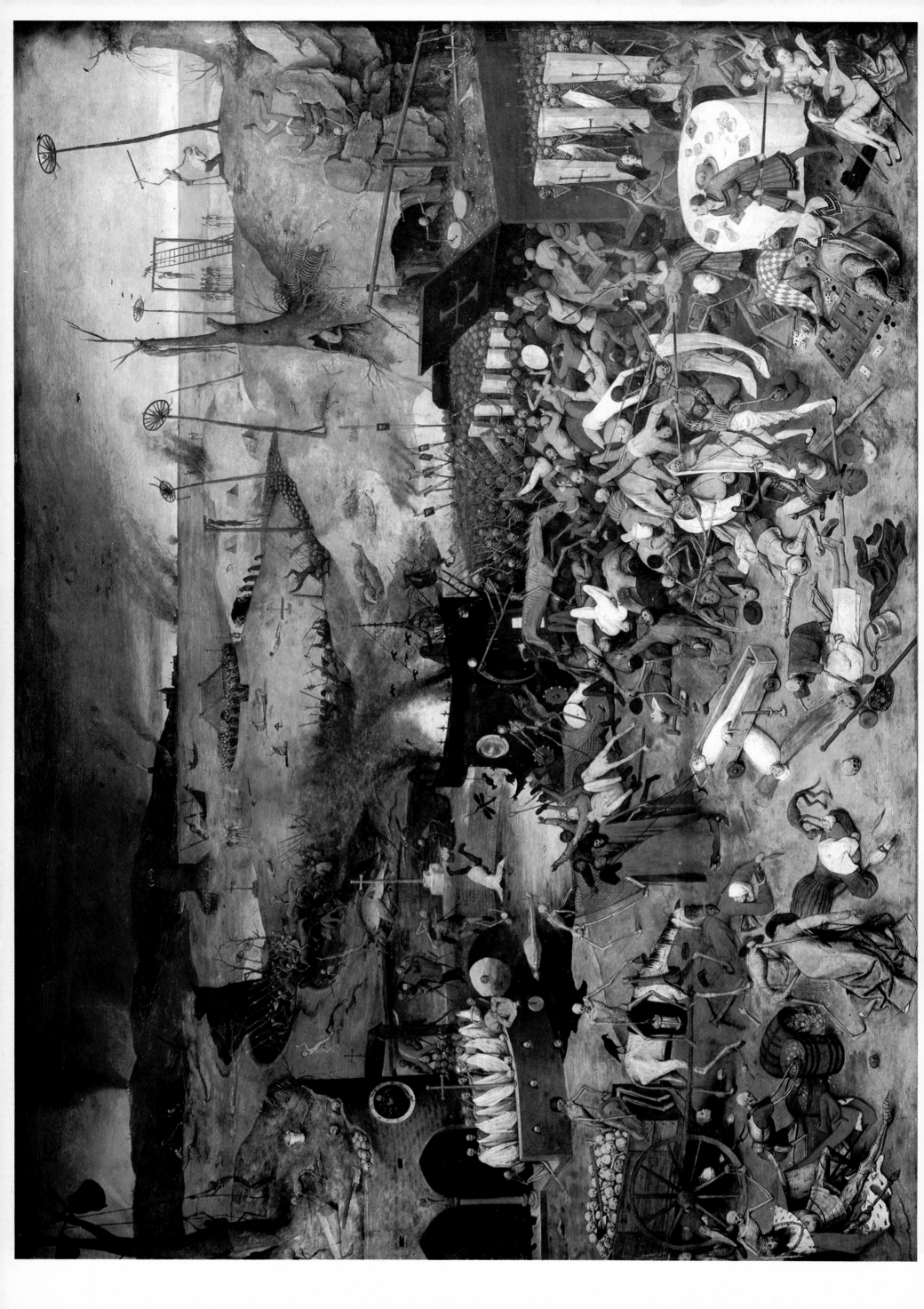

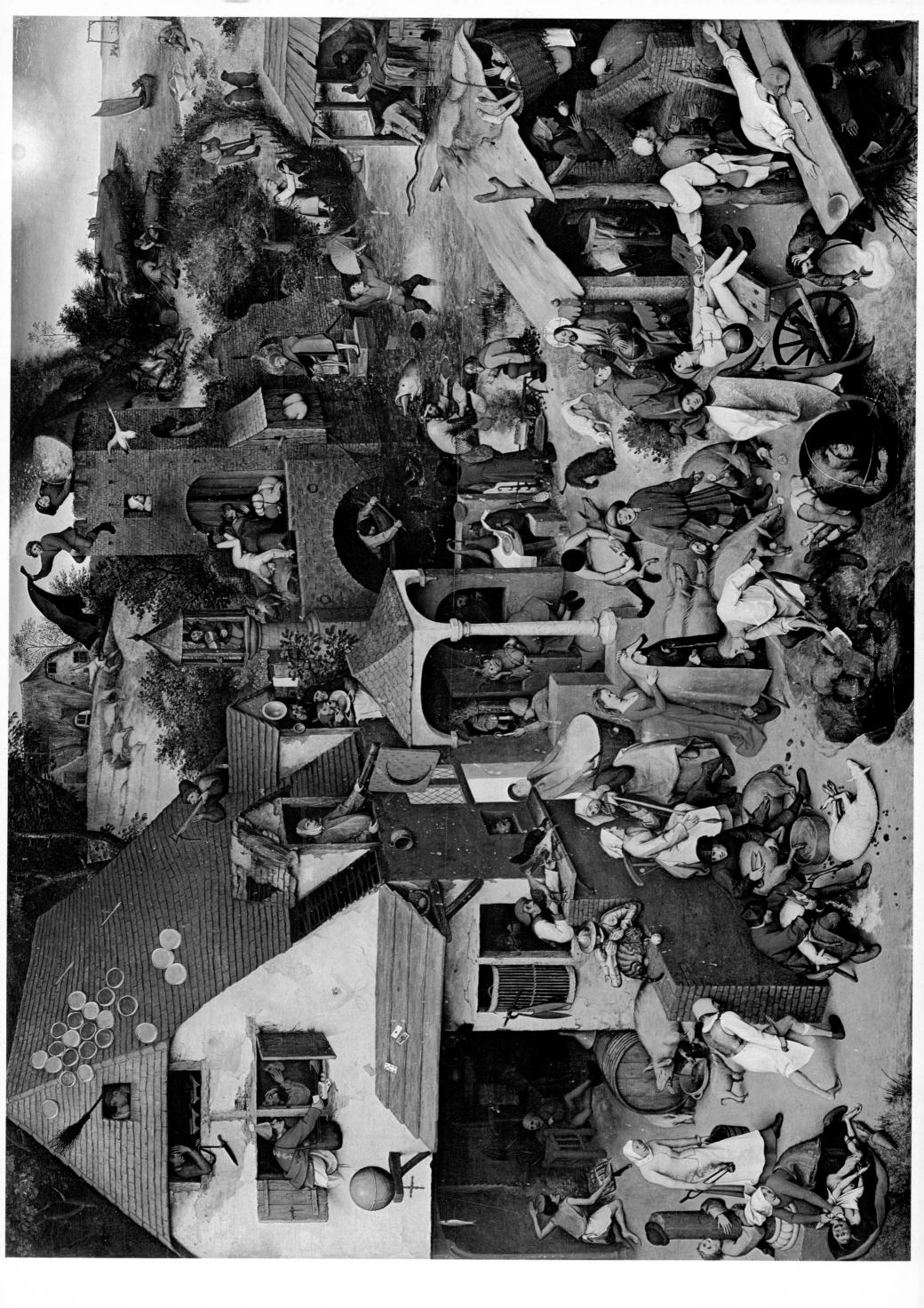

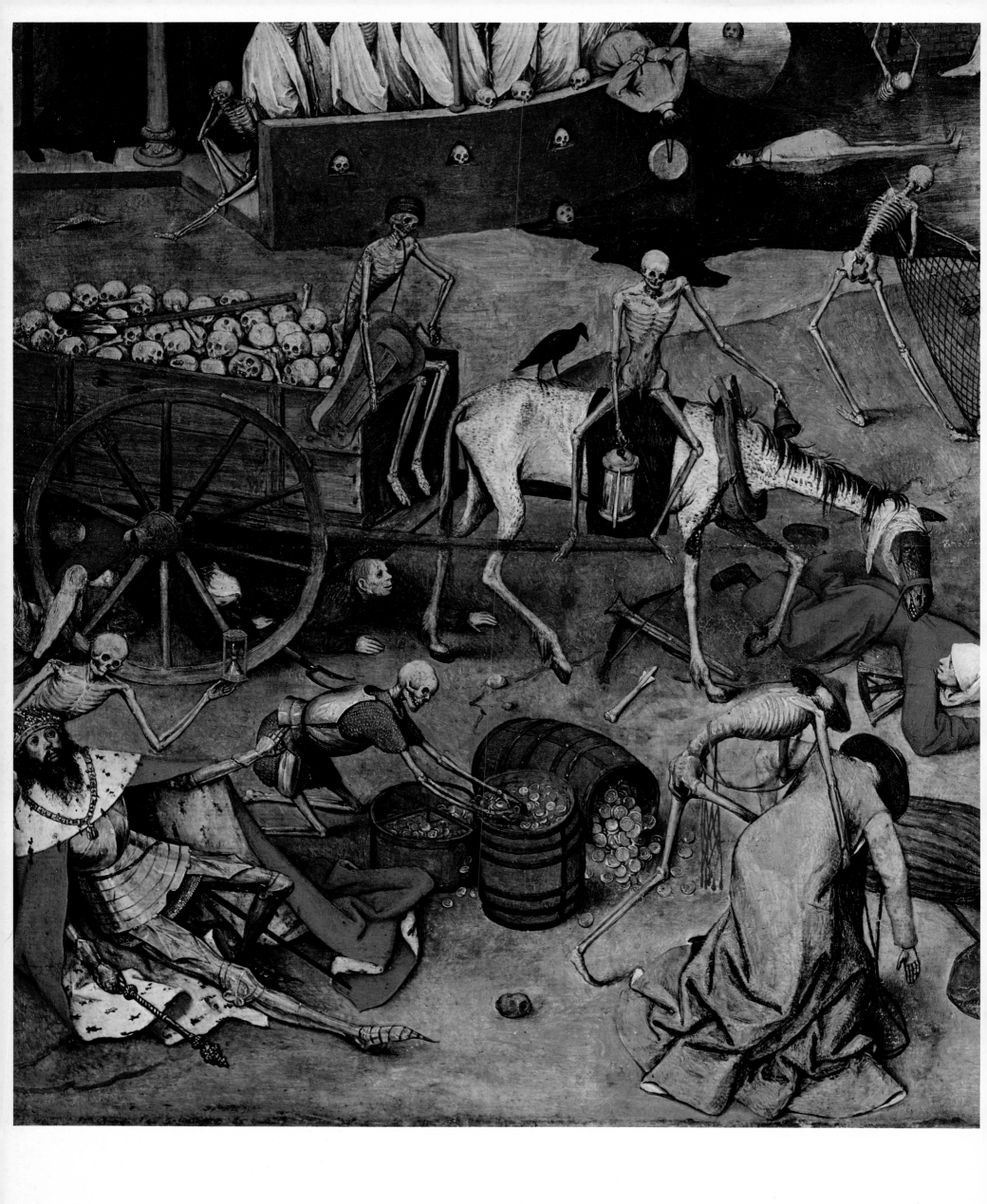

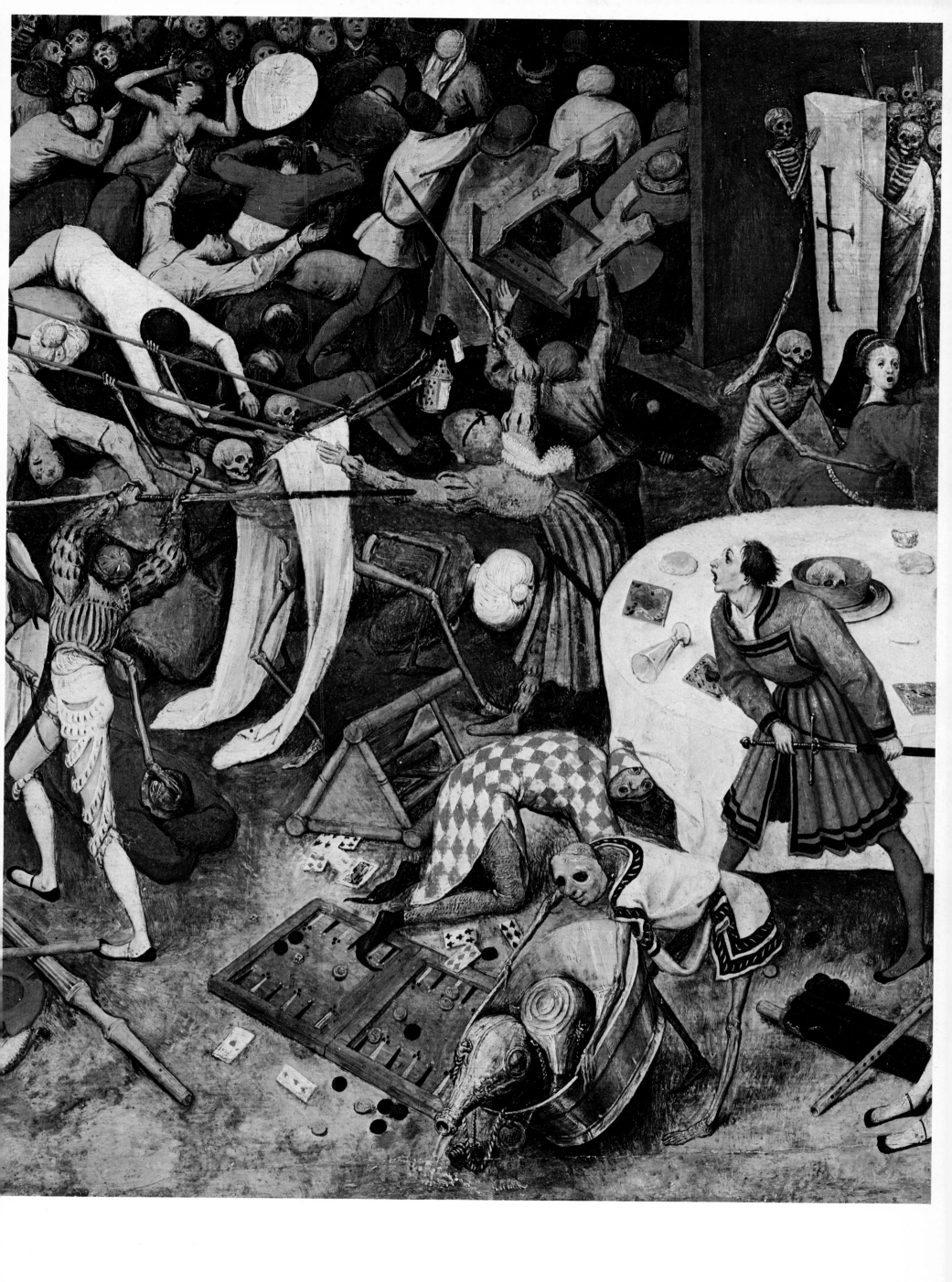

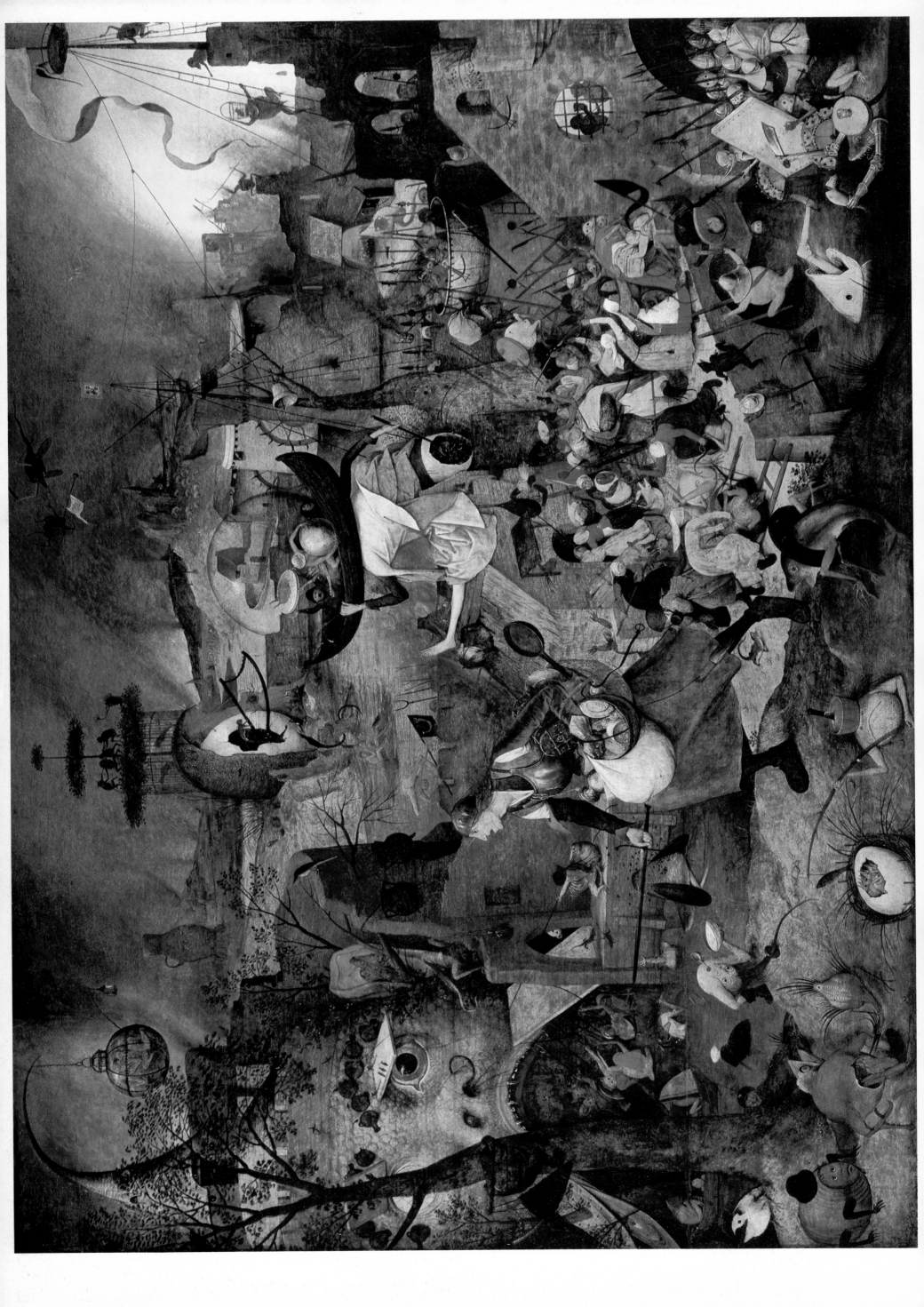

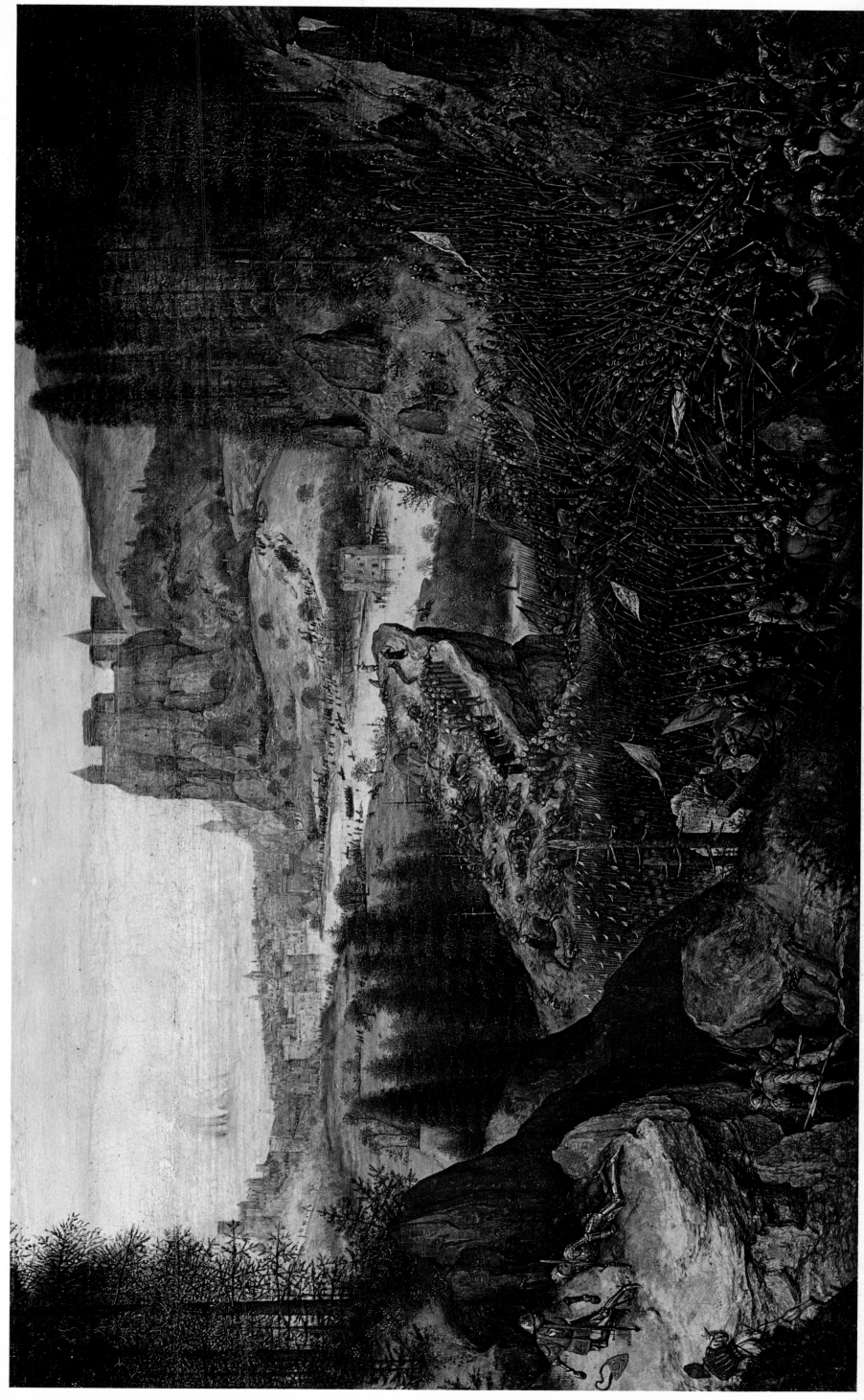

15

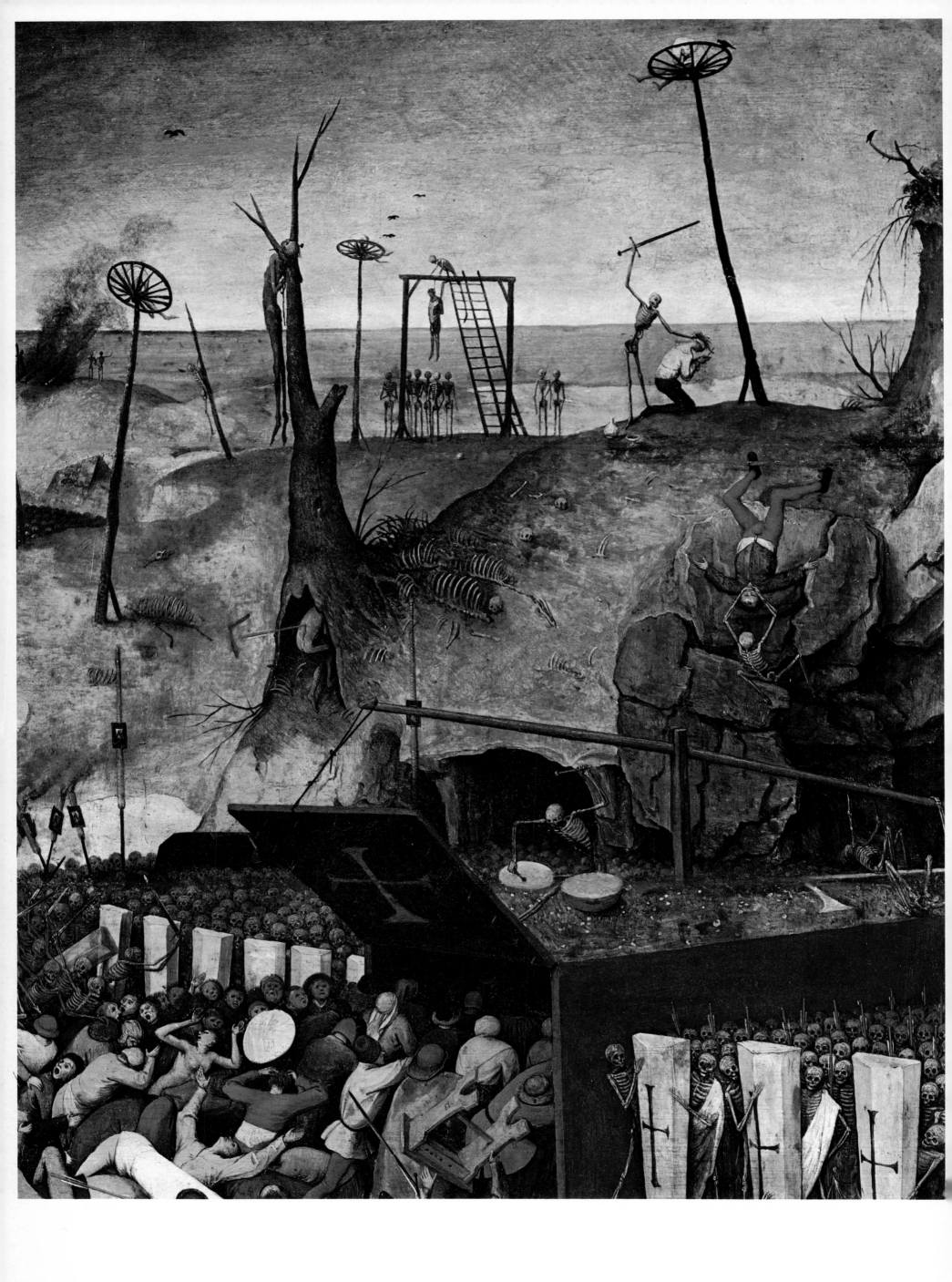

16

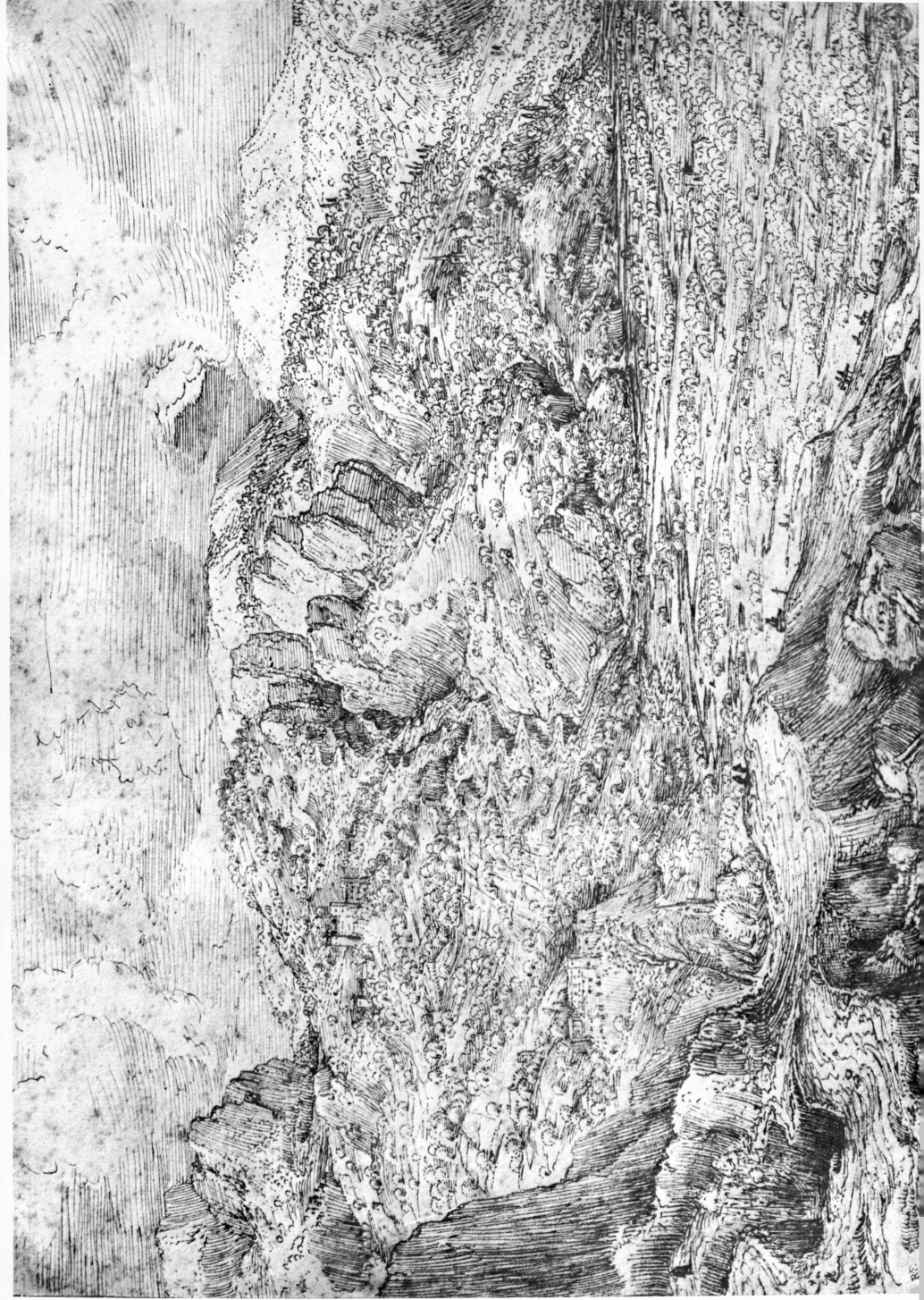

18

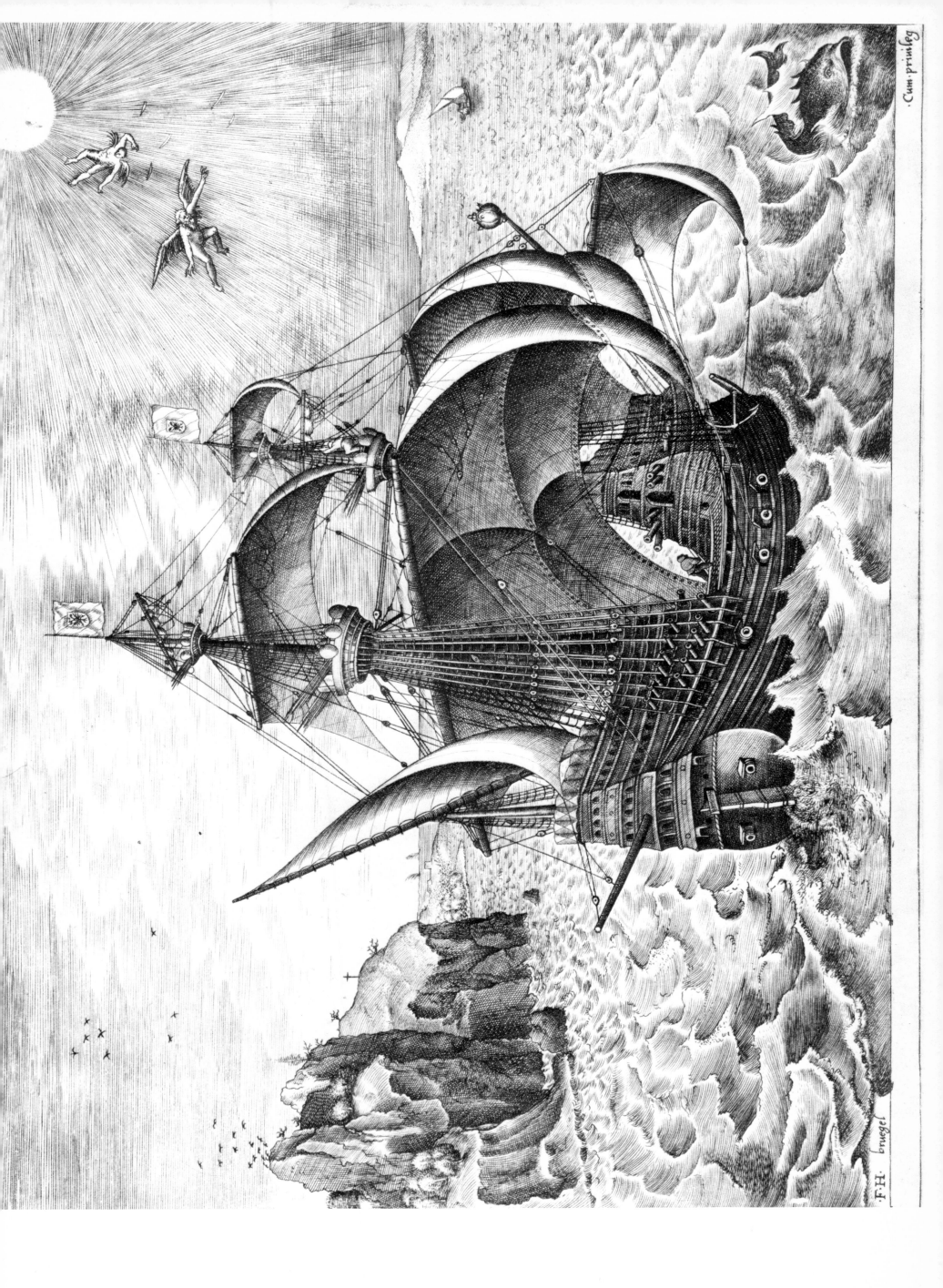

·F·H· brugel

·Cum·priuileg·

19

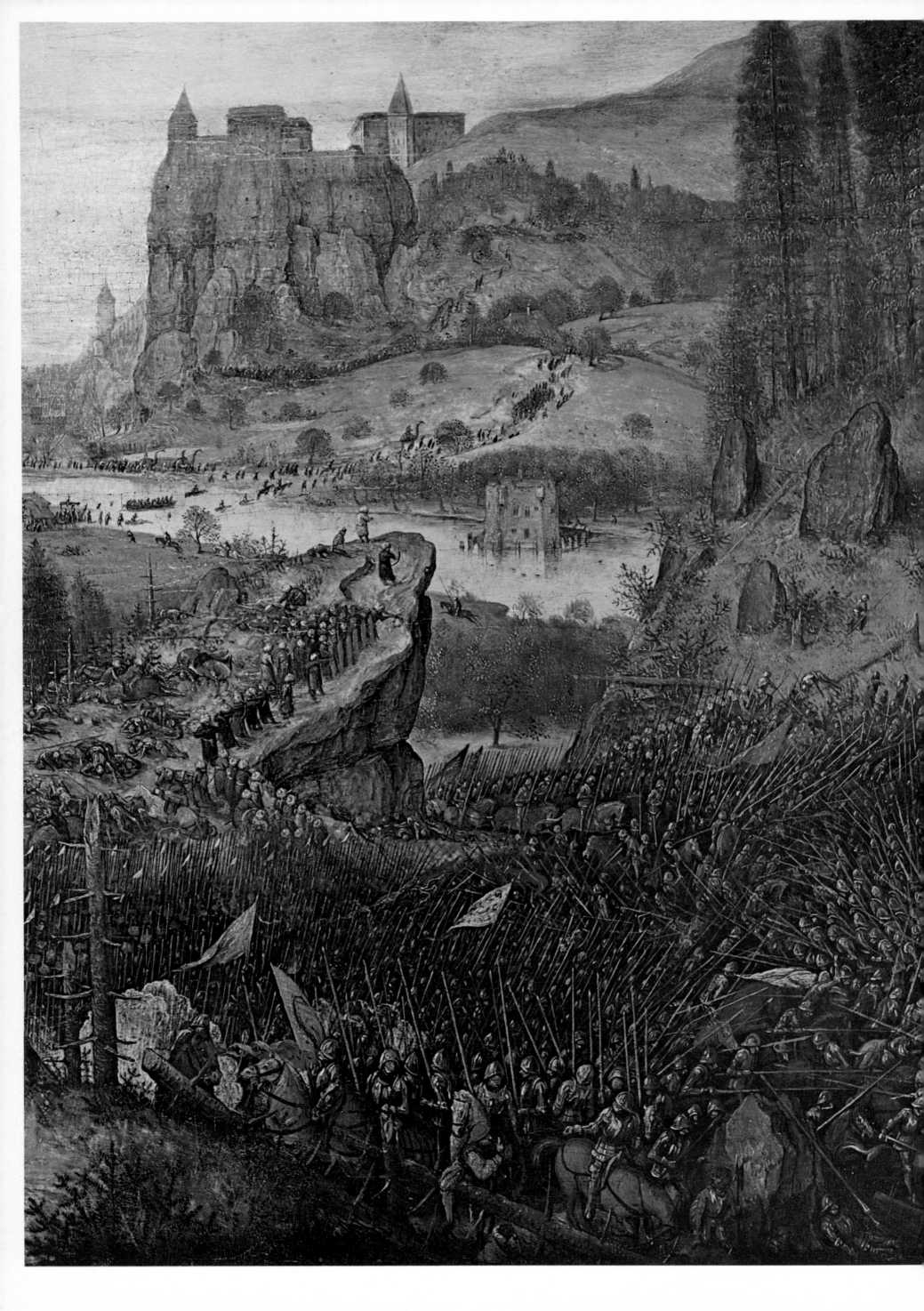

20

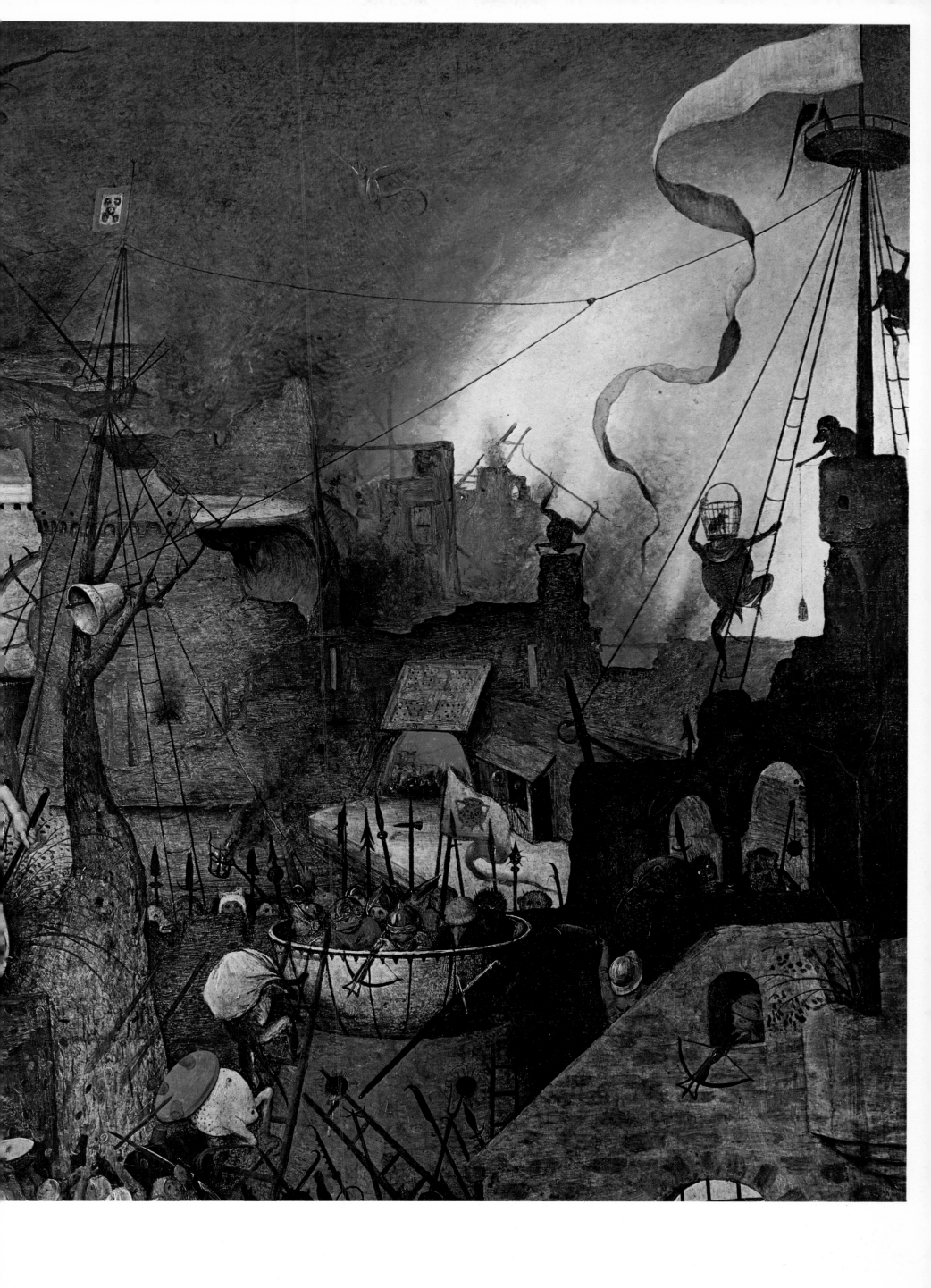

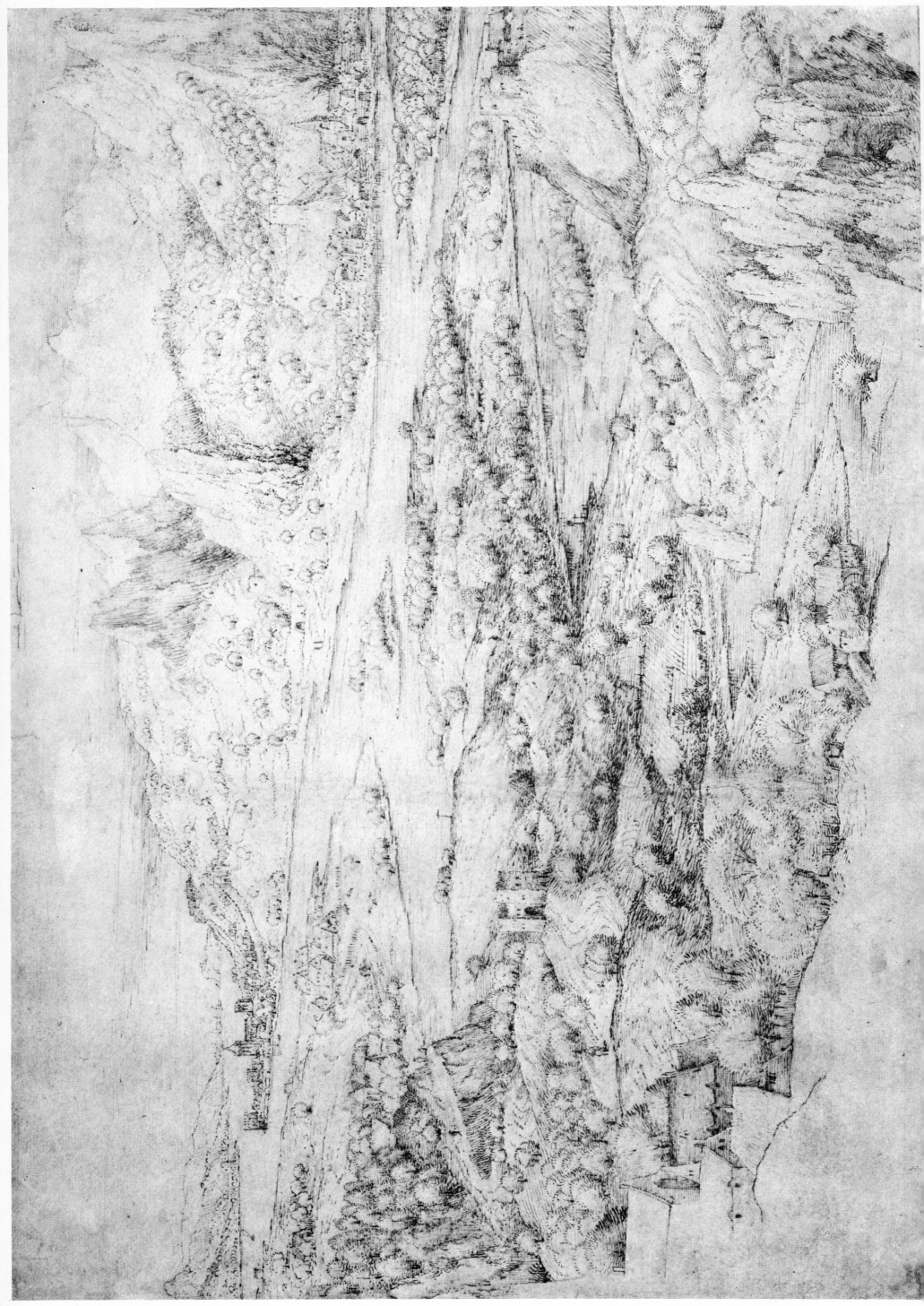

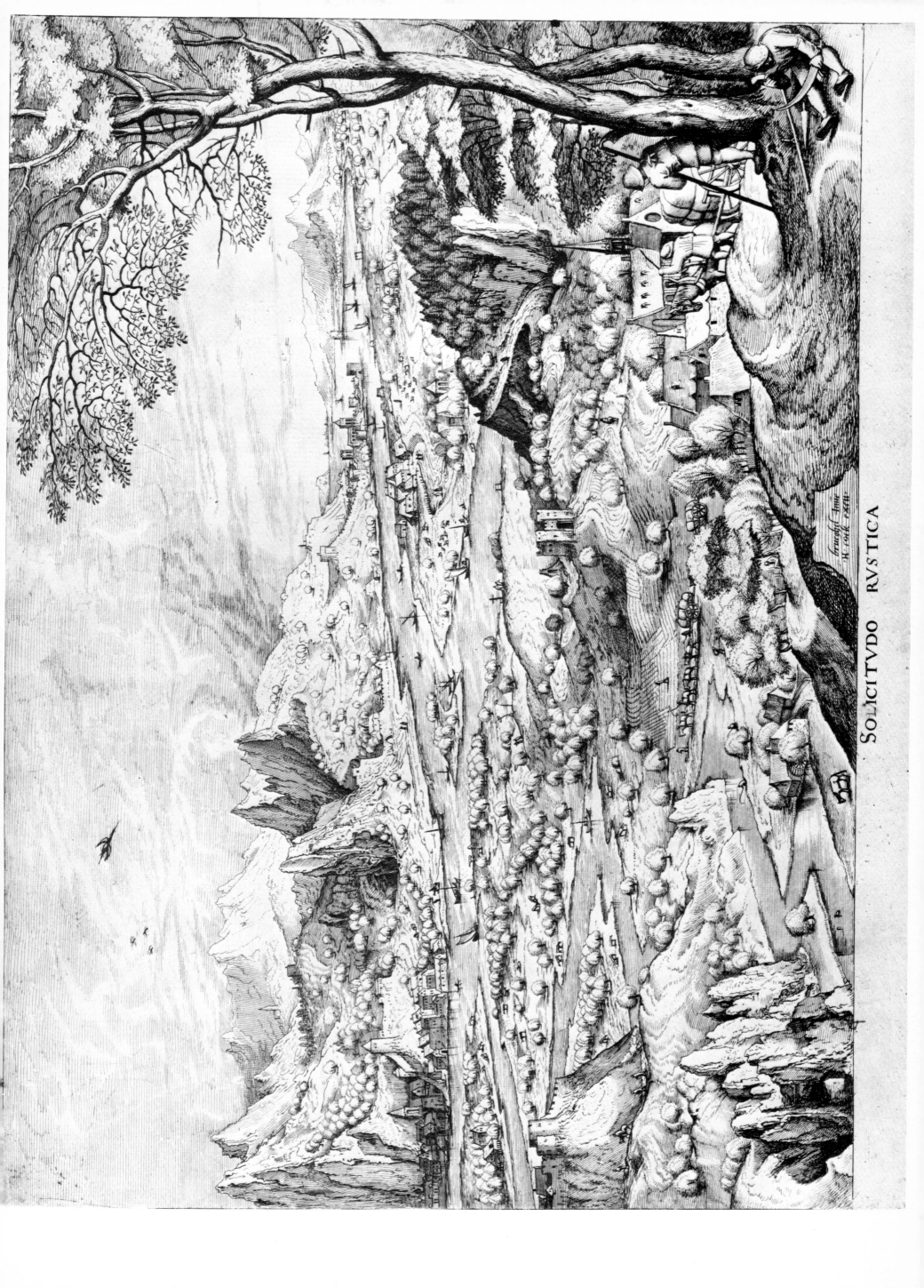

SOLICITVDO RVSTICA

bruegel Inue H. cock excu

23

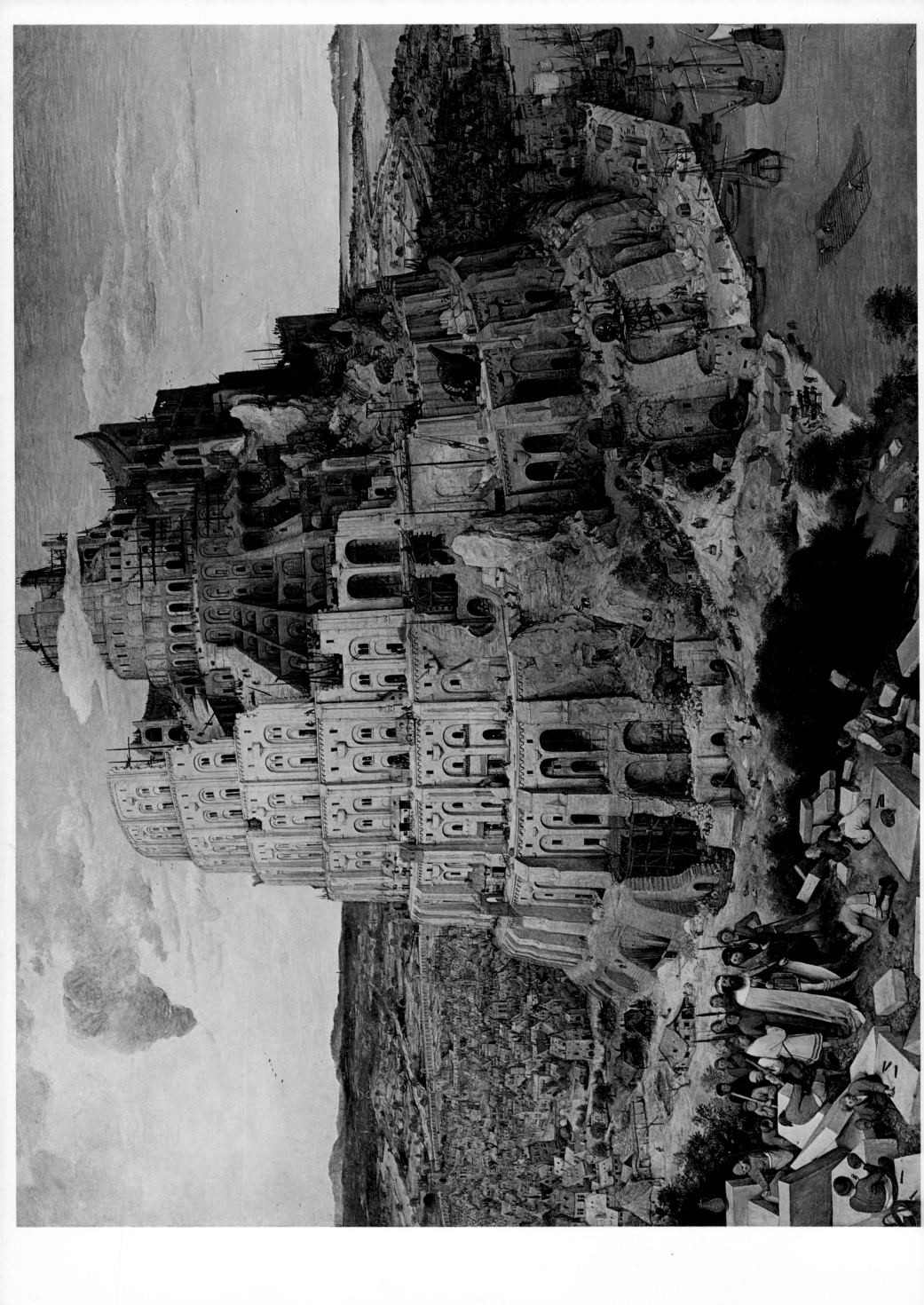

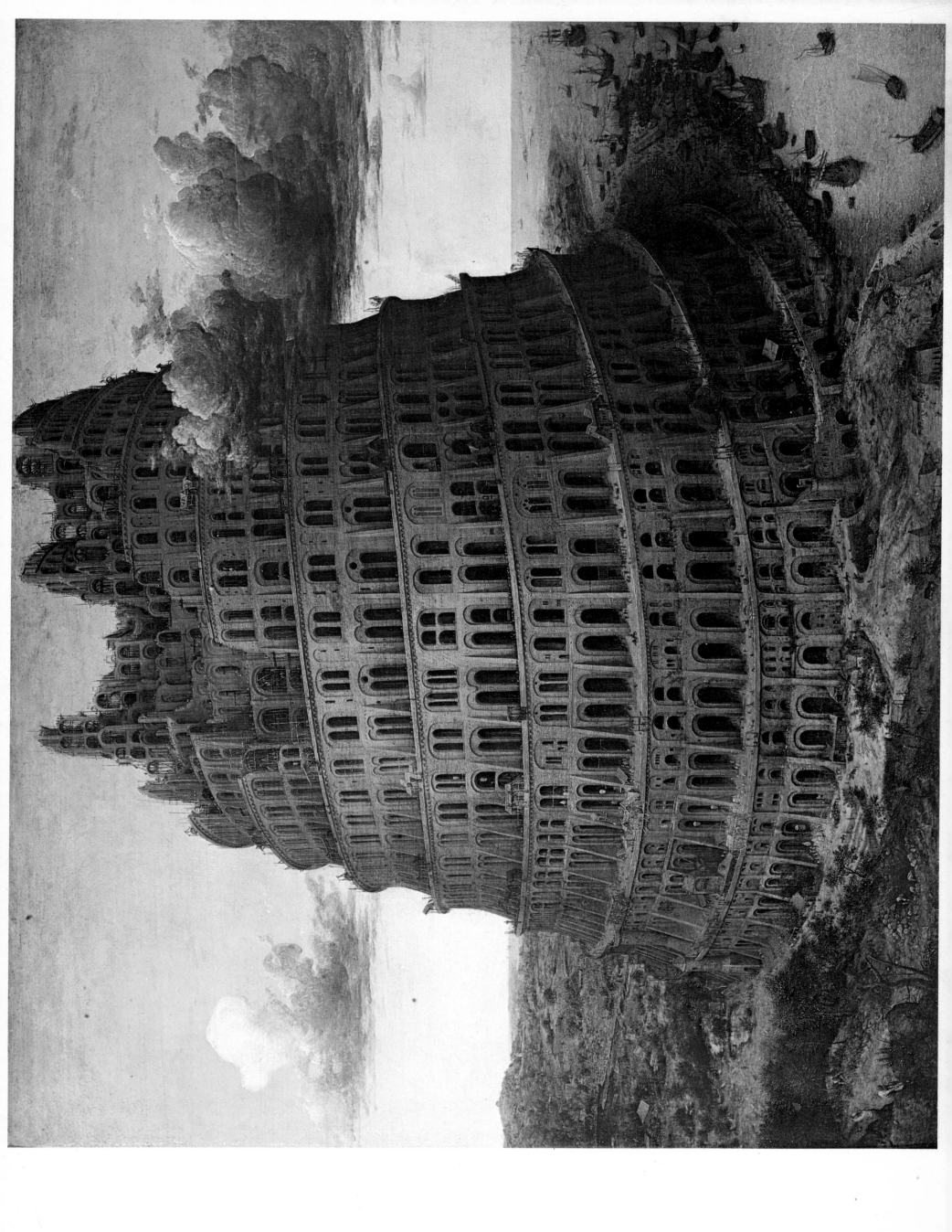

25

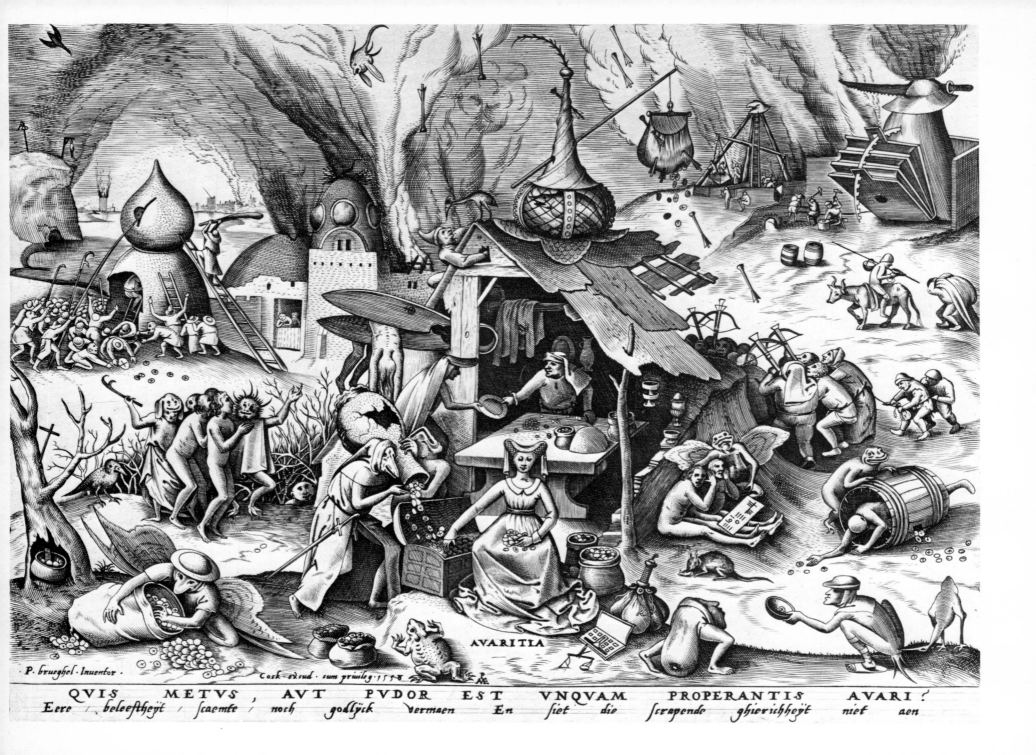

P. brueghel. Inuentor. Cock exud. cum priuileg. 1558

QVIS METVS, AVT PVDOR EST VNQVAM PROPERANTIS AVARI?
Eere / beleeftheyt / scaemte / noch godlijck vermaen En siet die scrapende ghierichheyt niet aen

AVARITIA

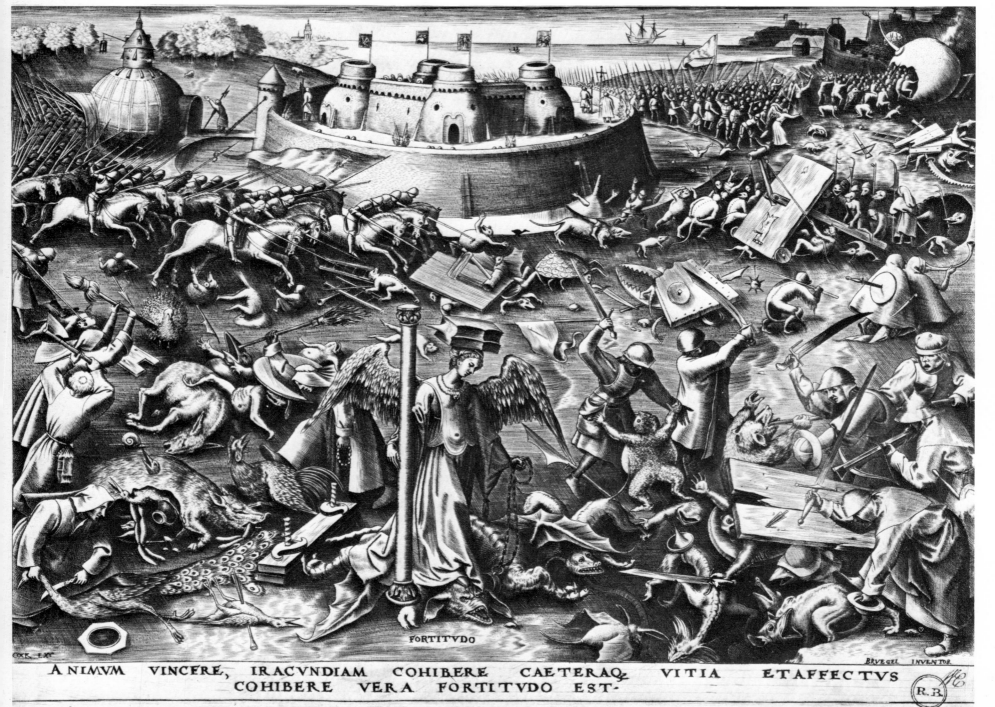

COCK EXC. BRVEGEL INVENTOR

FORTITVDO

ANIMVM VINCERE, IRACVNDIAM COHIBERE CAETERAQ. VITIA ET AFFECTVS
COHIBERE VERA FORTITVDO EST·

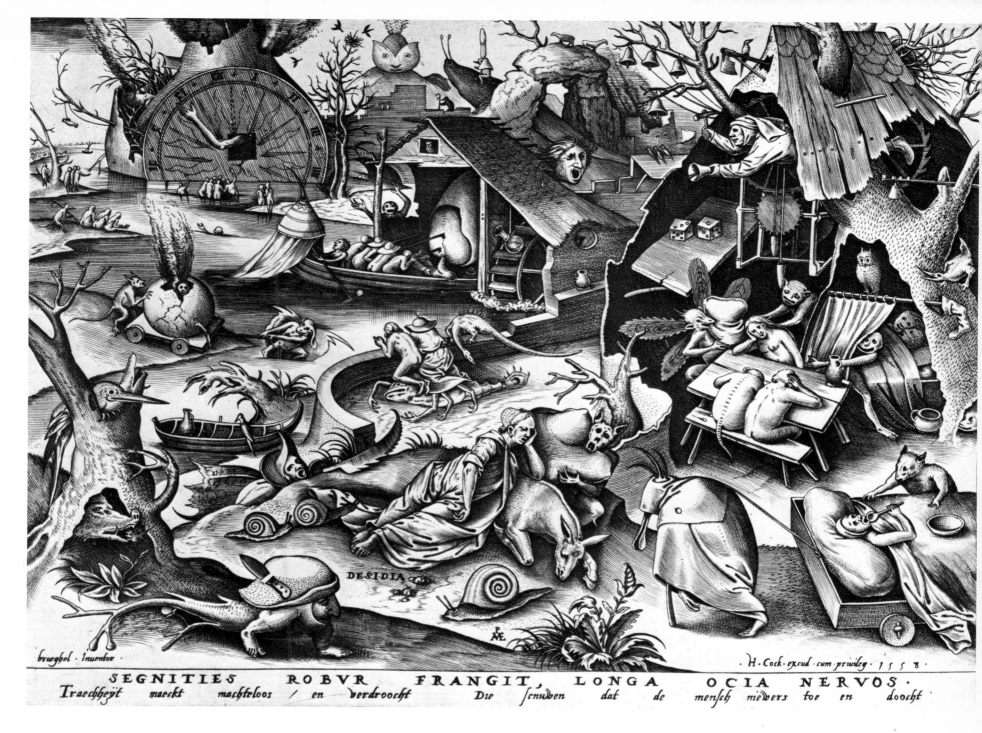

SEGNITIES ROBVR FRANGIT, LONGA OCIA NERVOS.

Traechheyt maeckt machteloos / en verdrooght Die schuwen dat de mensch niewers toe en doocht

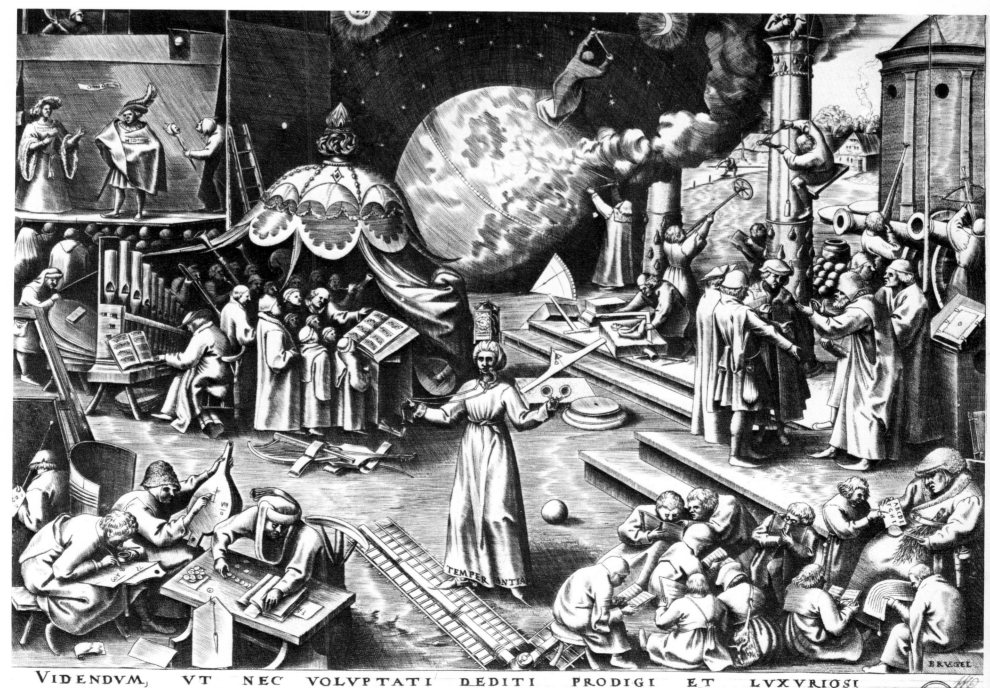

VIDENDVM, VT NEC VOLVPTATI DEDITI PRODIGI ET LVXVRIOSI
APPAREAMVS, NEC AVARA TENACITATI SORDIDI AVT OBCVRI EXISTAMVS

27

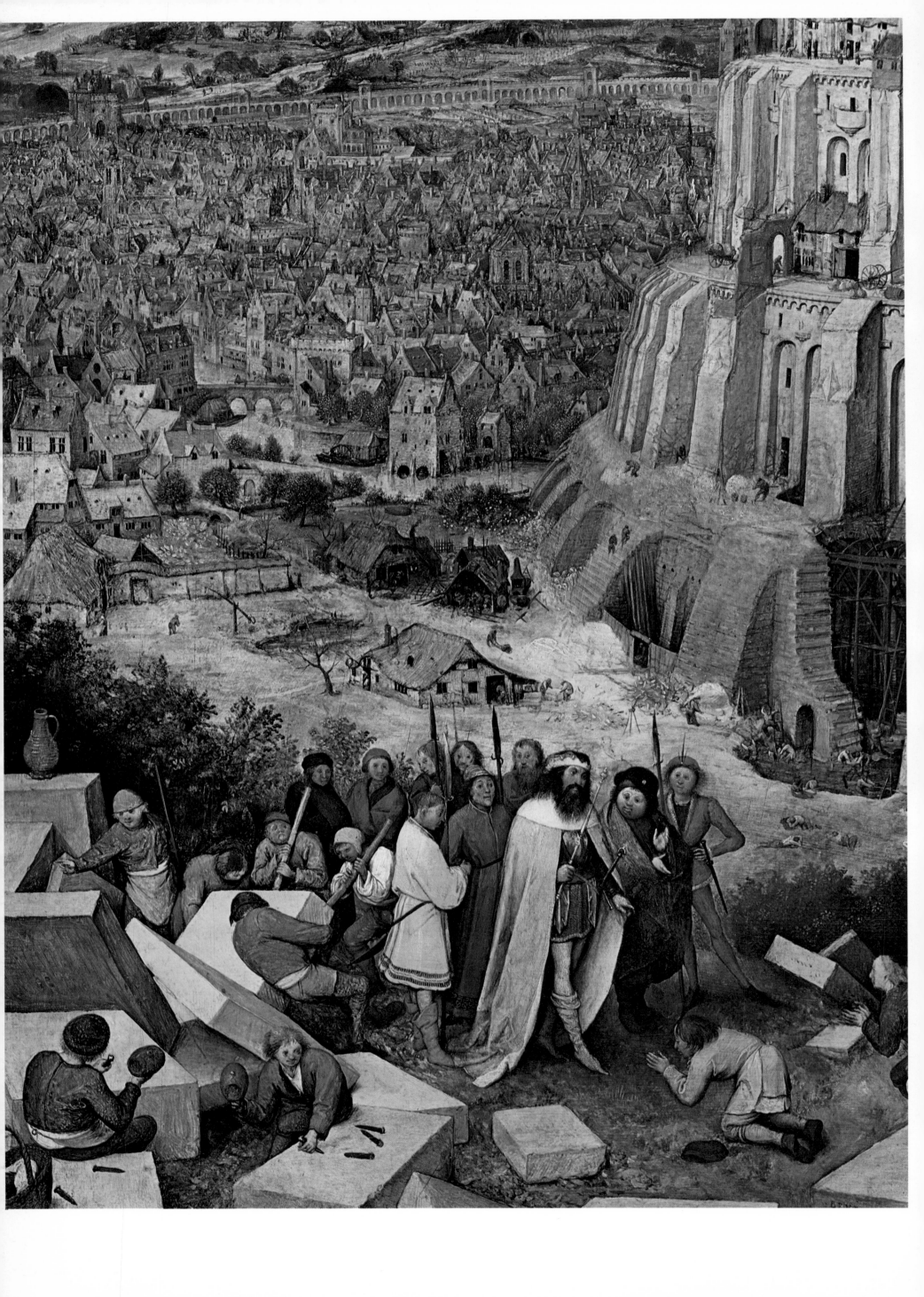

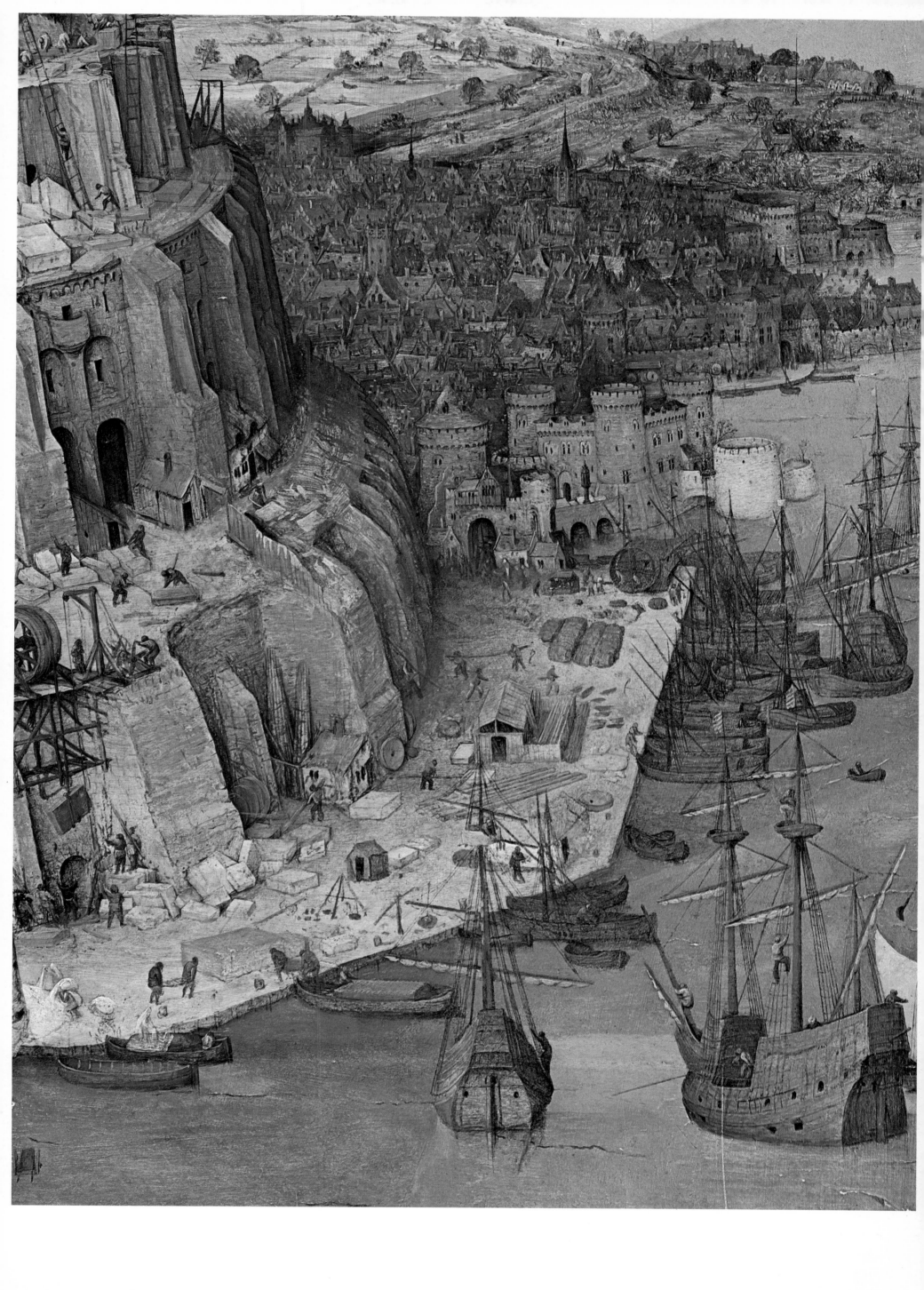

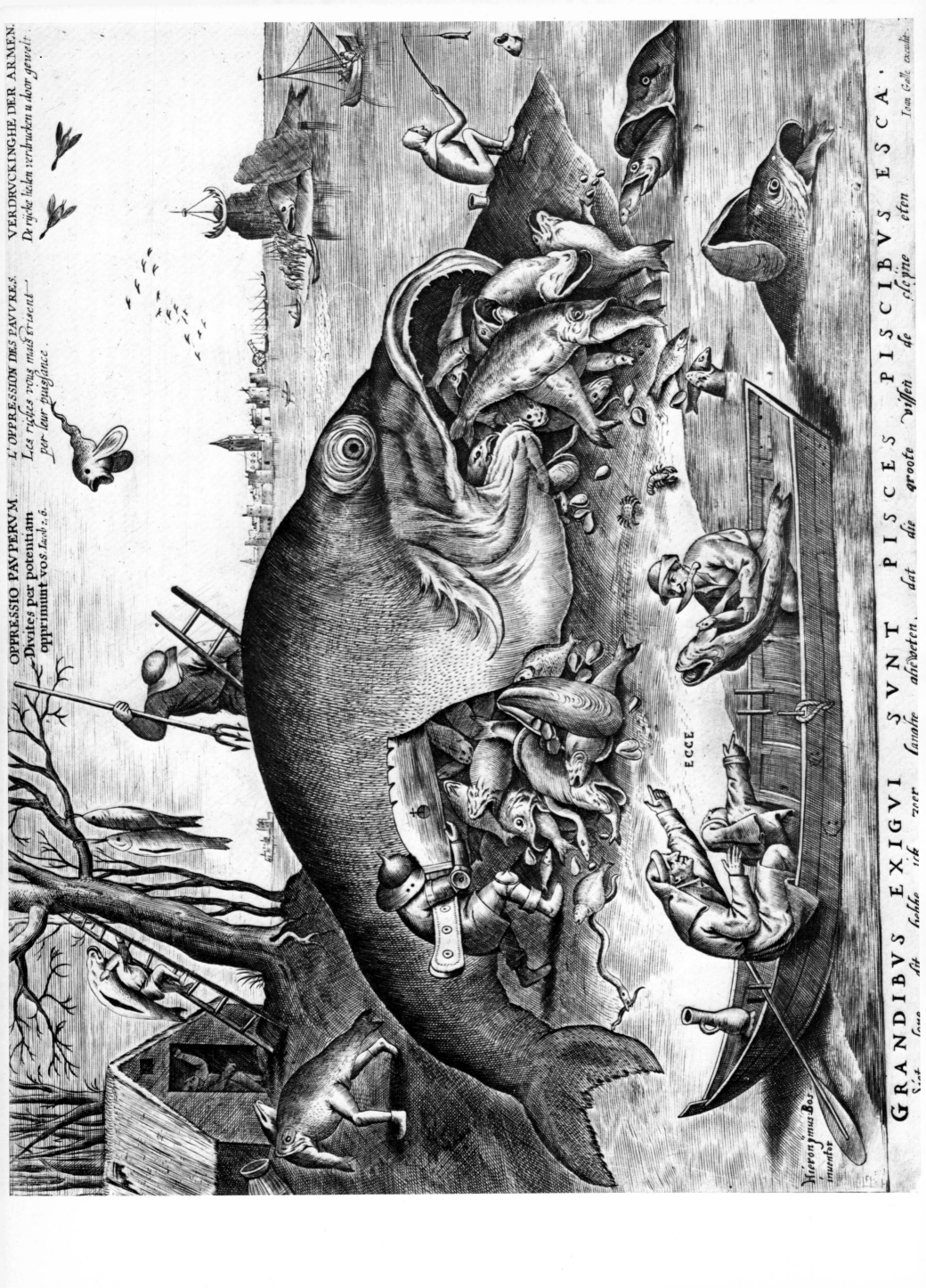

·S· HIERONŸMVS IN DESERTO·

31

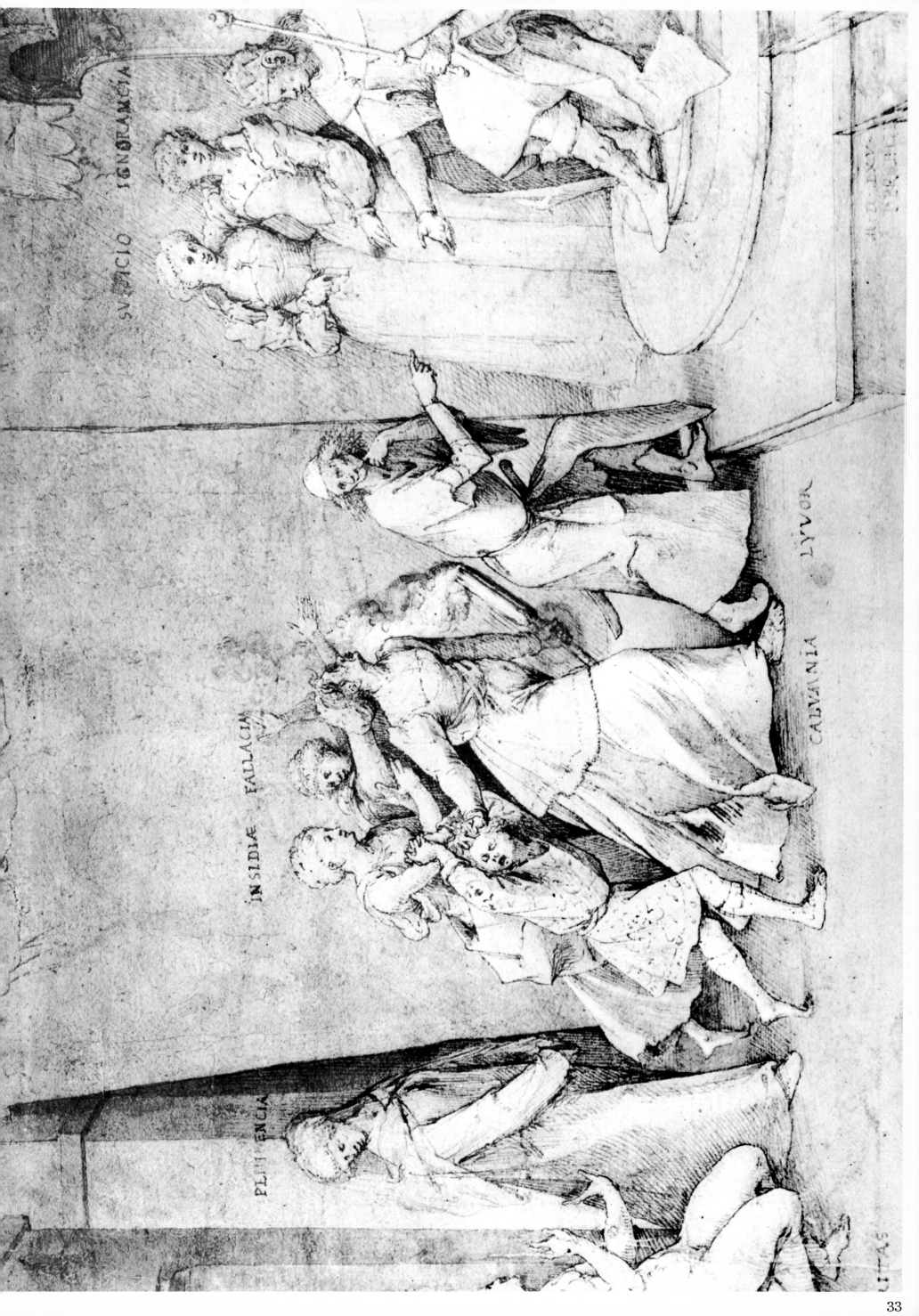

33

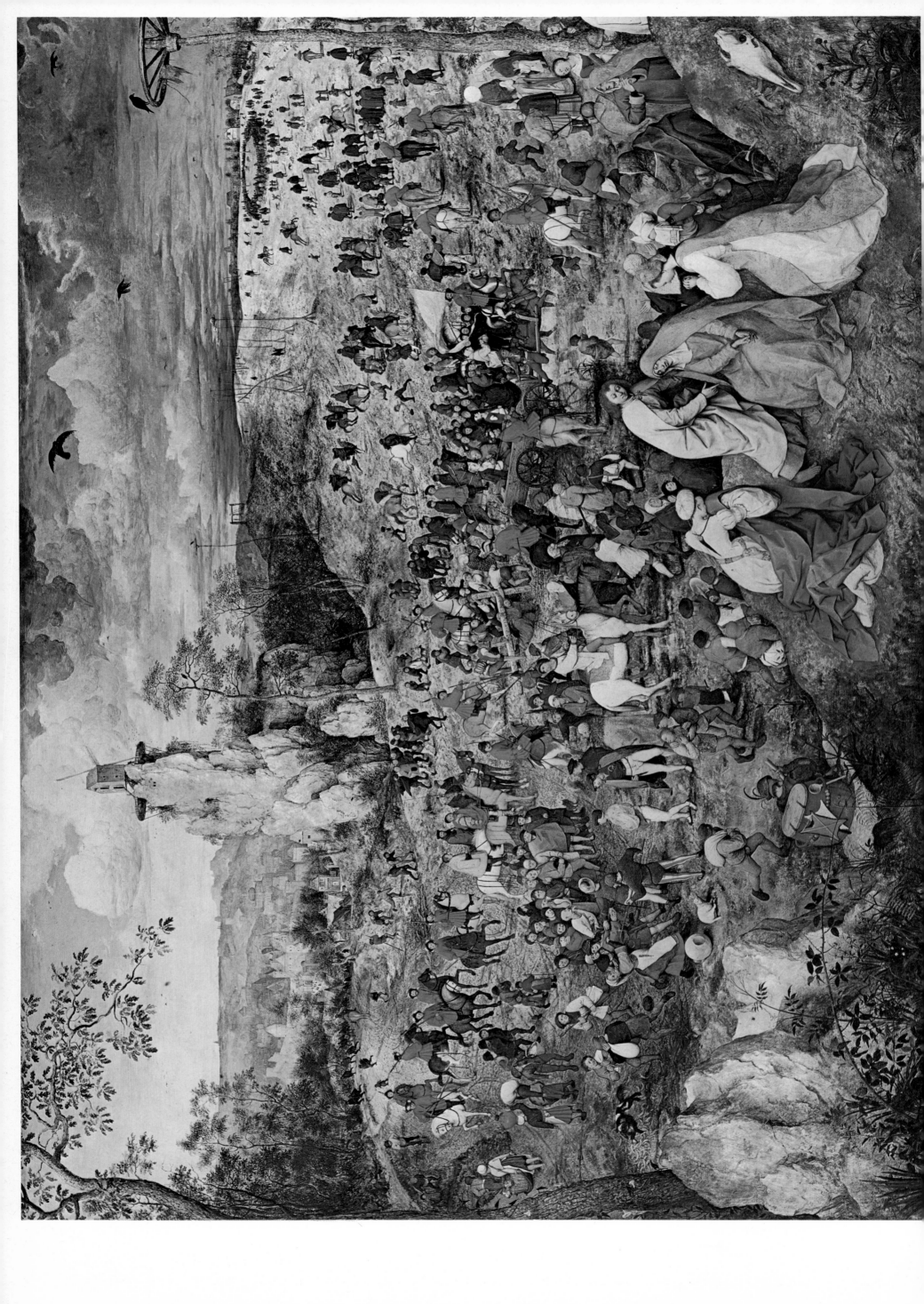

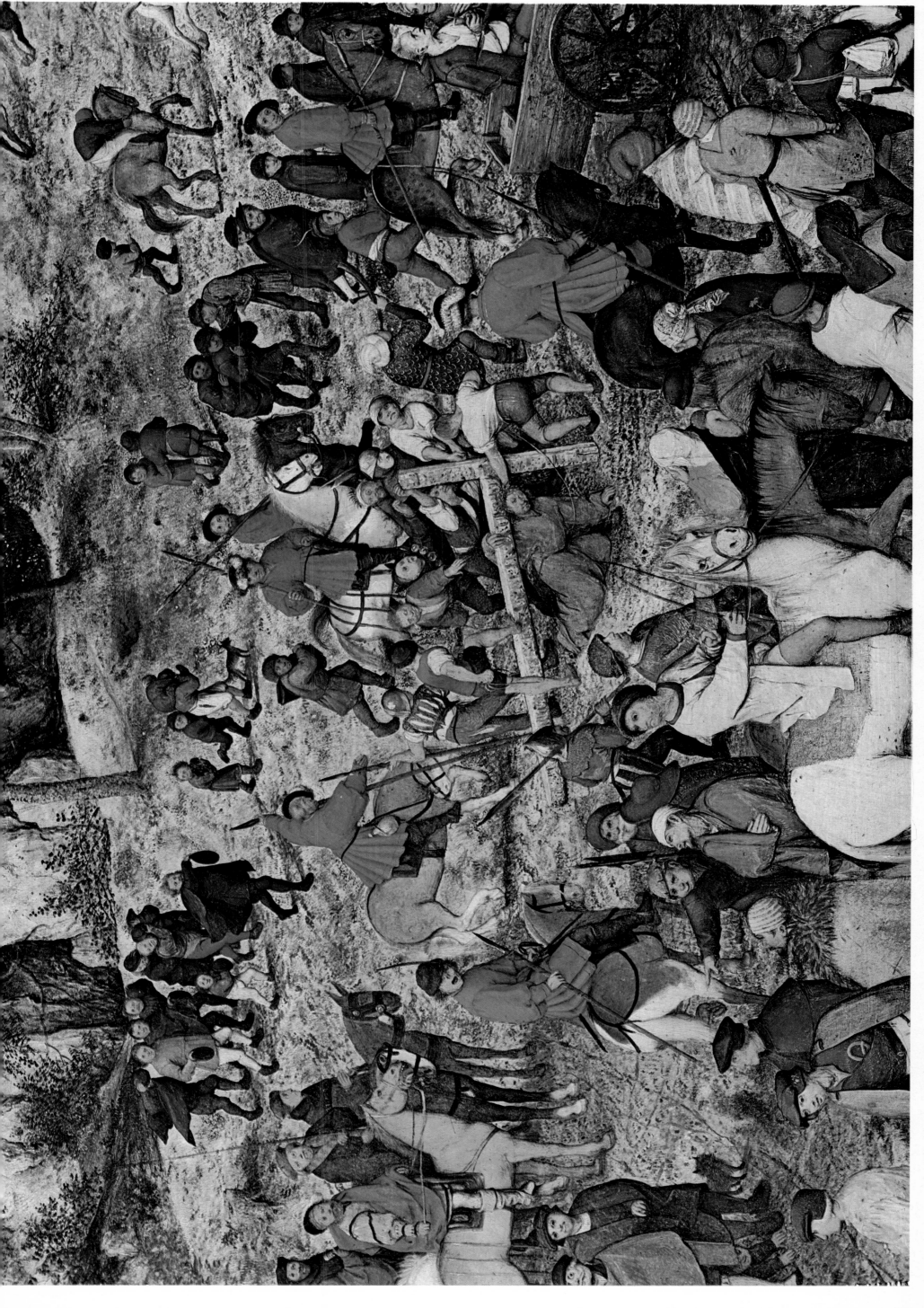

36

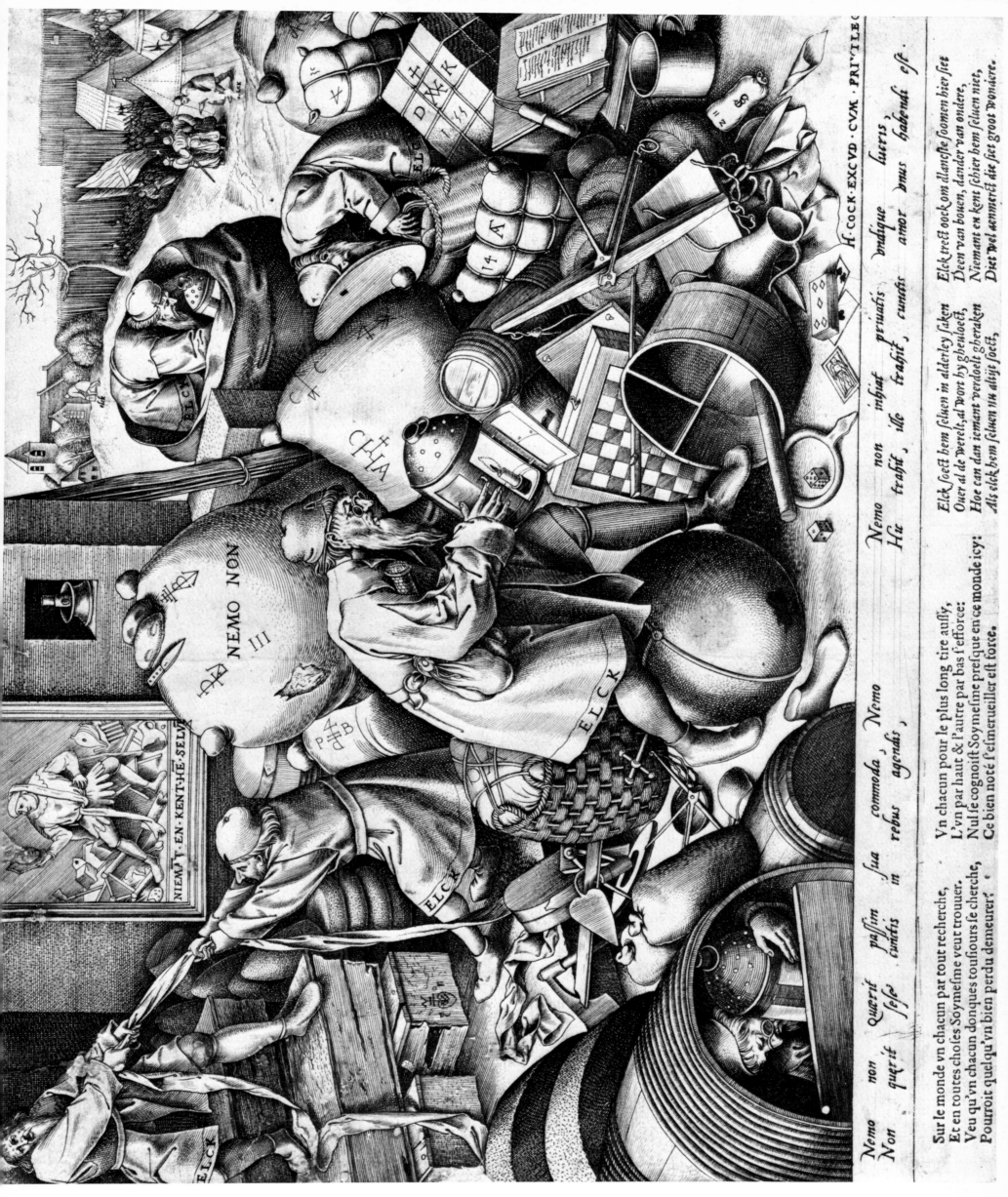

Nemo non quærit passim sua commoda, Nemo
Non quærit sese cunctis in rebus agendis,
Nemo non inhiat priuatis vndique lucris,
Hic trahit, ille trahit, cunctis amor vnus habendi est.

H. COCK EXCVD. CVM. PRIVILEG.

Elck soett hem seluen in alderley saken,
Ouer al de Vverelt, al Vort by ghenloett,
Hoe can dan iemant verdoelt gheraken
Als elck hem seluen vn altijt soett;

Elck treÇt oock om dlansche soomen hier siet
Deen van bouen, dander van ondere,
Niemant en kent schier hem seluen niet,
Diet Vel aenmerct die siet groot Voondere.

Sur le monde vn chacun par tout recherche,
Et en toutes choses Soymesme veut trouuer.
Veu qu'vn chacun donques tousiours se cherche,
Pourroit quelqu'vn bien perdu demeurer?

Vn chacun pour le plus long tire aussy,
L'vn par haut & l'autre par bas s'efforce:
Nul se cognoist Soymesme presque en ce monde icy:
Ce bien noté s'esmerueilleroit forse.

NIEMÀT. EN. KENT. HÊ. SELV.

NEMO NON III

37

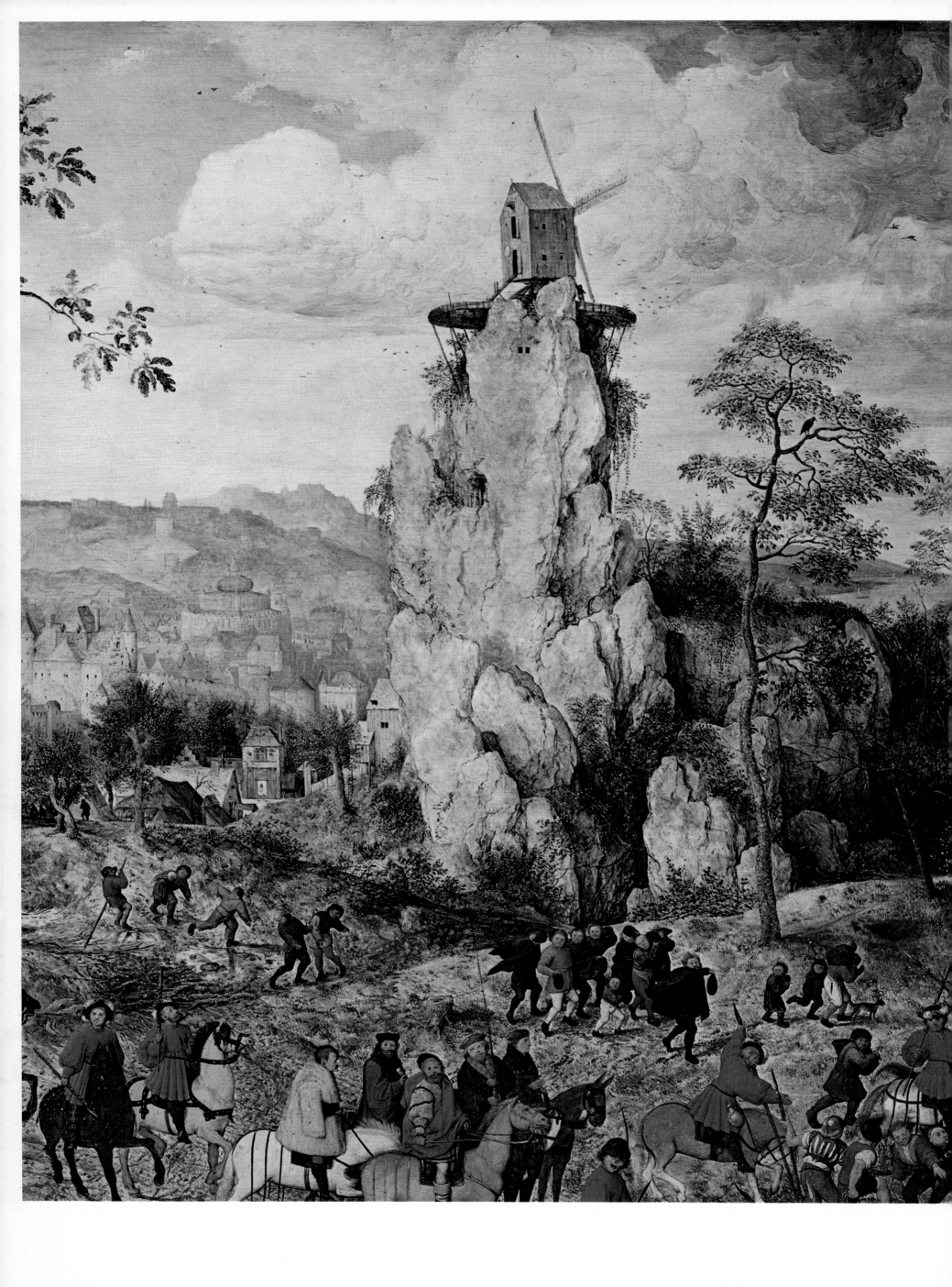

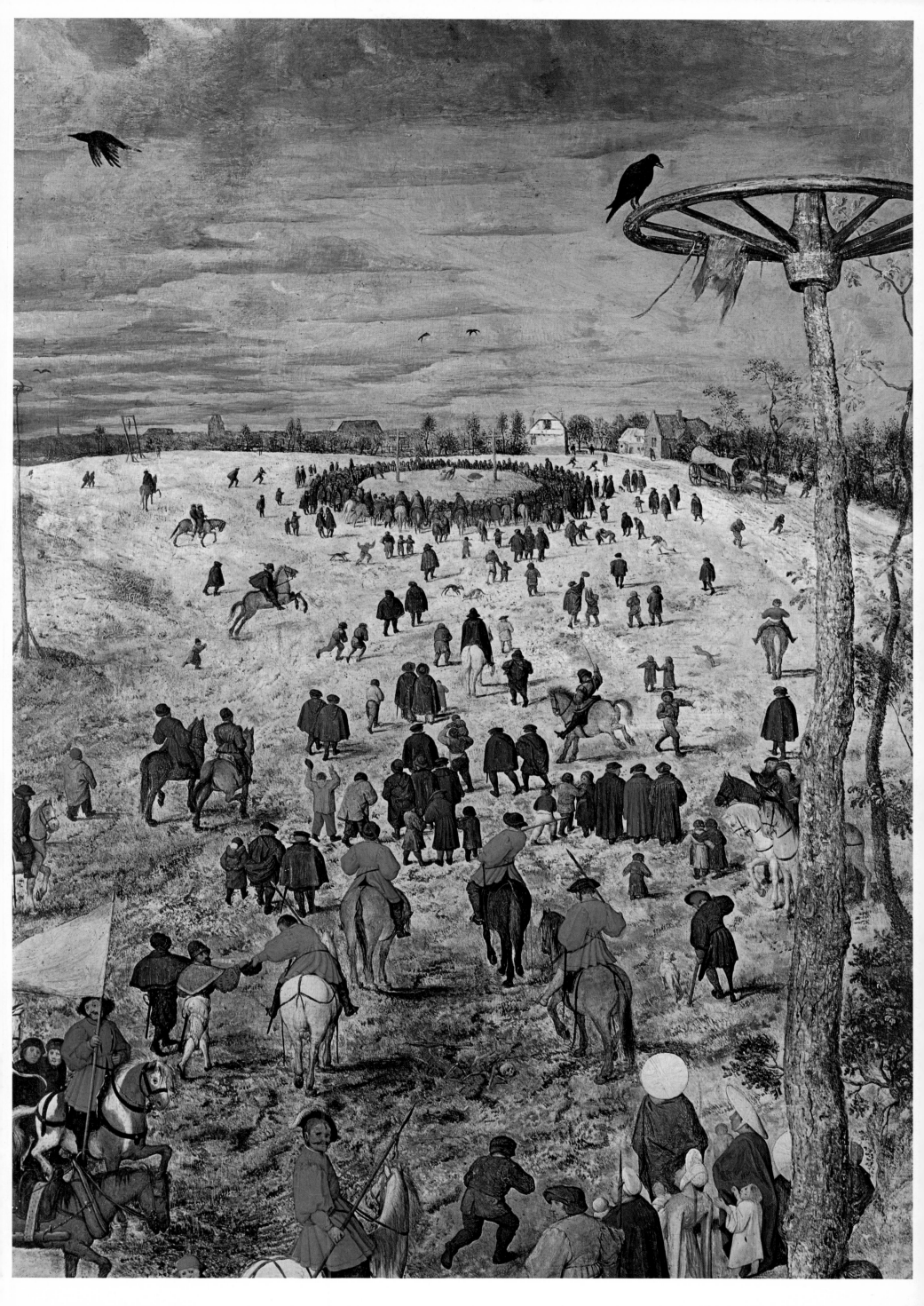

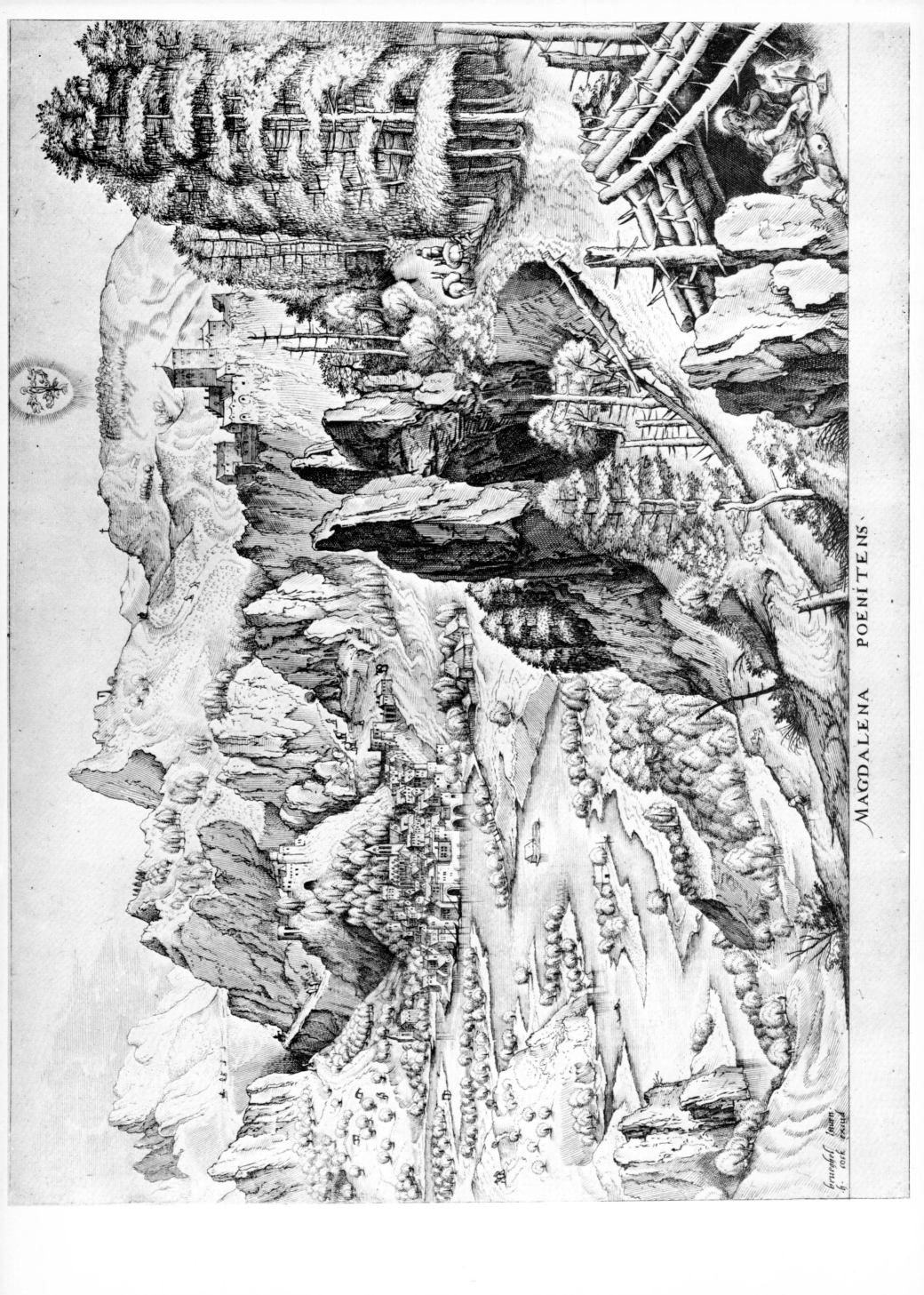

MAGDALENA POENÍTENS.

brueghel. Jouan
H. cock excud

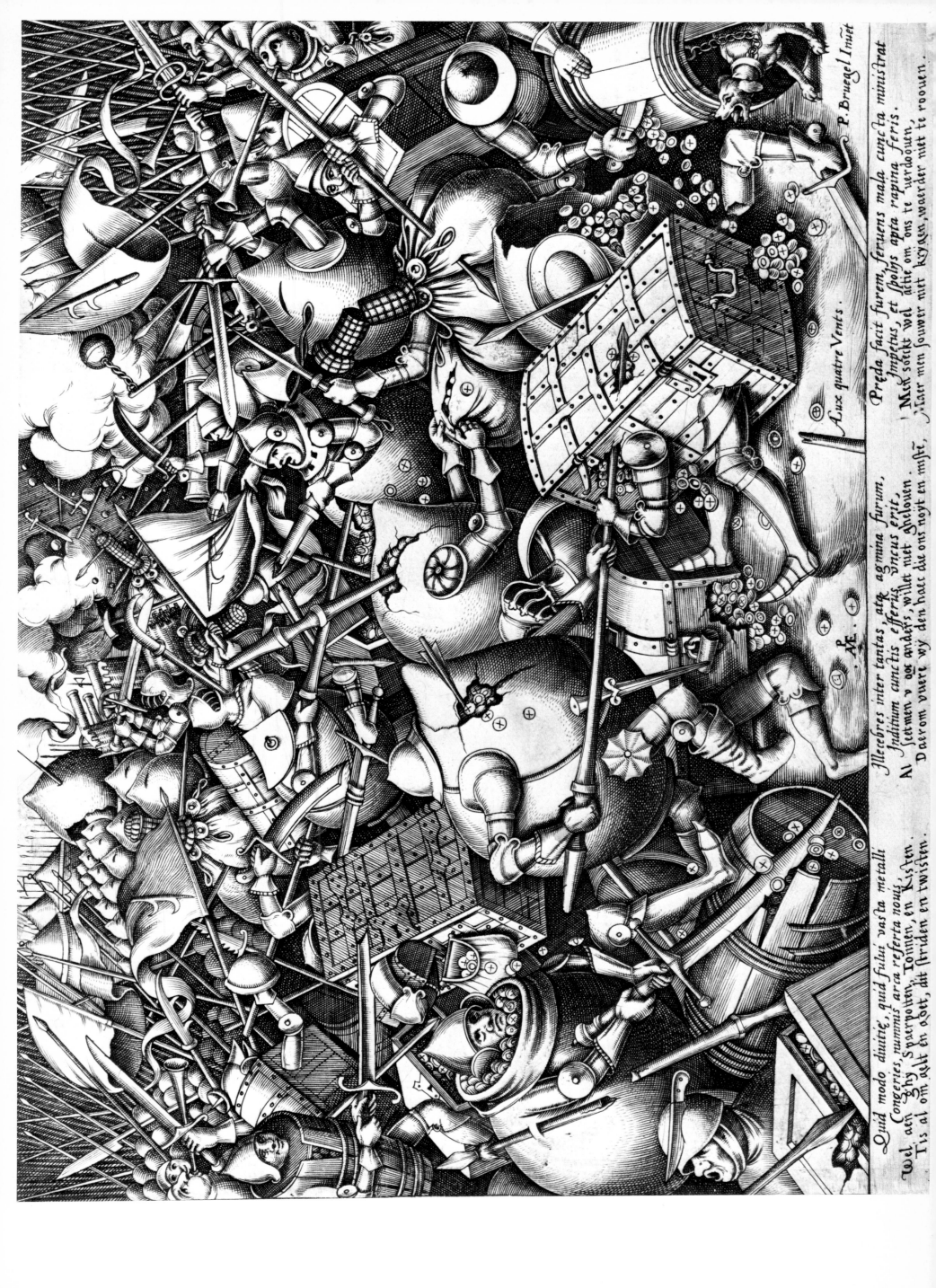

P. Bruegel Inuet.

Aux quatre Vents.

Præda facit furem, feruens mala cuncta ministrat
Impetus, et spolijs apta rapina feris.
Al soeckt ghy v oes anders, willt niet sheloun
Dat men souwer niet krijgen, waerder niet te roouen.

Quid modo diuitie, quid fuluæ vasta metalli
Congeries, nummis arca referta nouis,
Illecebras inter tantas, atq; agmina furum,
Inditum cunctis efferus vncus erit.
Wel acn ghy Spaerpotten, Tonnen, en Kisten,
Tis al om niet dat en aget, dit striden en twisten.

41

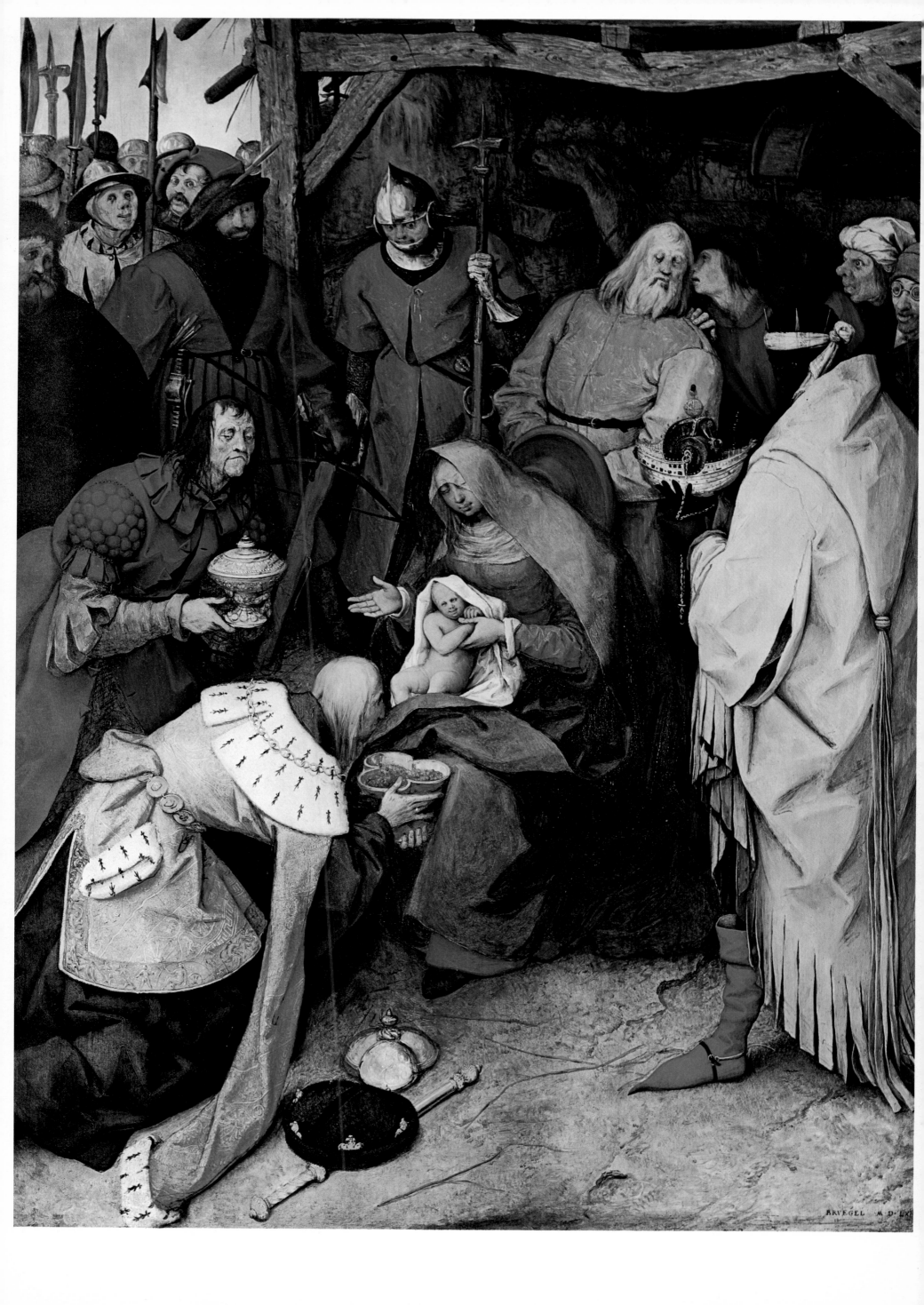

SPES

IVCVNDISSIMA EST SPEI PERSVASIO, ET VITAE IMPRÆMIS NECESSARIA, INTER TOT AERVMNAS PENEQ INTOLERABILES.

BRVGEL INV H. cock e

44

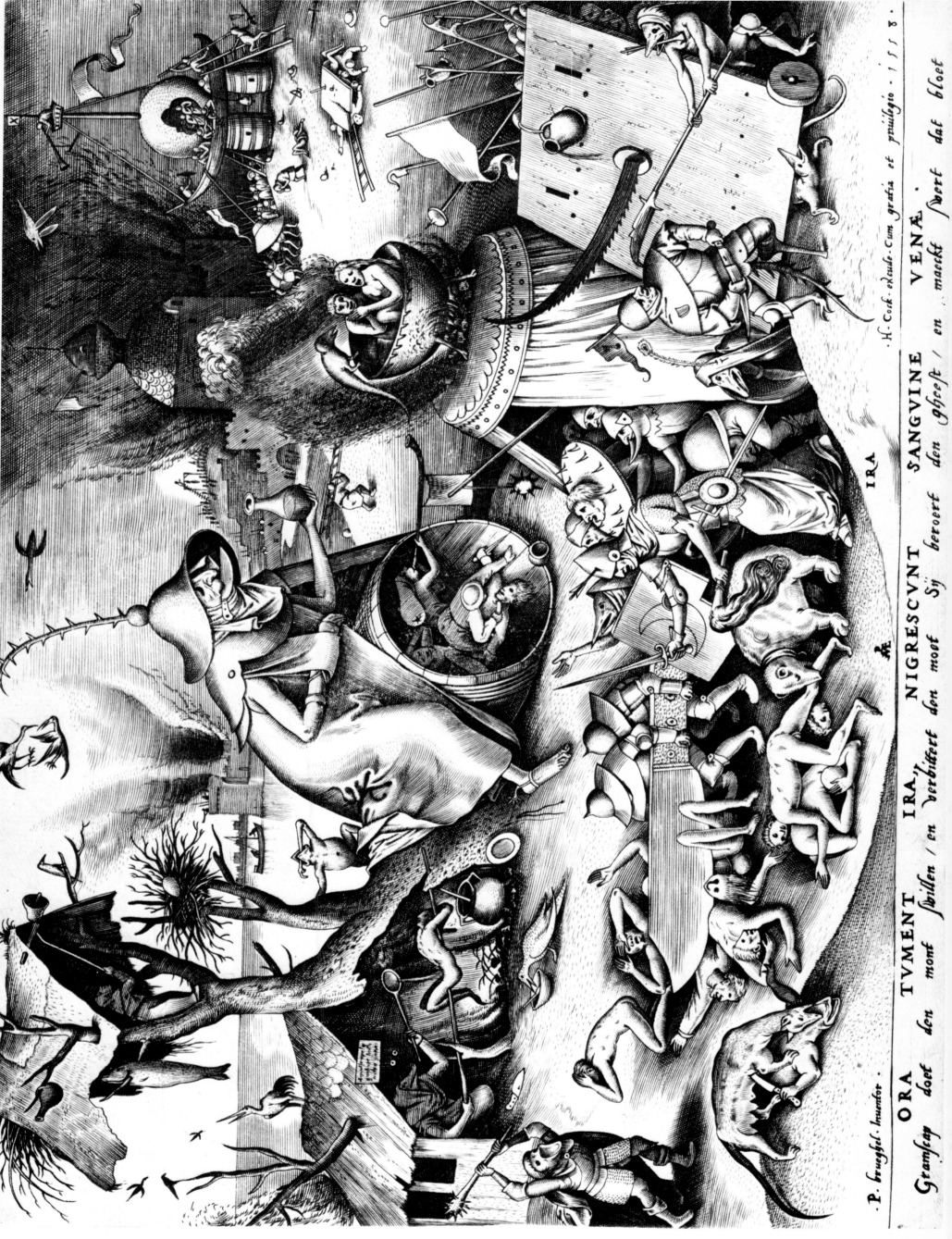

P. Brueghel. Inuentor. H. Cock excud. Cum gratia et priuilegio. 1558.

IRA.

ORA TVMENT IRA. IRA NIGRESCVNT SANGVINE VENÆ.

Gramfcap doet den mont fwillen / en verbittert den moet Sij beroert den gheeft / en maeckt fwert dat bloet

45

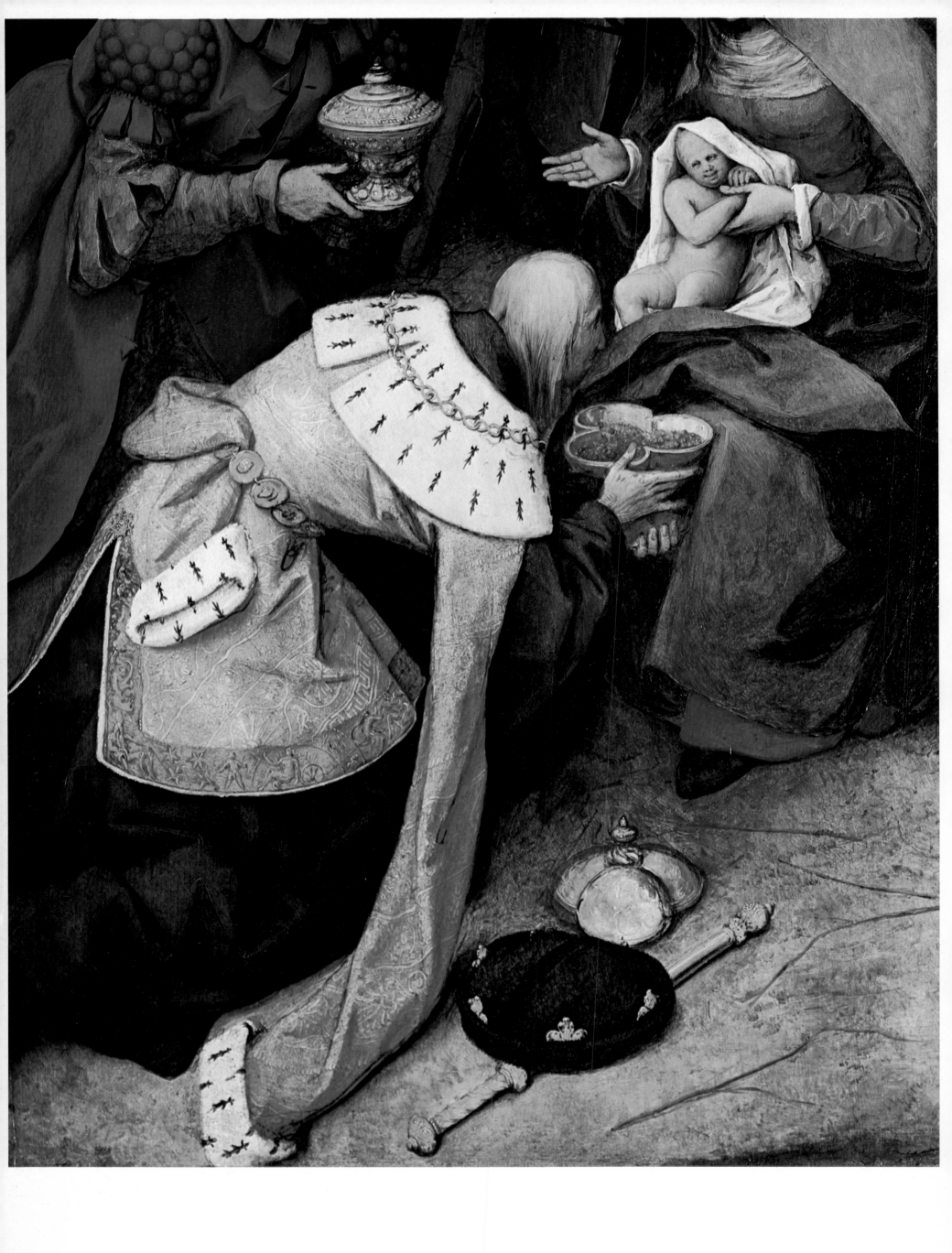

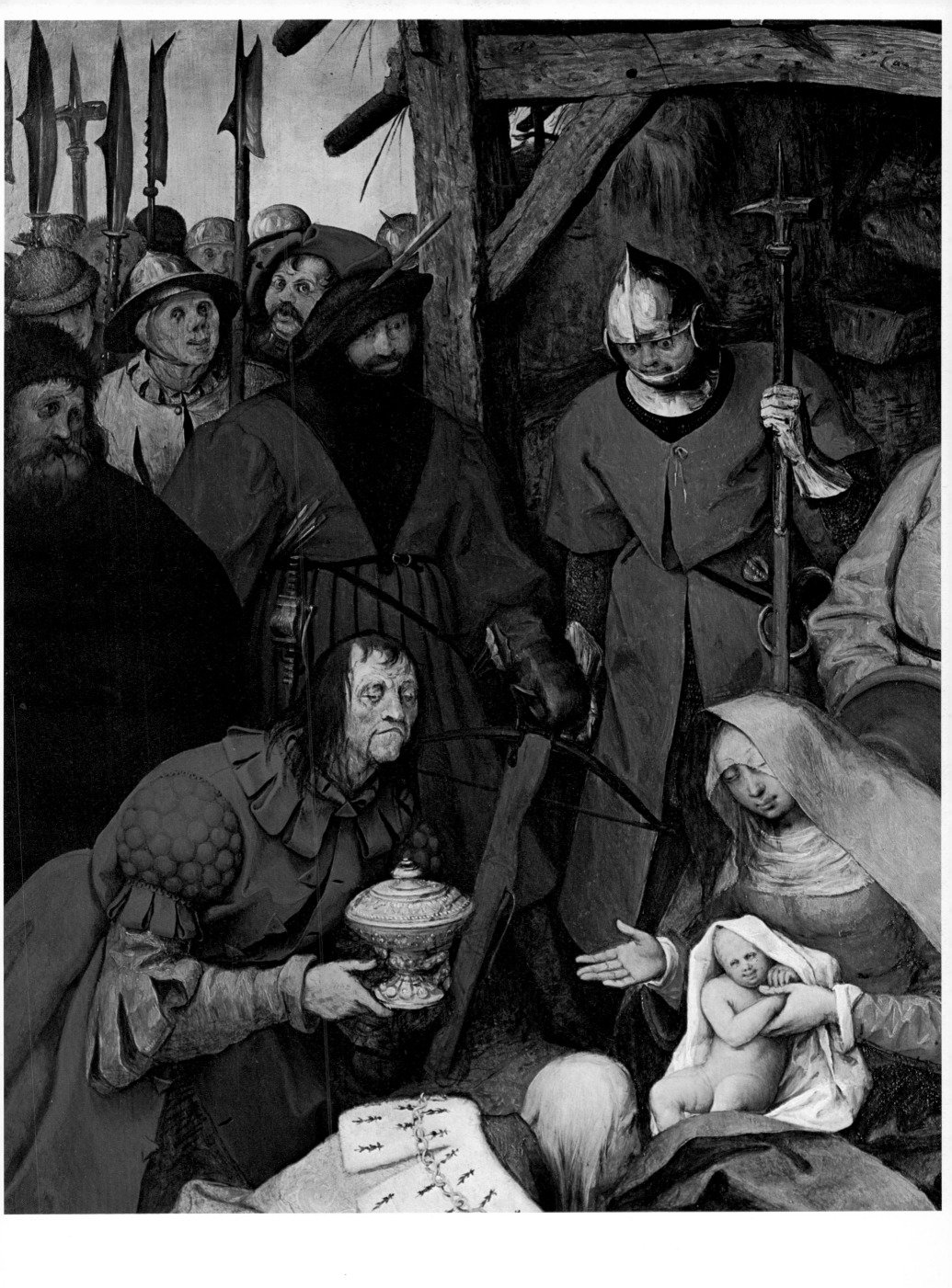

BRVEGEL

48

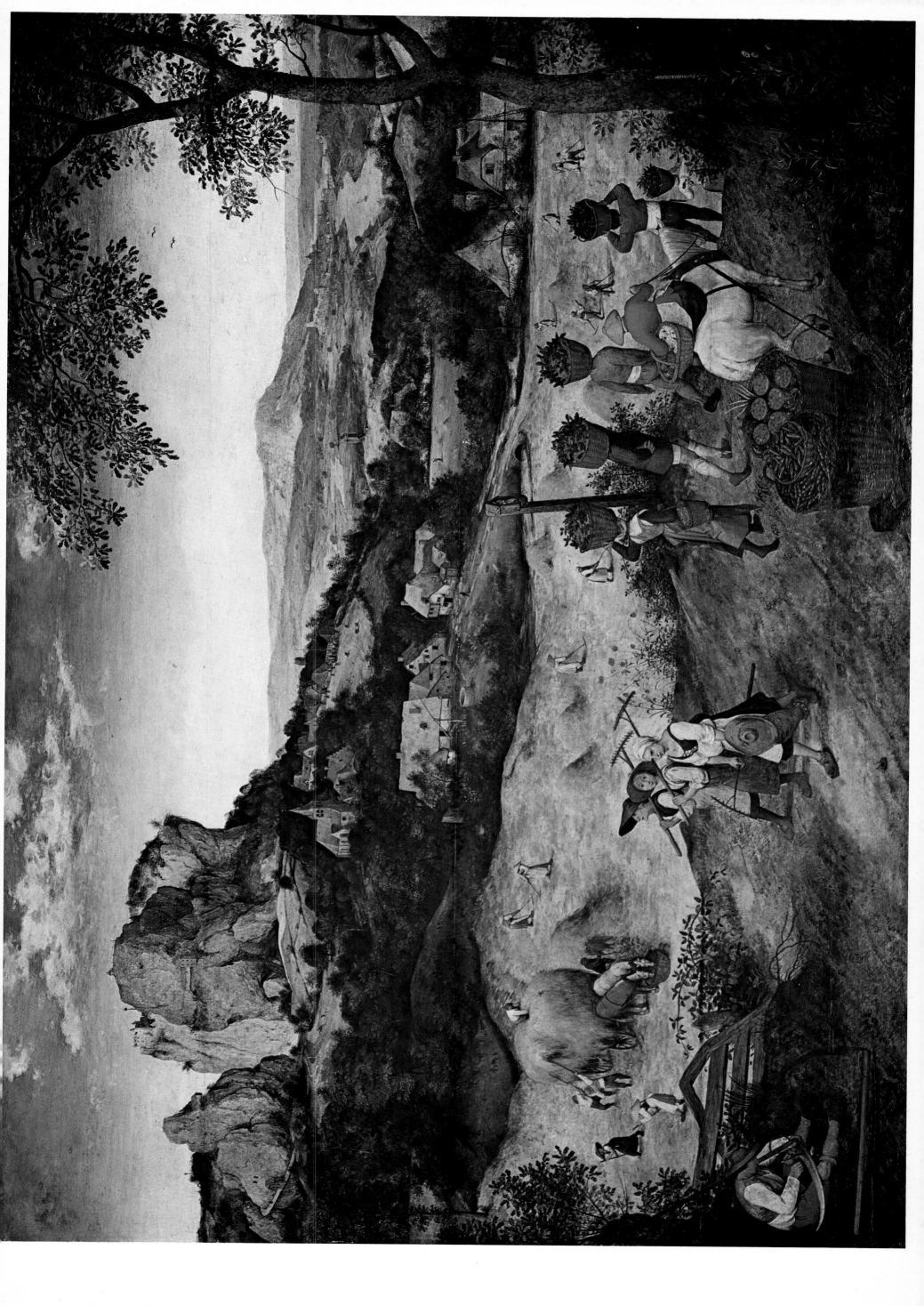

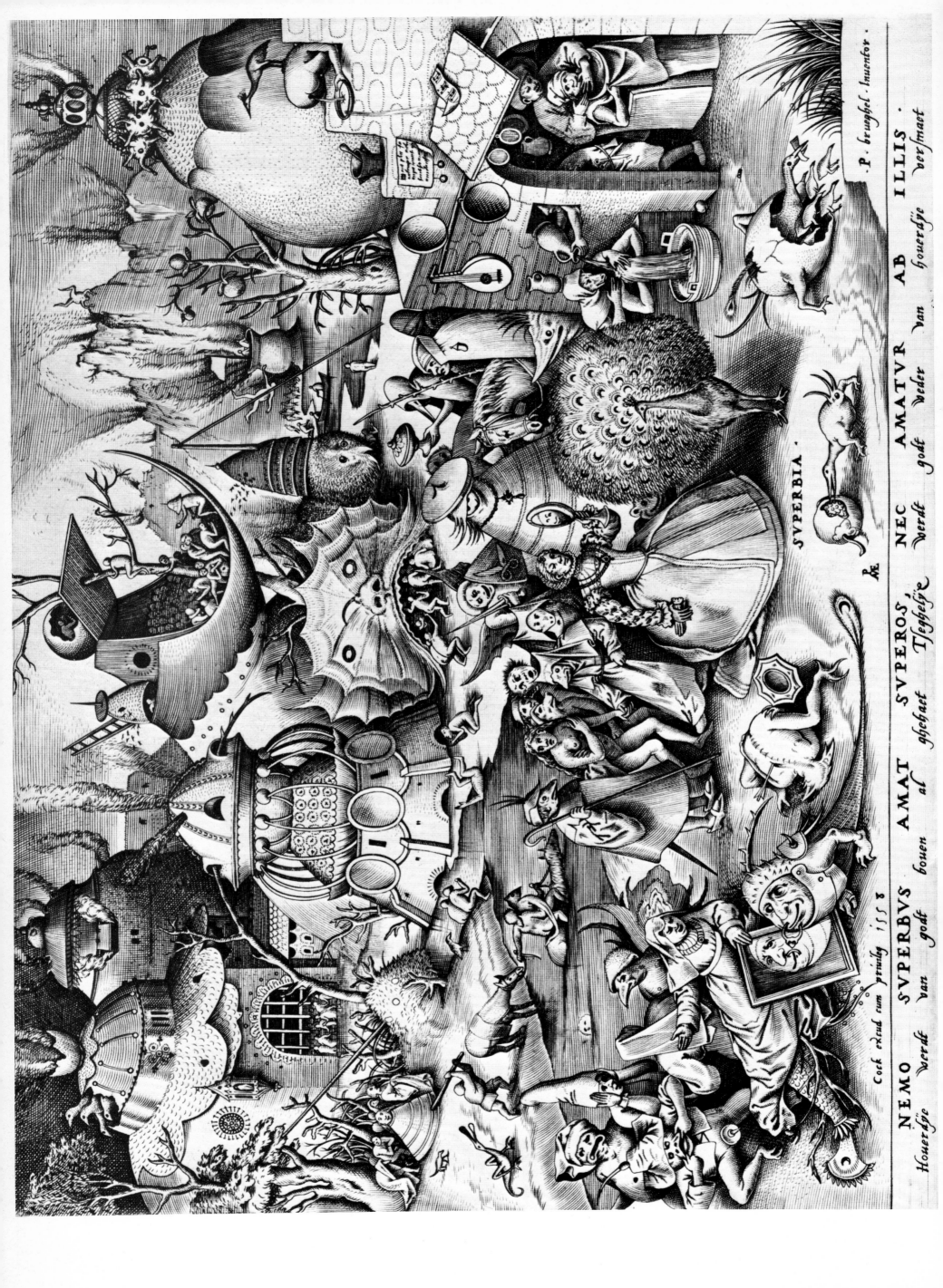

SVPERBIA.

NEMO SVPERBVS AMAT SVPEROS, NEC AMATVR AB ILLIS.
Homerſje werdt van godt bouen al ghehaet Teghelje werdt van godt verſmaet

Cock excud cum priuileg 1558

· P. brueghel · Inuentor ·

50

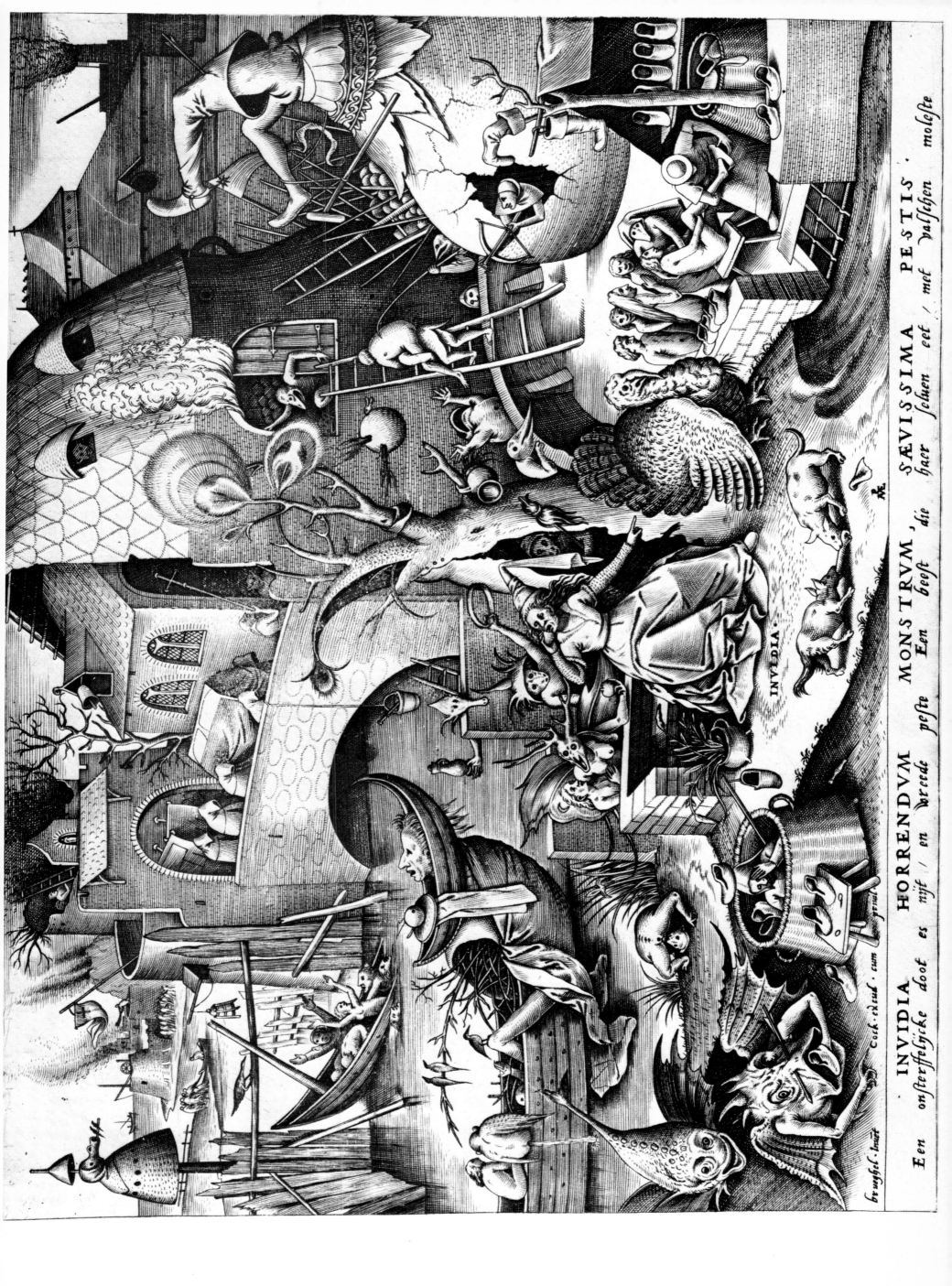

INVIDIA HORRENDVM MONSTRVM, SÆVISSIMA PESTIS.
Een onsterffelijcke doot es nijt / en wreede peste Een beest die haer seluen eet / met valschen molefte

brueghel·inuent Cock·excud·cum priuil

INVIDIA

51

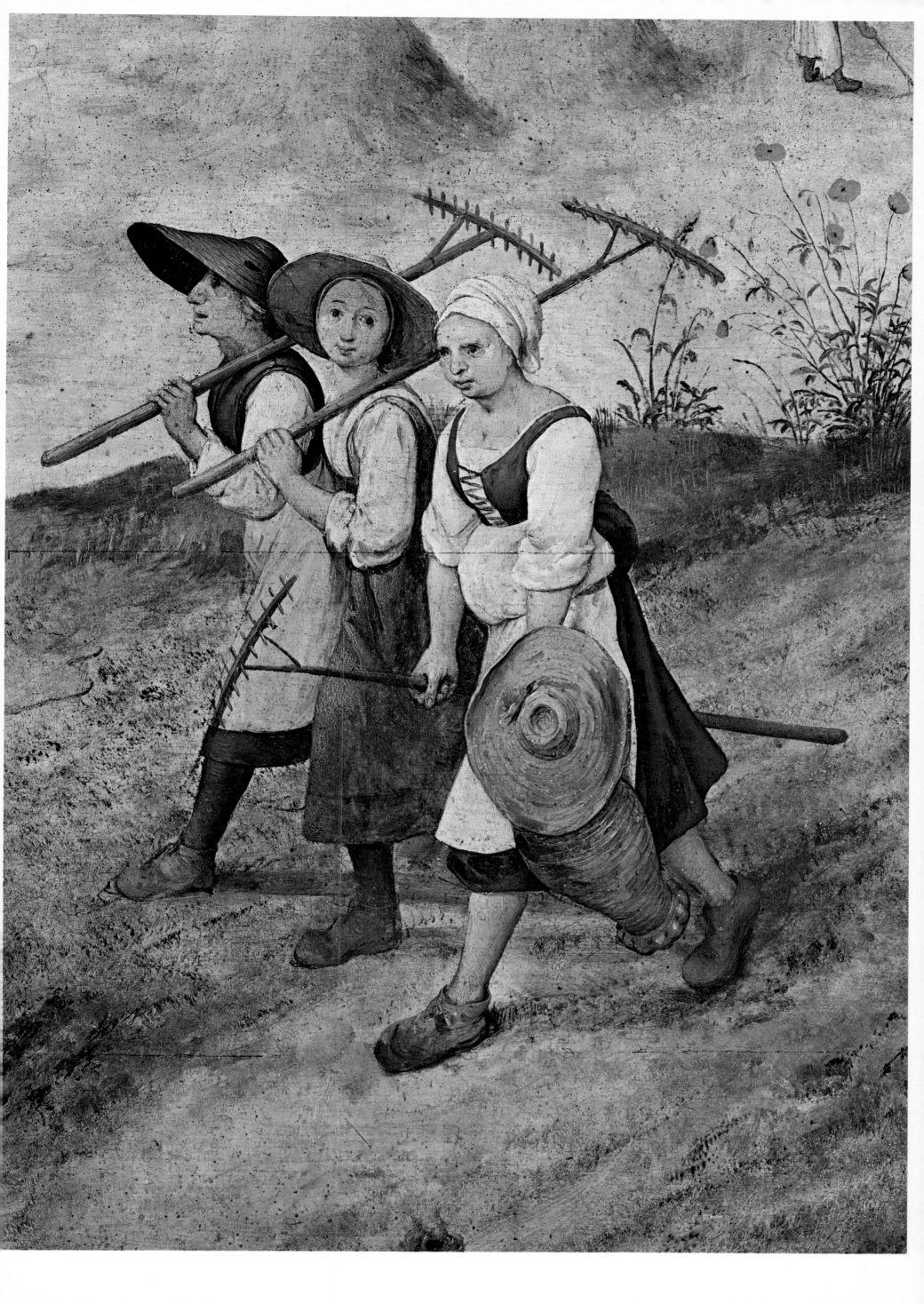

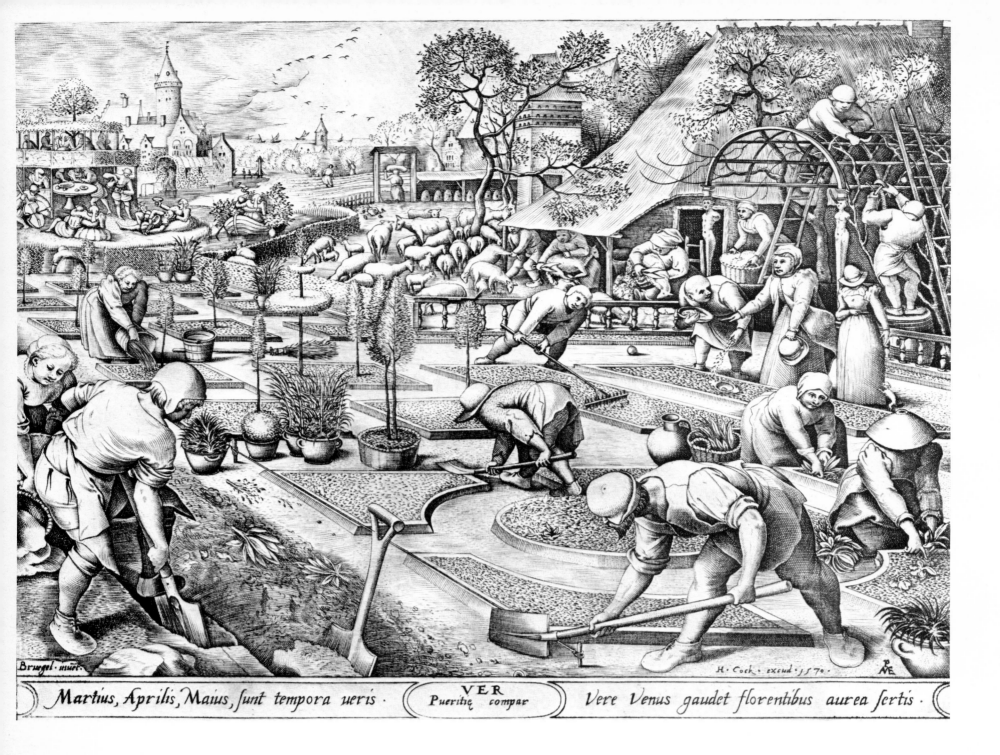

Bruegel inuet. H · Cock · excud · 1570 ·

Martius, Aprilis, Maius, sunt tempora ueris. (**VER** / *Pueritiæ compar*) *Vere Venus gaudet florentibus aurea sertis*.

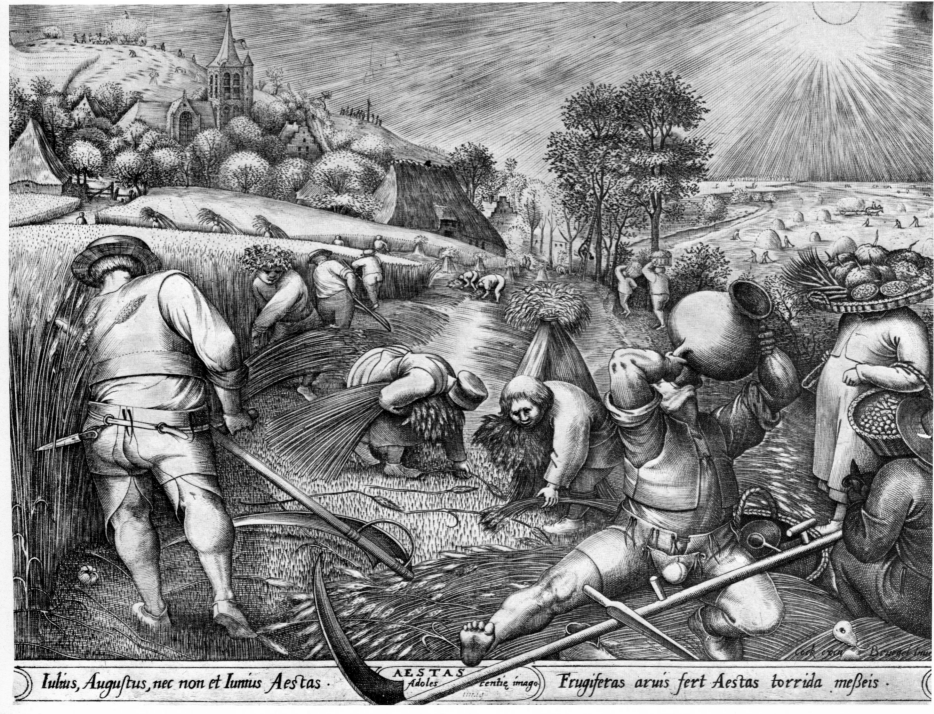

Iulius, Augustus, nec non et Iunius Aestas (**AESTAS** / *Adolescentiæ imago*) *Frugiferas aruis fert Aestas torrida meßeis*.

54

Wat baet keers oft bril
als den esel niet sien en wil

P. brugel inu. Hh exe.

Parisios stolidum si quis transmittat asellum. Al reys t den esel ter scholen om leeren
Si hic est asinus non erit illec equus. is t eenen esel, by en sal geen peert wederkeeren.

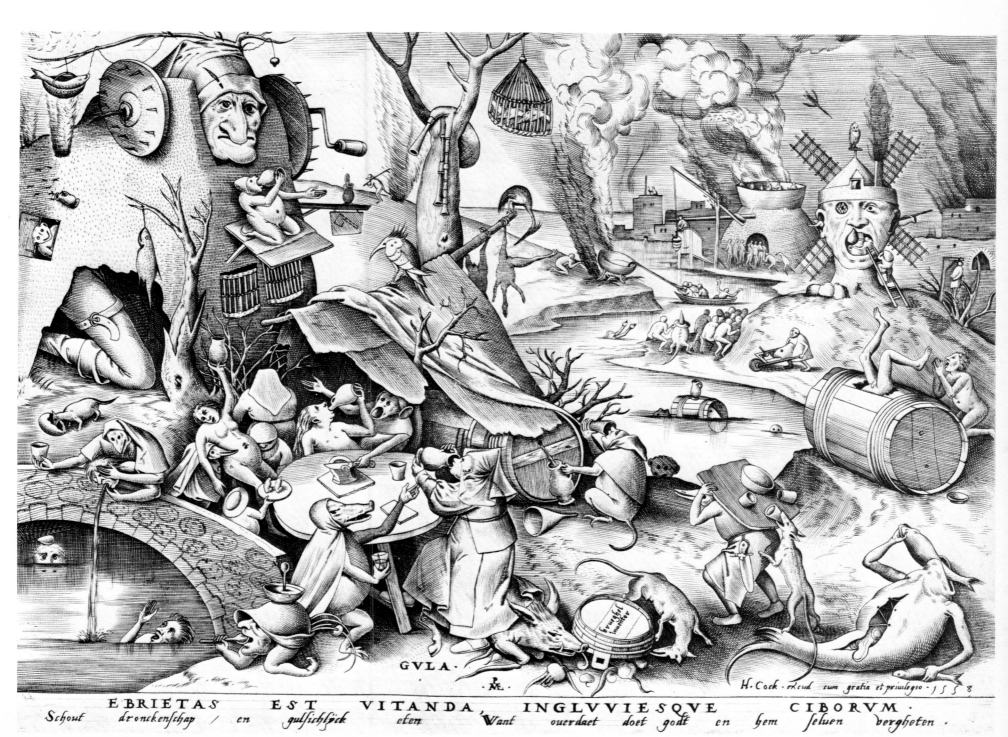

GVLA.

H. Cock excud cum gratia et priuilegio 1558

EBRIETAS EST VITANDA, INGLVVIESQVE CIBORVM.
Schout dronckenschap / en gulsichlijck eten Want ouerdaet doet godt en hem seluen vergheten.

55

DEBENT IGNARI RES FERRE ET POST OPERARI QVATVOR INSERTA NATVRIS IN NVBE REFERTA
IVS LAPIDIS CARI VILIS SED DENIQ3 RARI NVLLA MINERALIS RES EST VBI PRINCIPALIS
VNICA RES CERTA VILIS SED VBIQ3 REPERTA SED TALIS QVALIS REPERITVR VBIQ3 LOCALIS.

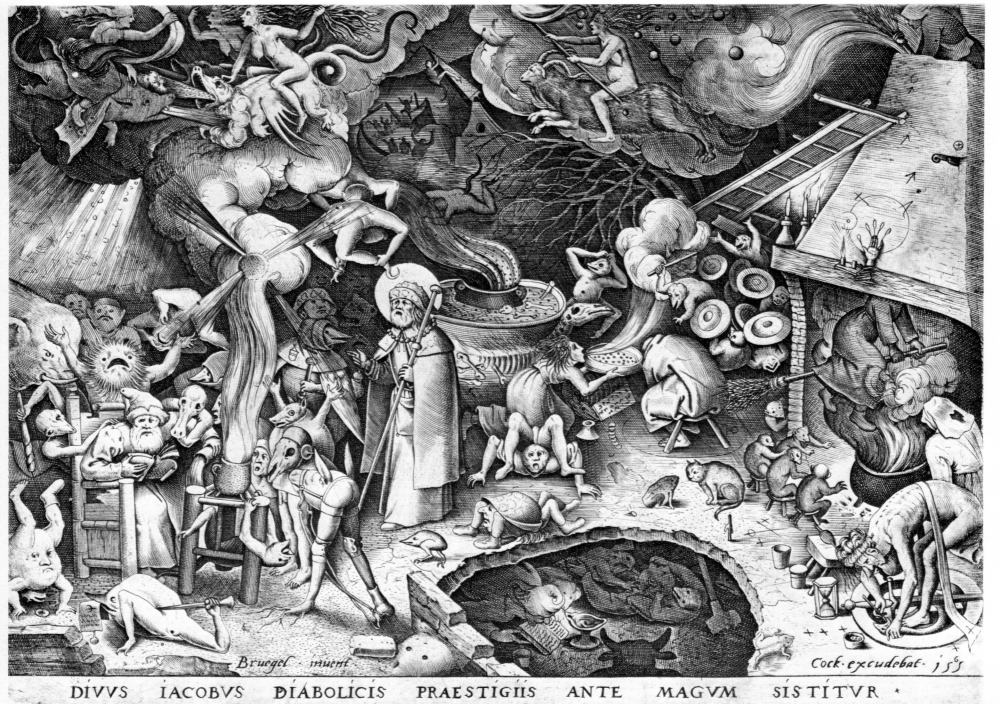

Bruegel inuent. Cock·excudebat·1565

DIVVS IACOBVS DIABOLICIS PRAESTIGIIS ANTE MAGVM SISTITVR·

Die boeren verblycen hun in sulken feesten Te danfen springhen en dronckendrincken als beeften . Bartolomeus
Sy moeten die kermiffen onderhouwen Al souwen sy vaften en fteruen van kauwen de mumpere . Excu

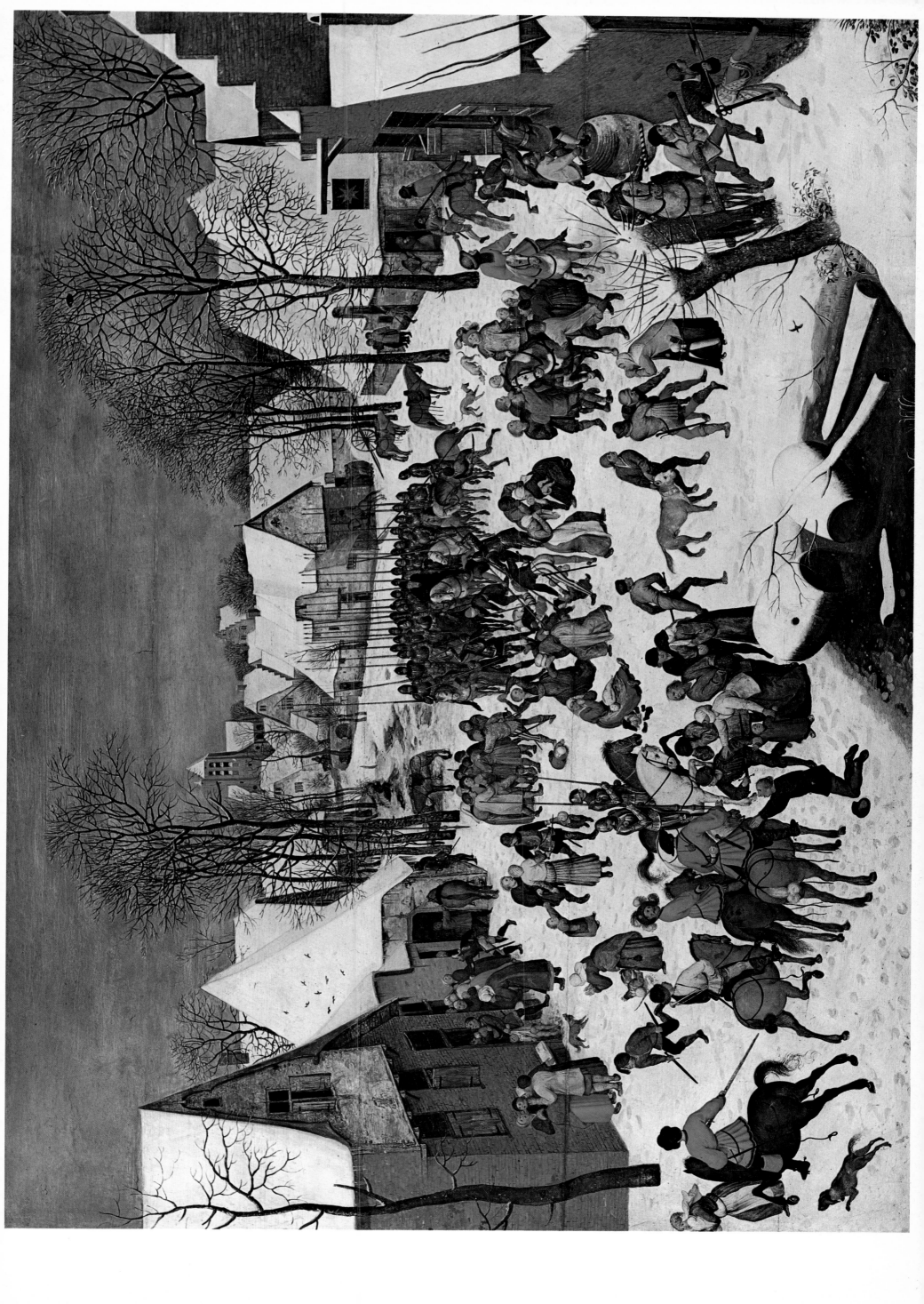

61

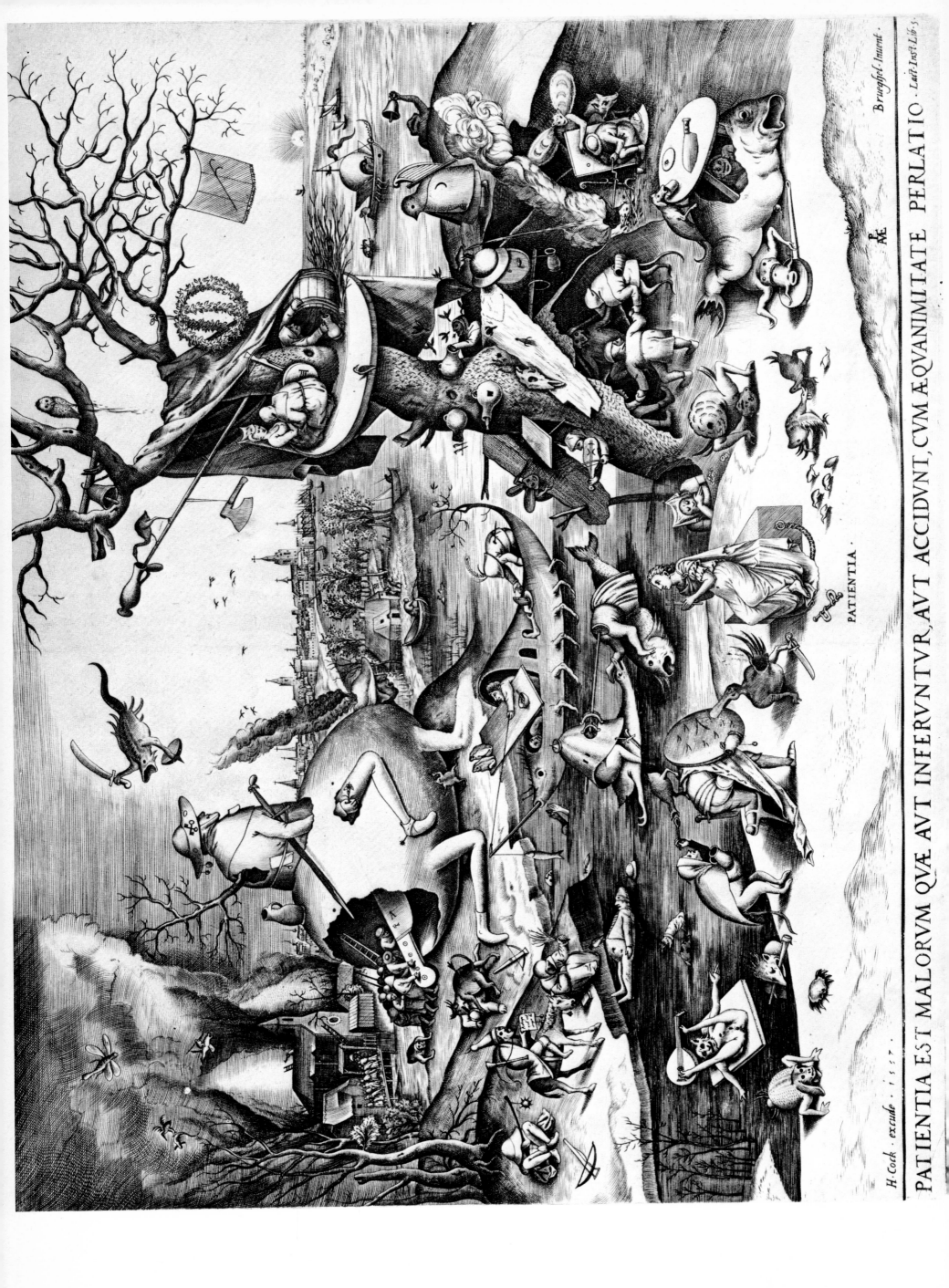

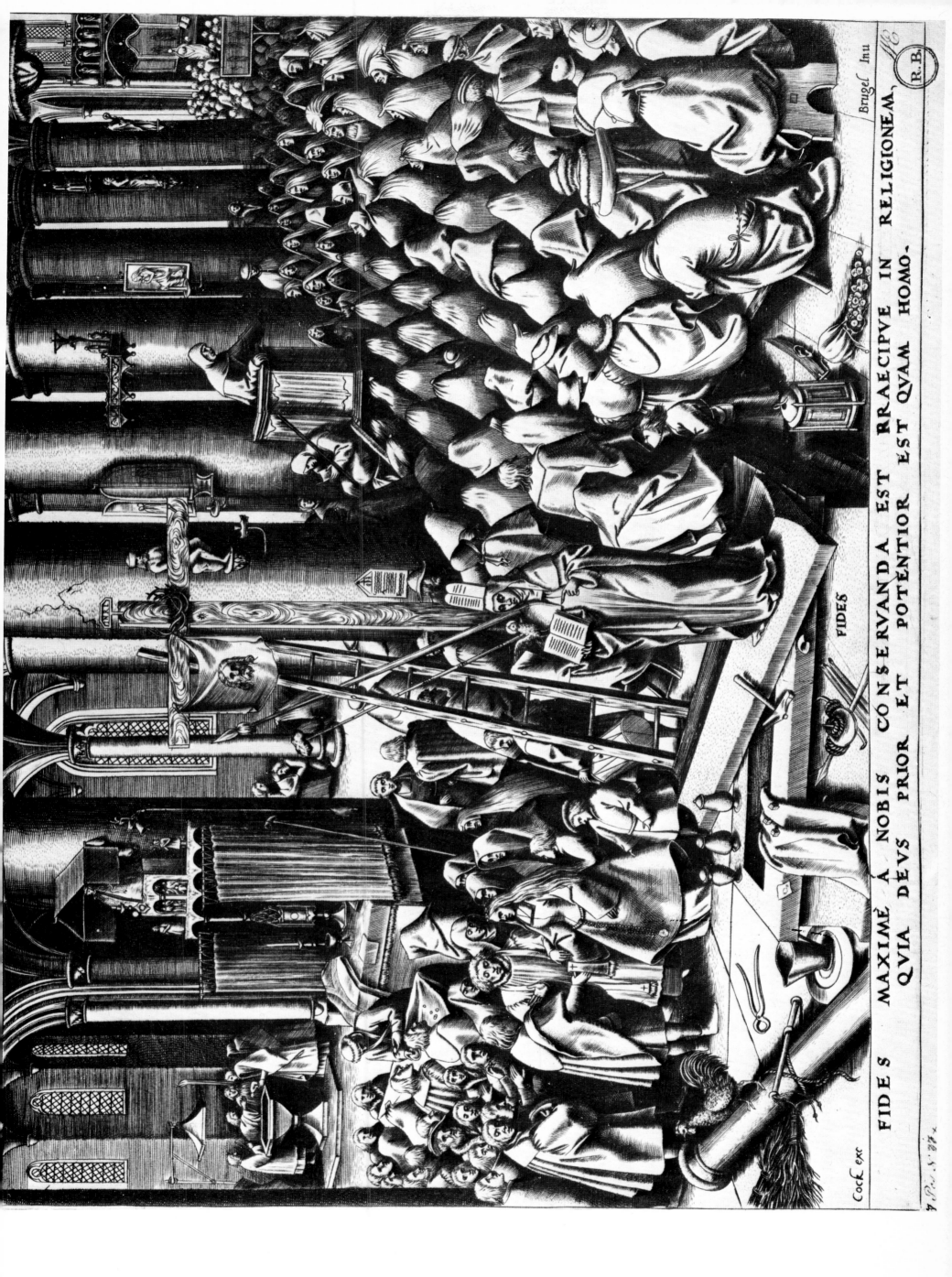

Cock exc

FIDES MAXIMÉ À NOBIS CONSERVANDA EST PRAECIPVE IN RELIGIONEM, QVIA DEVS PRIOR ET POTENTIOR EST QVAM HOMO.

Brugel Inu

R.B.

FIDES

63

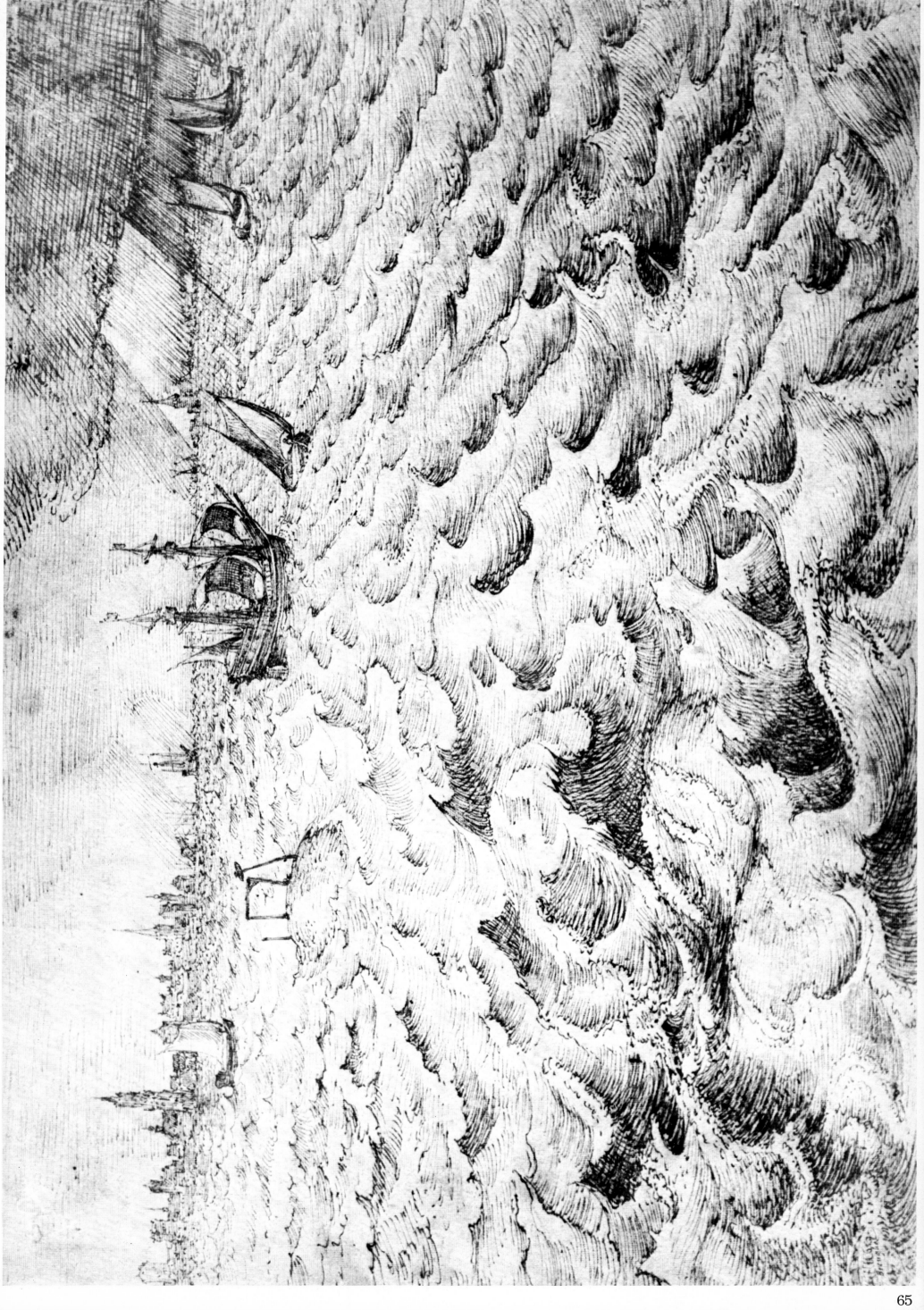

BRVEGEL · M·D·LXV. P. Perret fc ·79· Cum Priulegio.

QVI SINE PECCATO EST VESTRVM, PRIMVS IN ILLAM LAPIDEM MITTAT. Ioan. 8.

Antverpiæ apud Petrum de Iode.

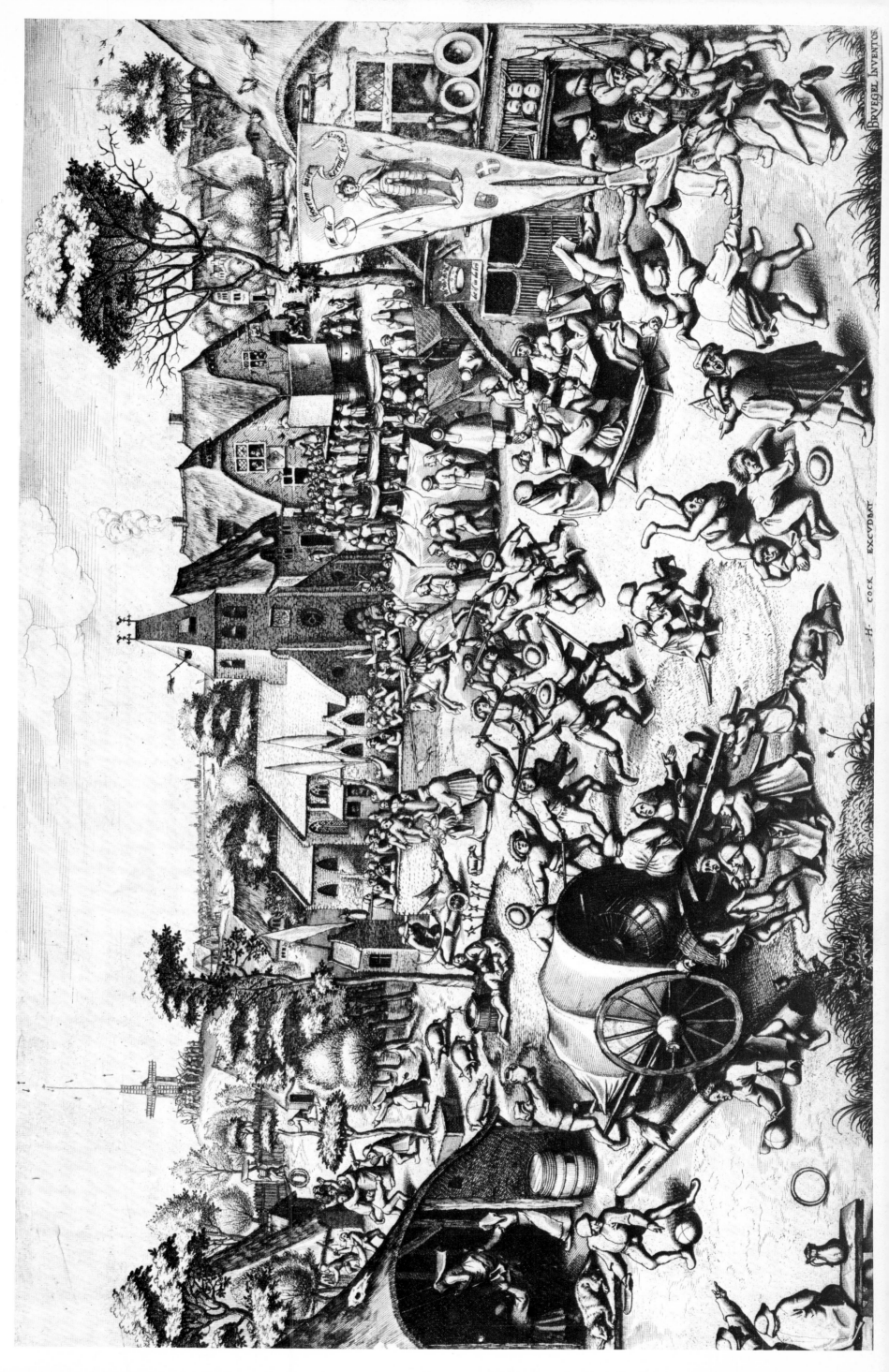

70

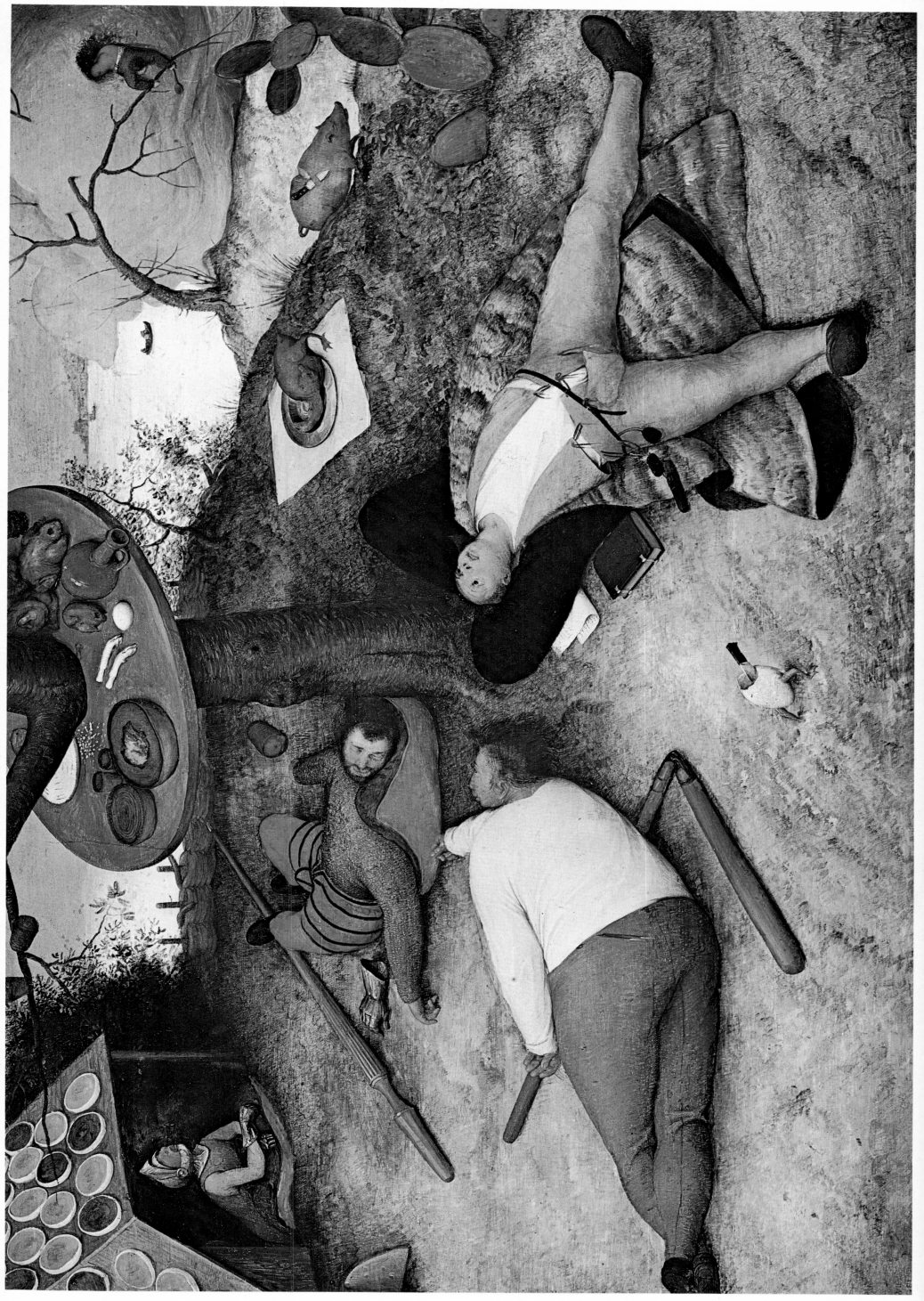

bruegbel inue 1563

Daer magherman die pot roert is een arm ghasterije
dus Loop ick nae de vette Cuecken met herten blije

P.
Æ.

Ou Maigre-os le pot moue est Ou pouure Conuiue
Pourie, à Grasse-cuisine iray, tant que ie viue

H. cock fe.

72

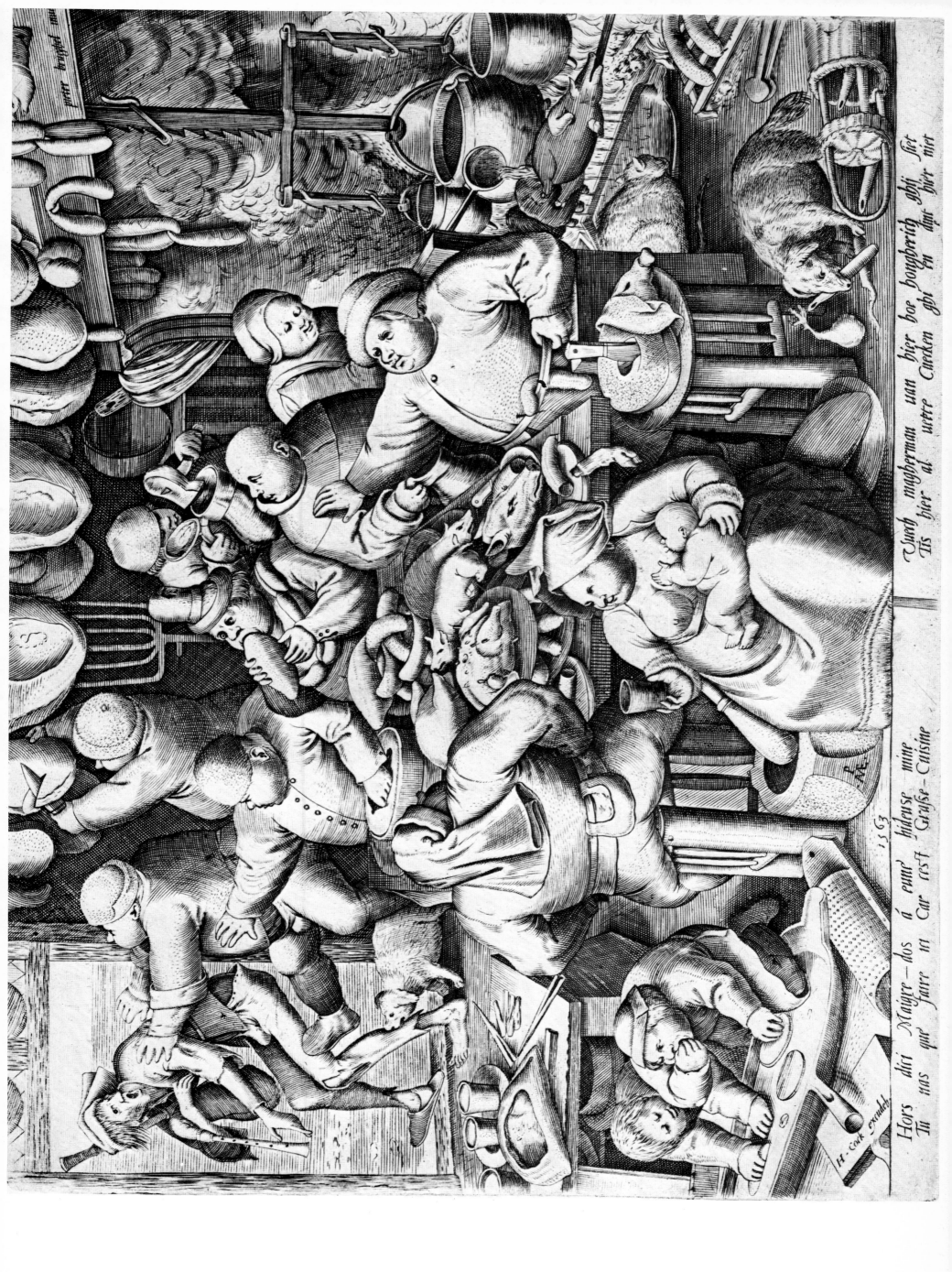

73

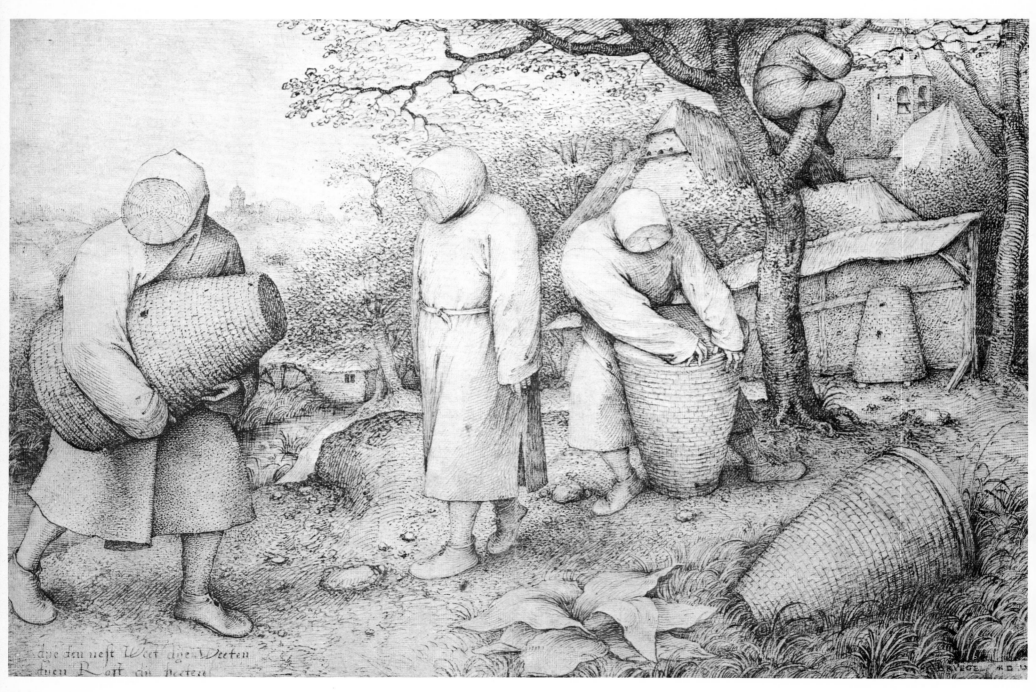

die den nest weit die weeten
den Roof an heeten

76

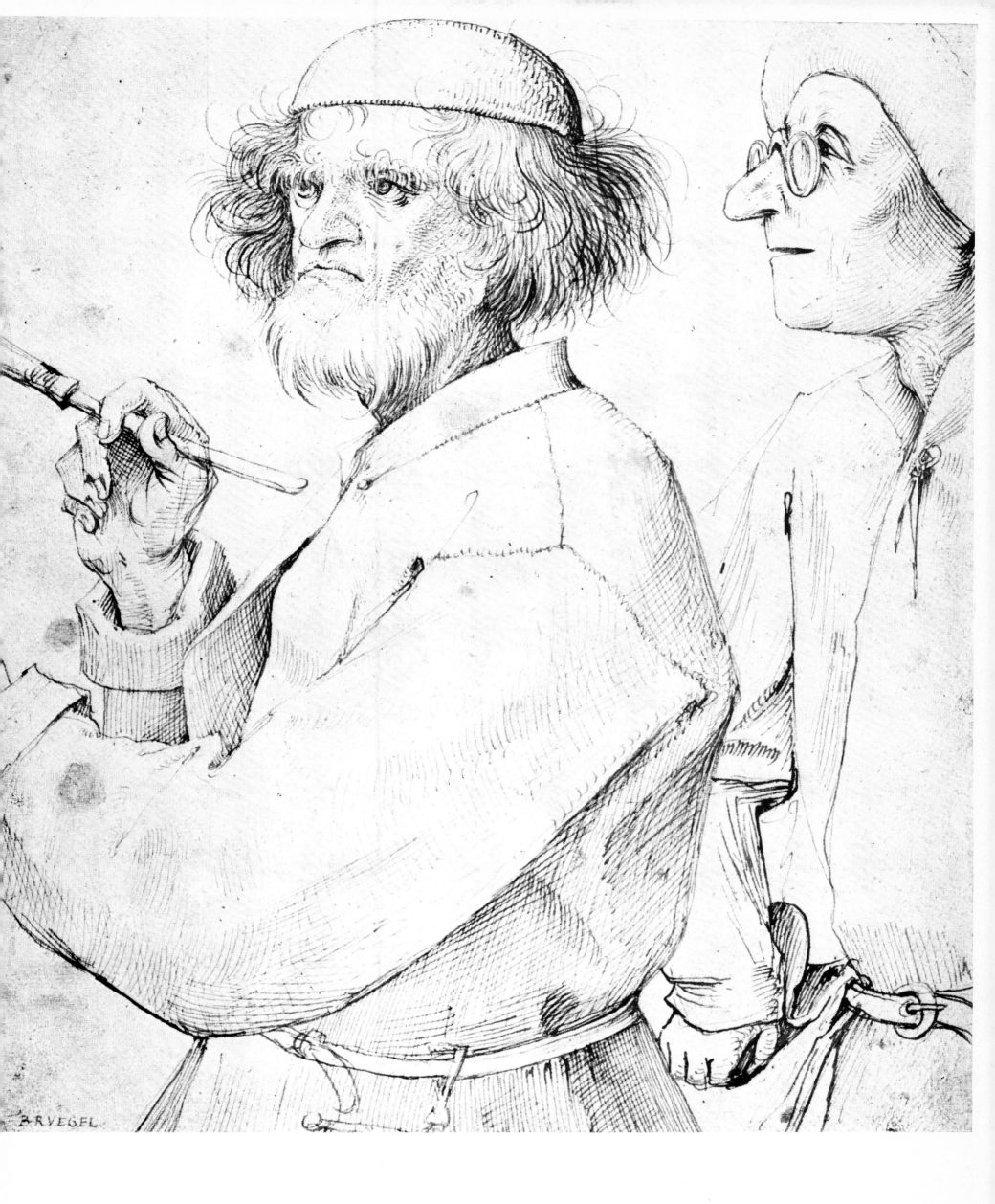

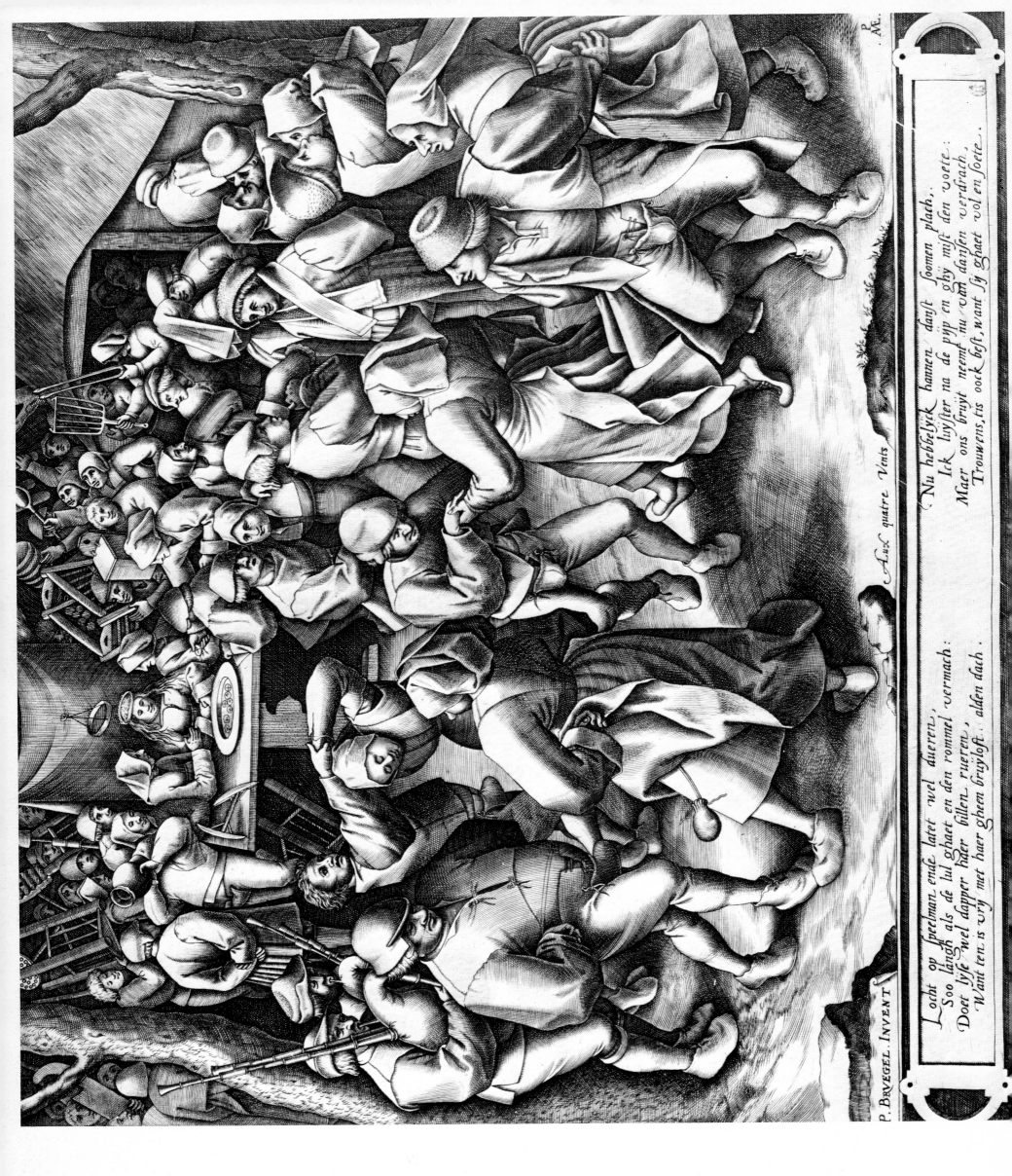

P. BRVEGEL. INVENT

Aux quatre Vents

Locht op speelman ende latet wel dueren,
Soo langh als de lul ghaet en den rommel vermach:
Doet lyste wel dapper haer billen rueren,
Want ten is vry met haer gheen Bruyloft, alden dach.

Nu hebbelyck hannen danst soomen plach.
Ick luyster na de pyp en ghy mist den voete:
Maer ons bruyt neemt nu-vm dansen verdrach.
Trouwens, tis oock best, want Sy ghaet vol en soete.

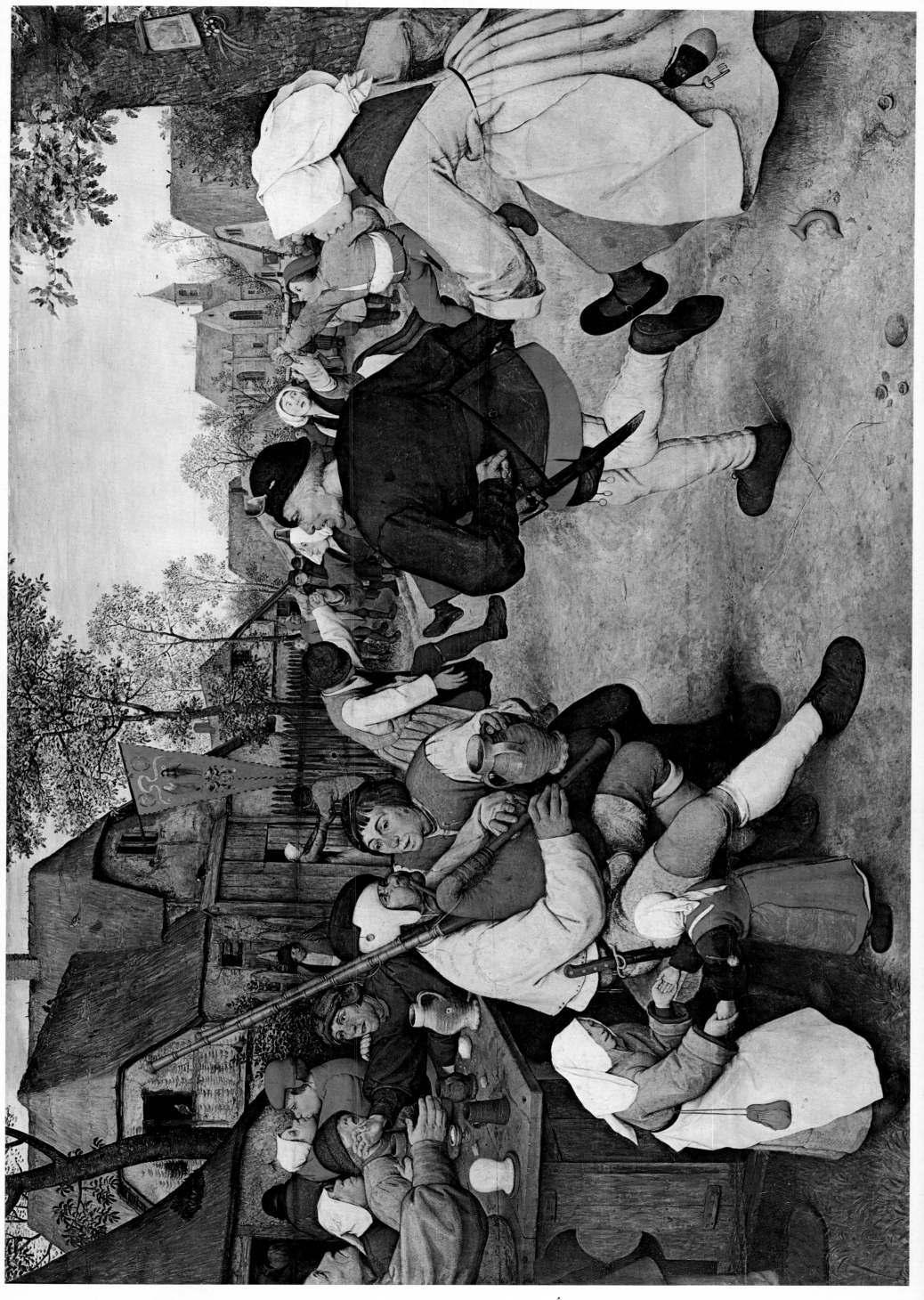

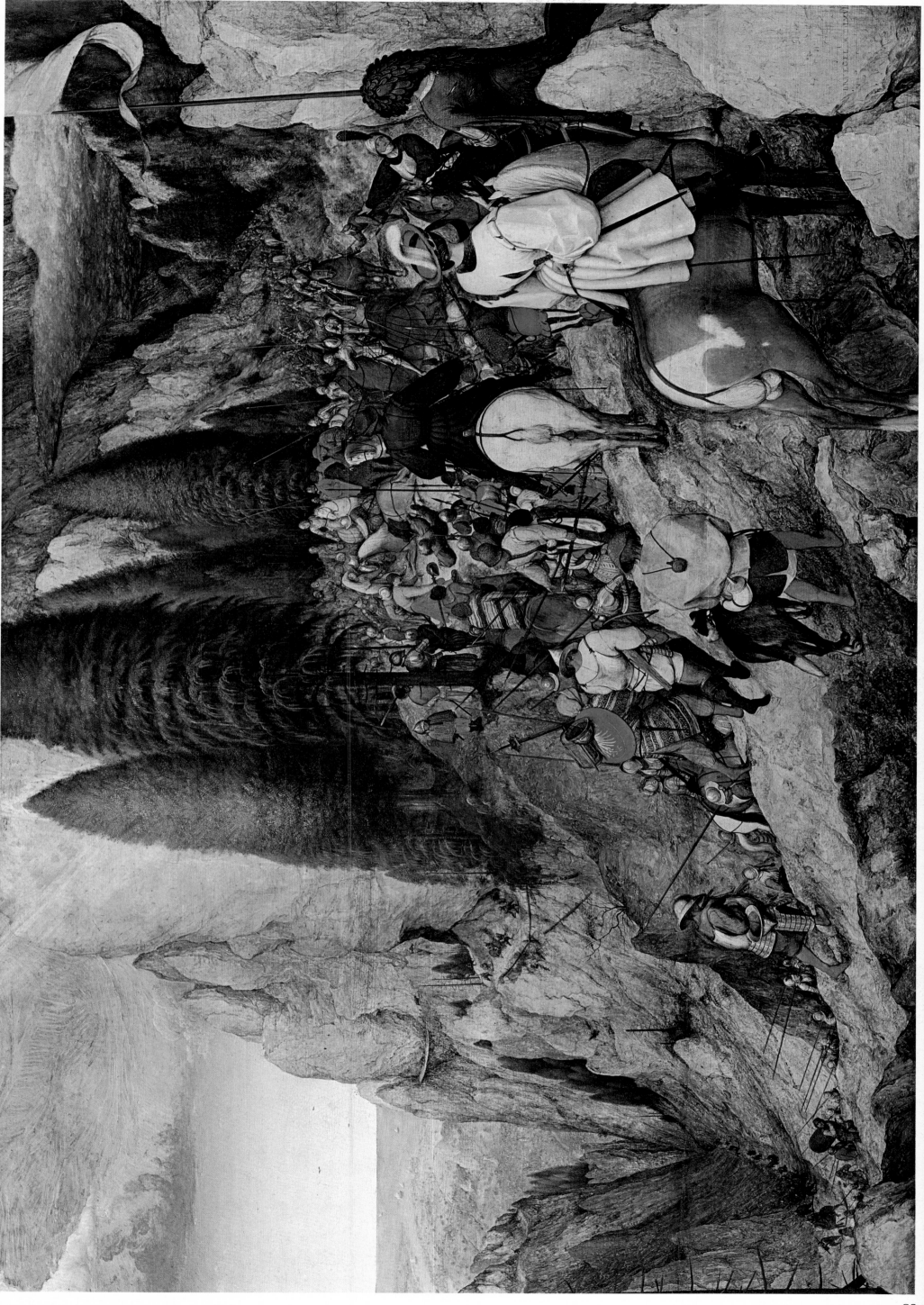

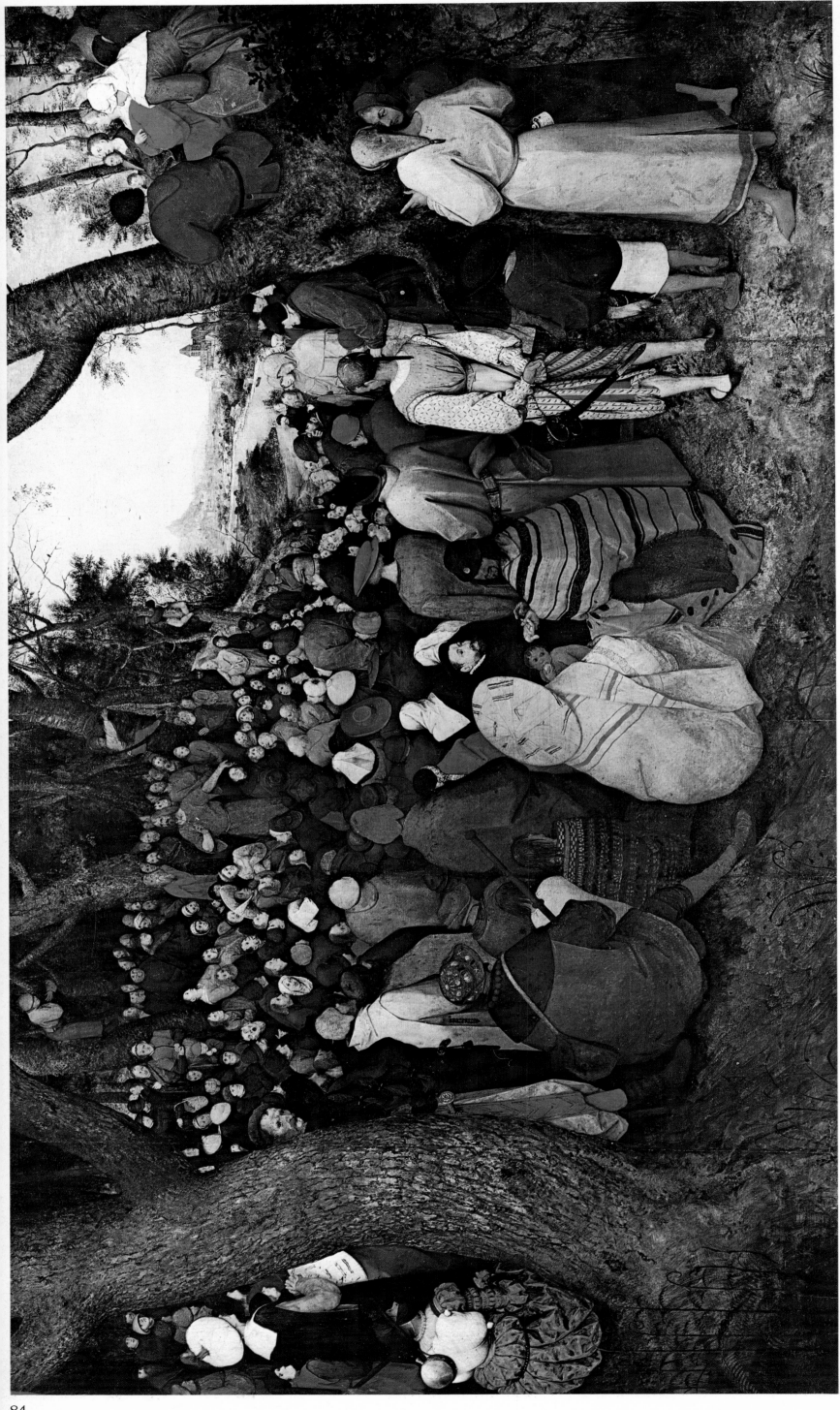

85

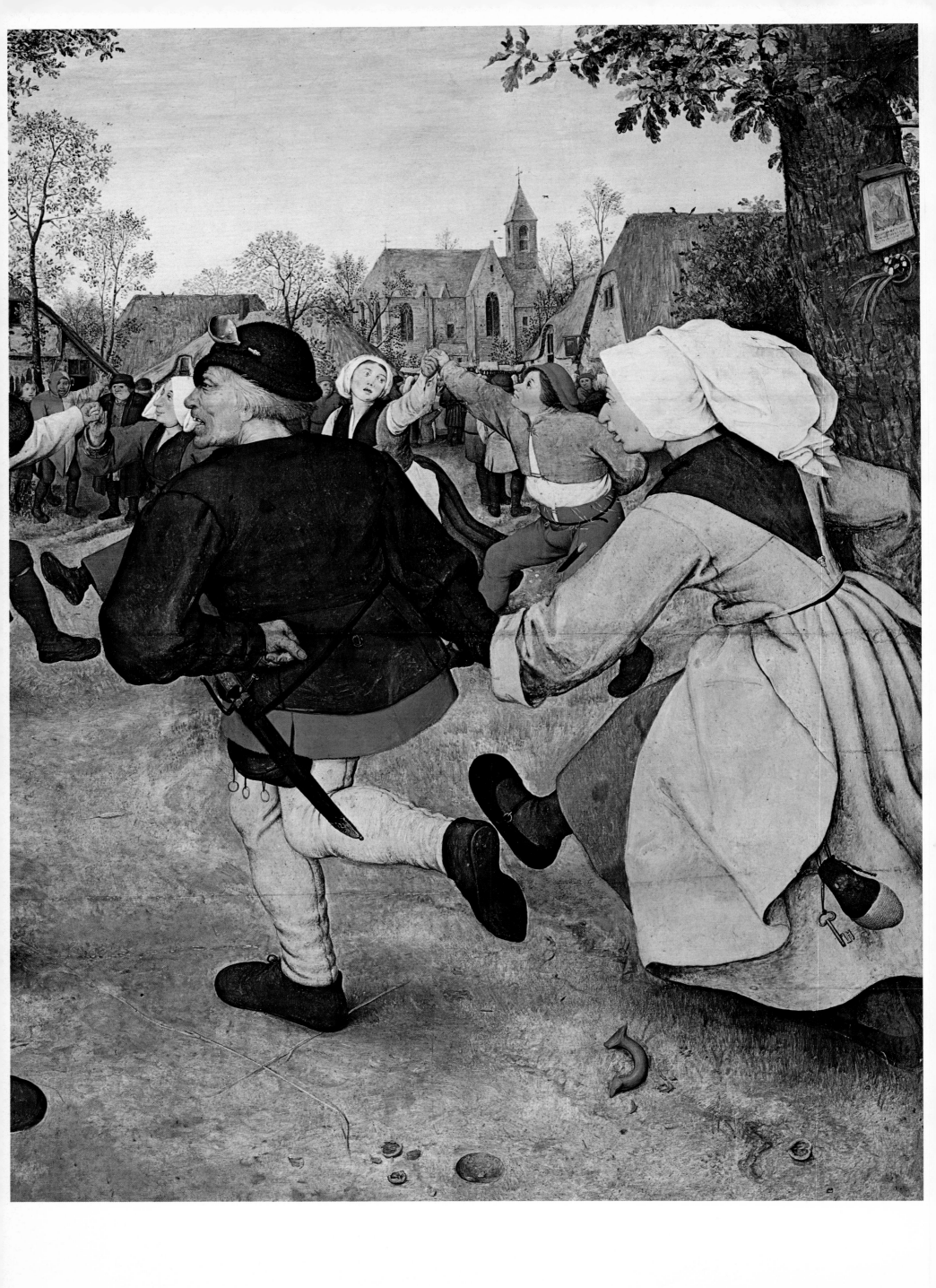

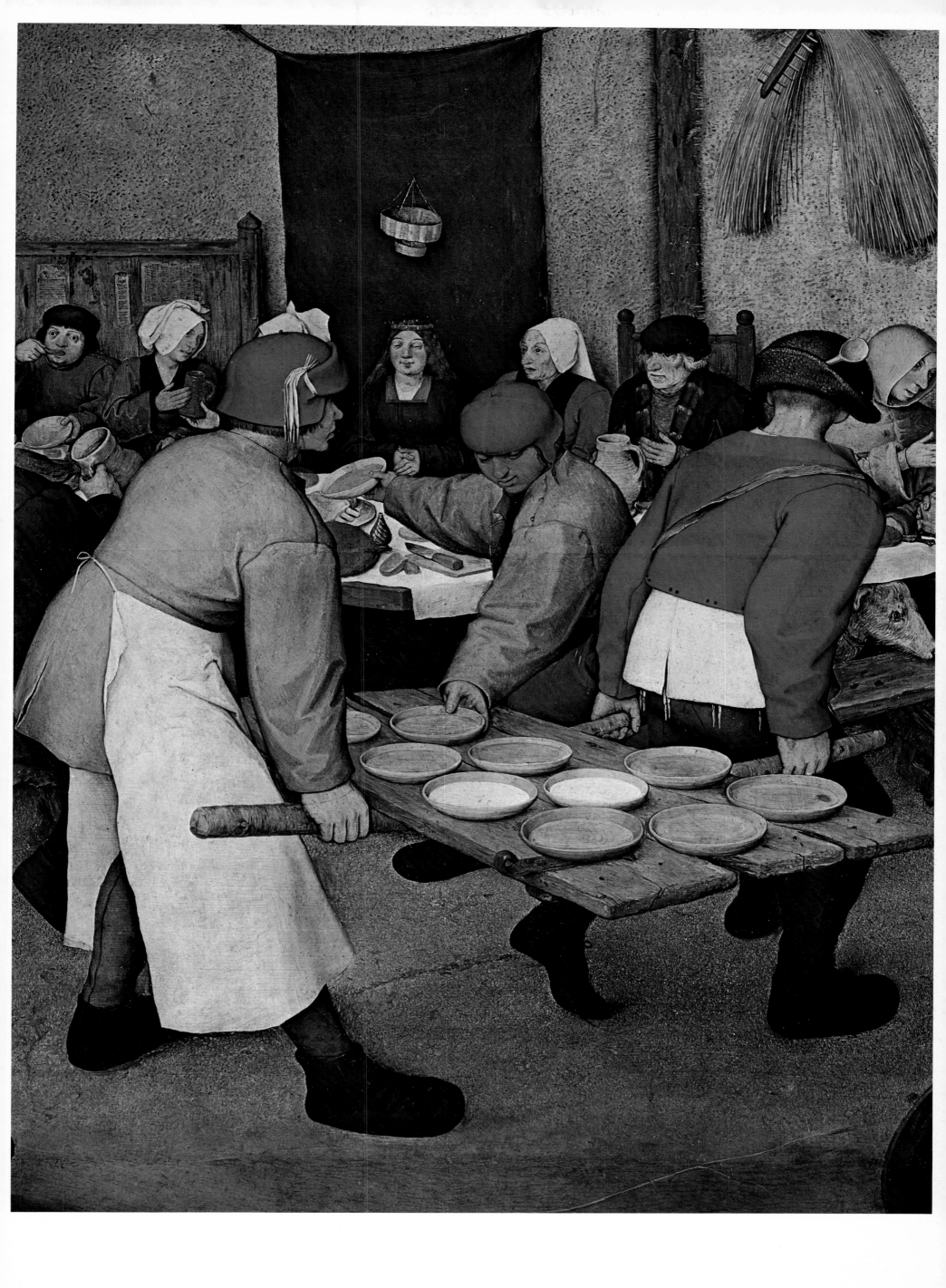

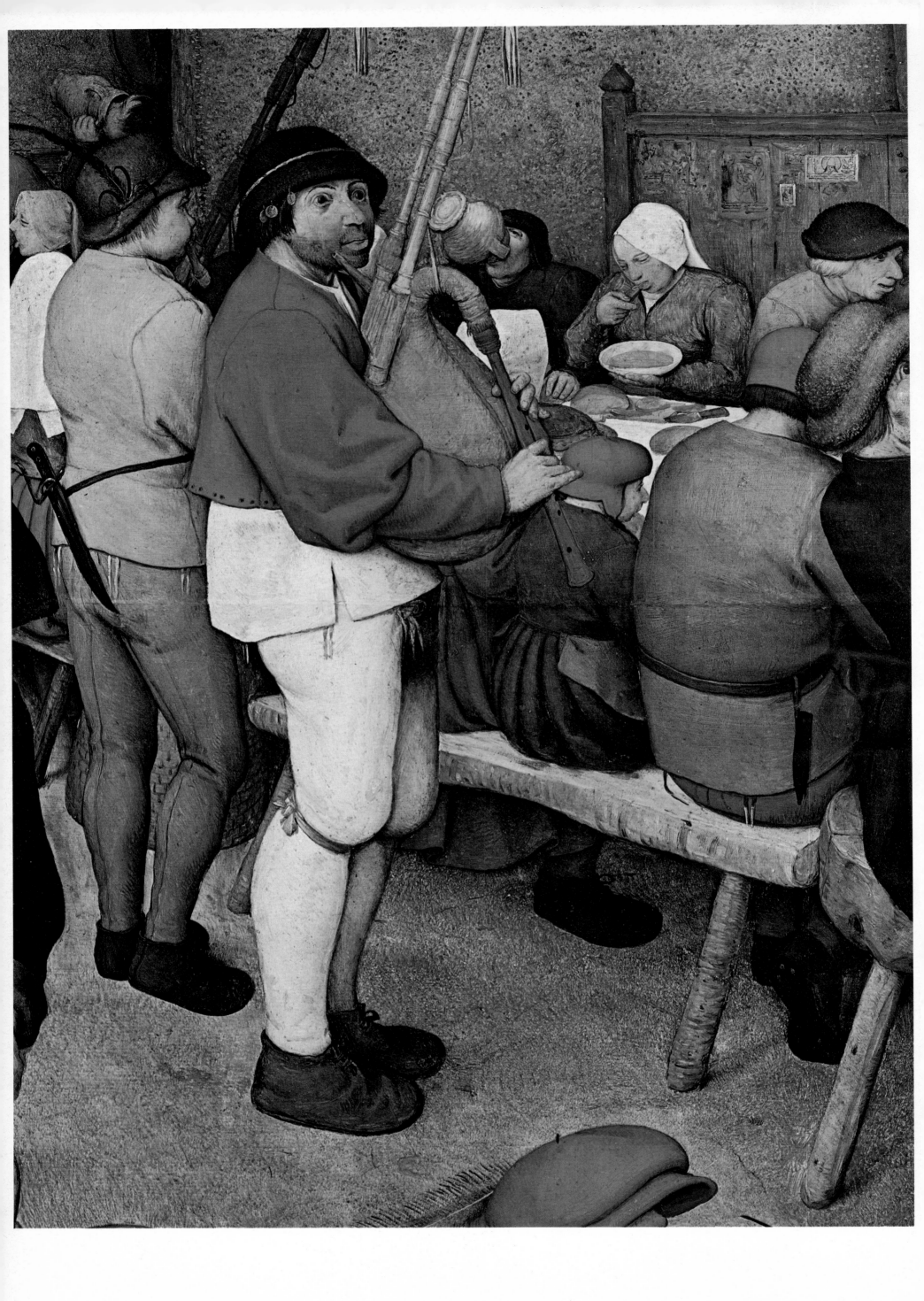

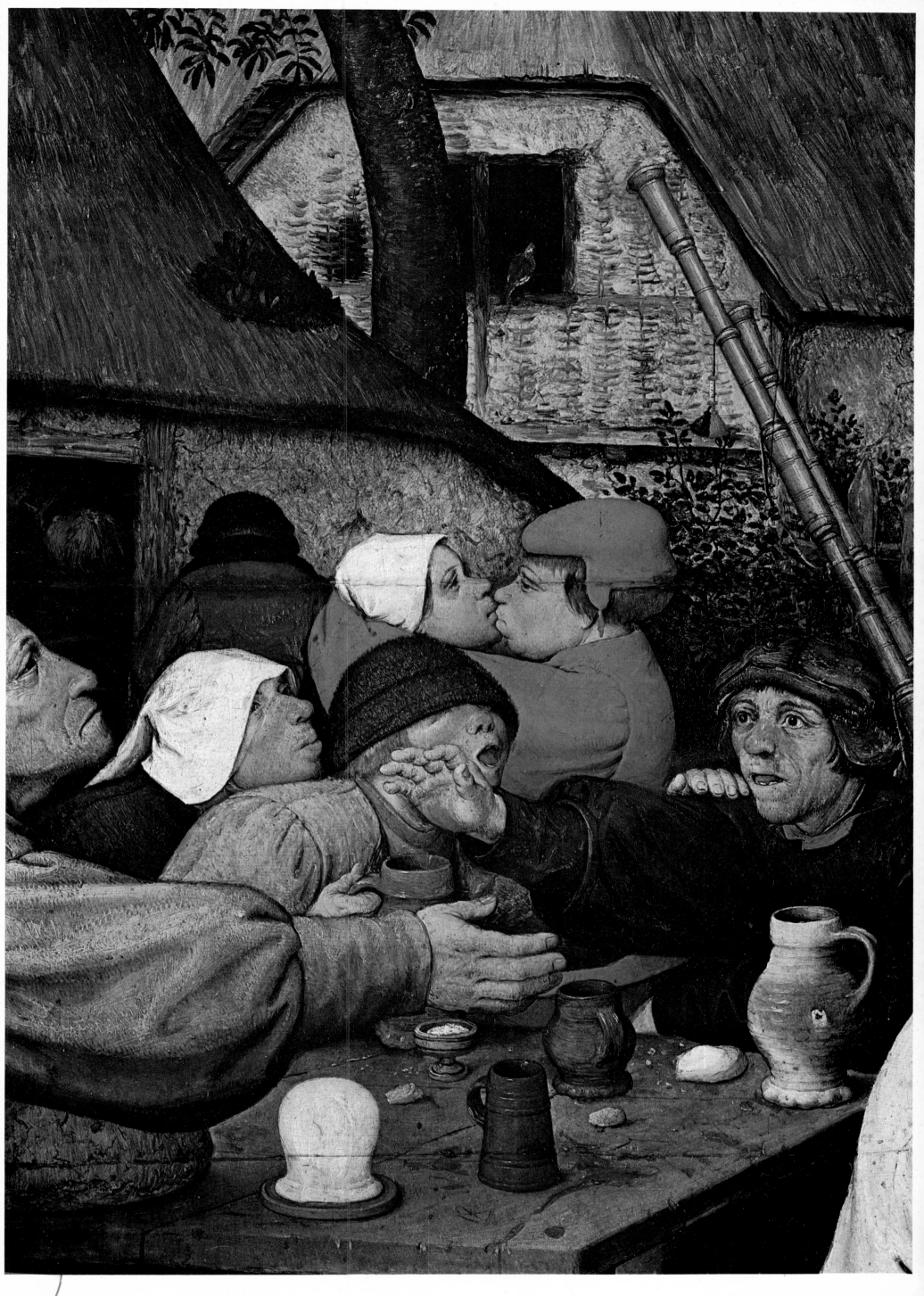

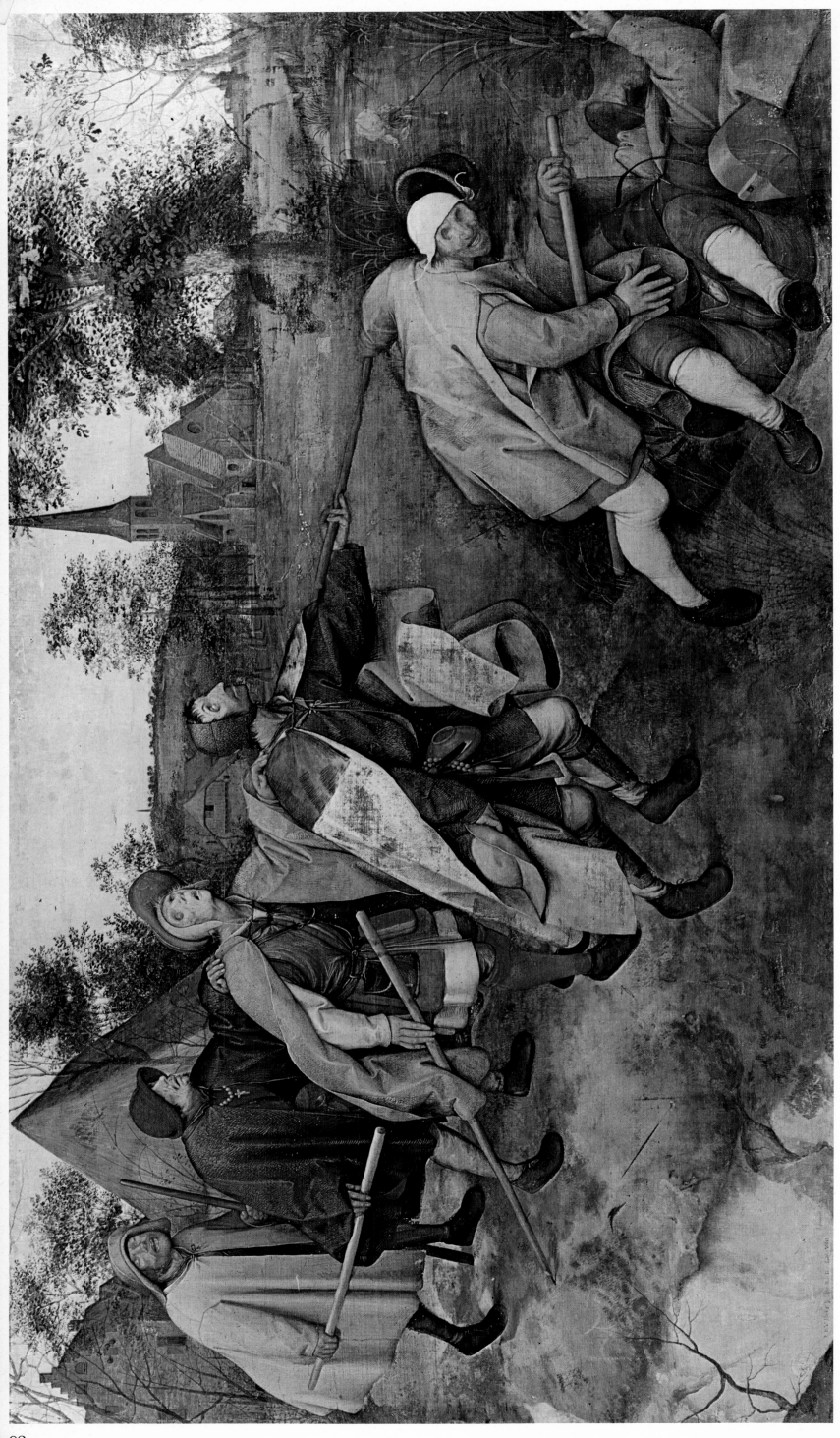

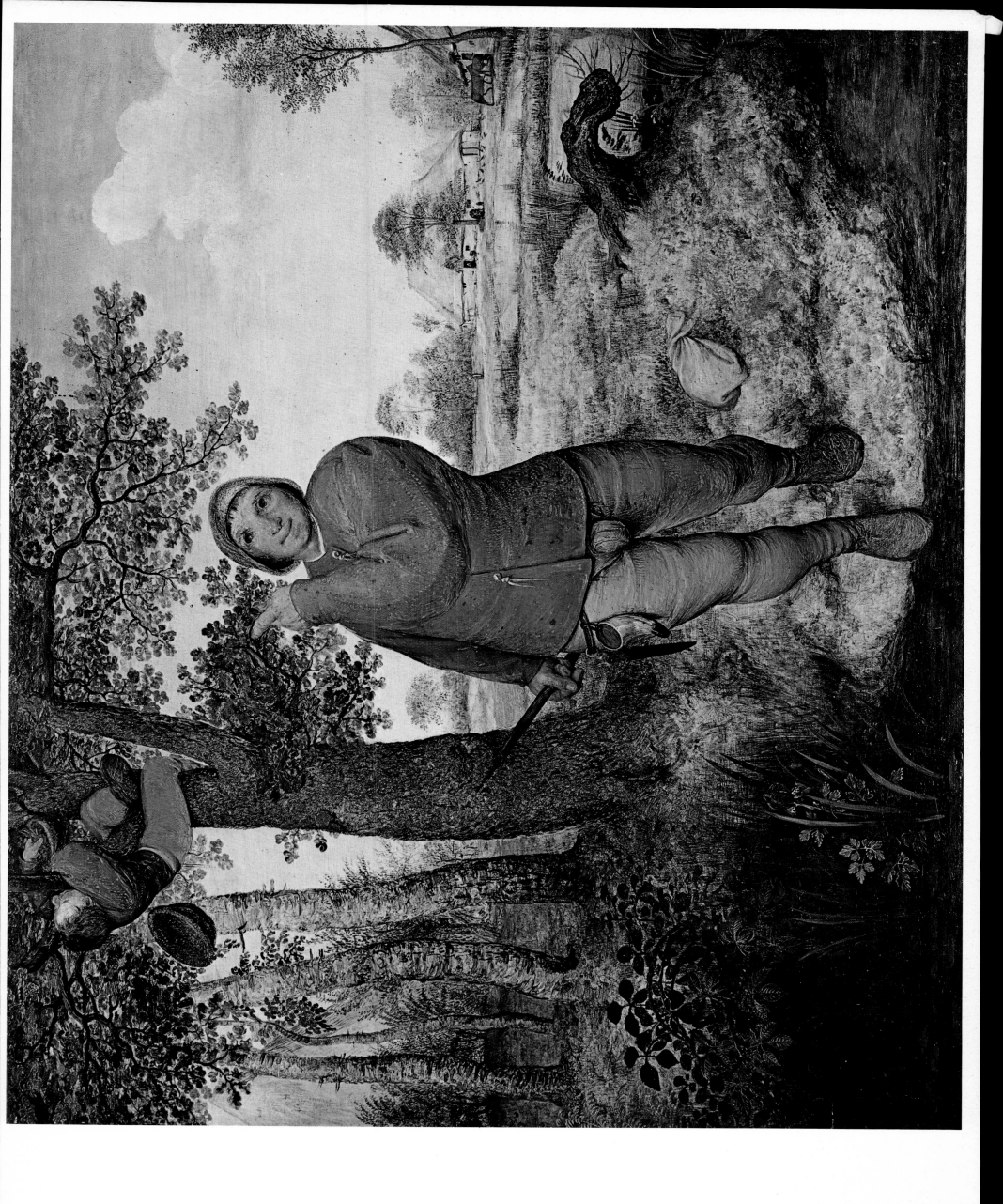

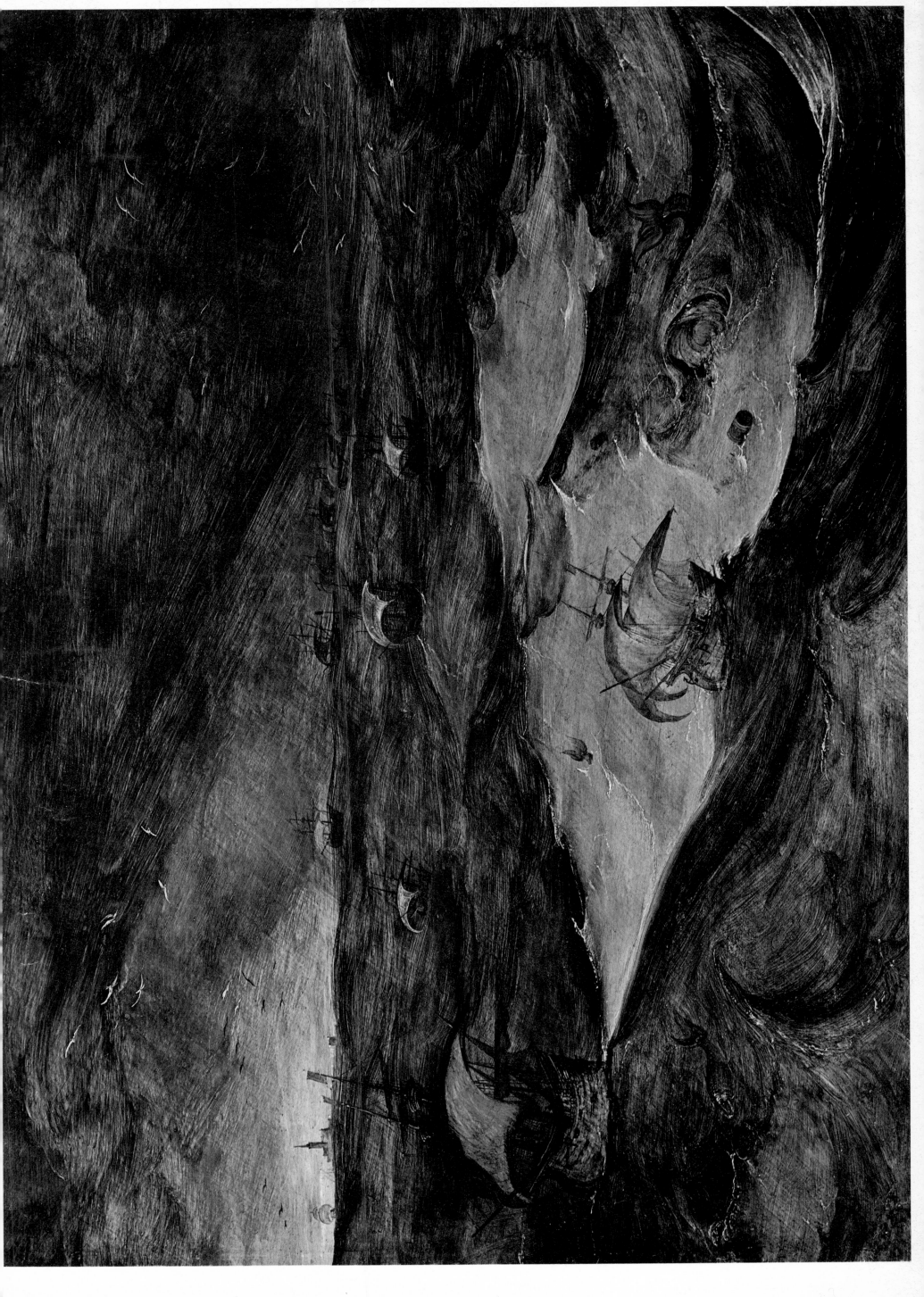

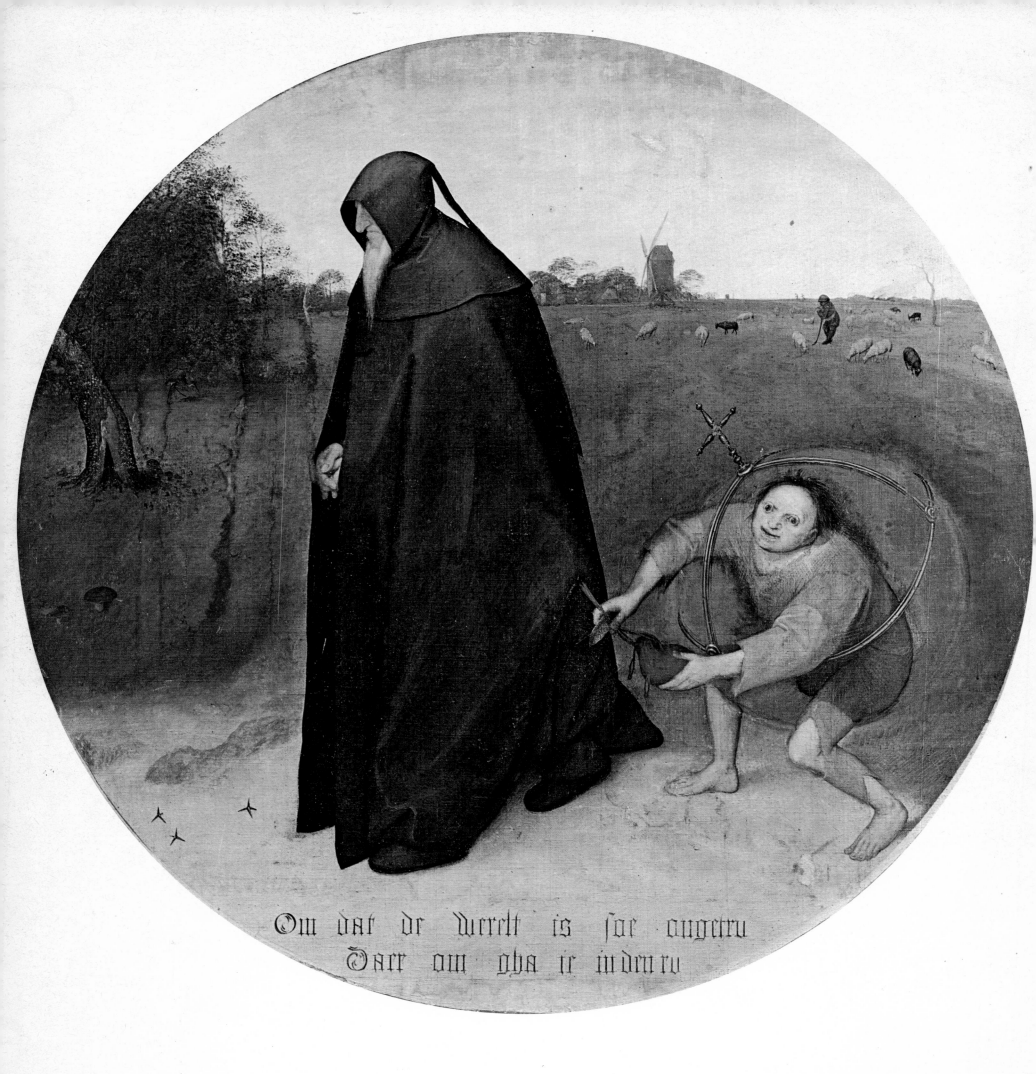

Om dat de werelt is soe ongetru
Daer om gha ic in deuru

96